A HISTORY OF
AMERICAN PAINTING

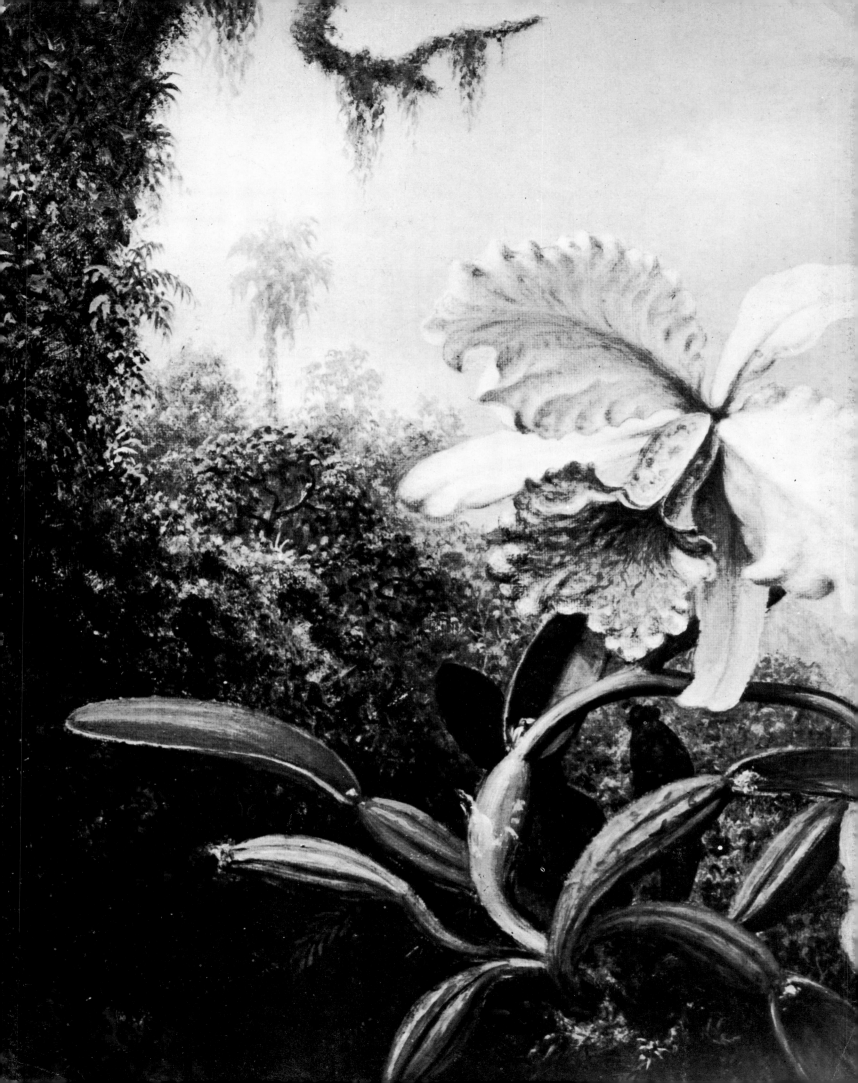

A HISTORY OF
AMERICAN PAINTING

Ian Bennett

Hamlyn
London · New York · Sydney · Toronto

For Sean and Roz

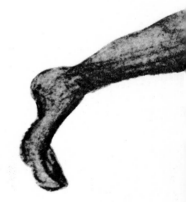

Published by
The Hamlyn Publishing Group Limited
London · New York · Sydney · Toronto
Astronaut House, Feltham, Middlesex, England
© Copyright The Hamlyn Publishing Group Limited 1973
ISBN 0 600 34400 2
Phototypeset in England by
Filmtype Services Limited, Scarborough
Printed in Italy by
Officine Grafiche Arnoldo Mondadori, Verona

Contents

In the beginning

Even before a settled colony was established in America in the early years of the 17th century, artists had become fascinated by that strange and weird land reported by the voyagers and conquerors. It is perhaps a matter of regret that no first-class artist accompanied any of these expeditions, but then, until the advent of John Singleton Copley in the second half of the 18th century, it is probably true to say that no artist of great, international, significance worked in America.

The late 16th century, however, witnessed the presence of two important painters on American soil. Both were competent, and their depictions of flora and fauna, and of native life, are amongst the earliest that have come down to us. One, Jacques Le Moyne, called de Morgues, was a Frenchman, and the other, John White, was English.

In 1564, Le Moyne was sent to Florida by the French Government as the artist with a party of Huguenots under Laudonnière. The expedition established itself at the mouth of the St John's river at Fort Caroline, but the following year the garrison was destroyed by the Spaniards, who considered Florida to be Spanish territory and who, in

any case, loathed the Huguenots for their heretical beliefs. The Spanish commander, Pedro Menendez de Aviles, hanged the inhabitants 'not as Frenchmen but as Lutherans', an act which provoked the French Government into sending a retaliatory force under Dominique de Gourges, who in turn, in 1568, hanged the Spanish occupants of the fort 'not as Spaniards but as murderers'.

When the Spaniards captured Fort Caroline in 1564, Le Moyne was one of the few Frenchmen to escape. He was brought subsequently to London, where he became a 'servaunt to Sir Walter Raleigh', the latter having become deeply interested in Laudonnière's expedition. After he settled in London, Le Moyne continued to produce drawings and watercolours, mainly of English flora and fauna. He died in 1588.

After Le Moyne's death, his American watercolours and drawings were purchased by Theodore de Bry, together with his narrative journal. This journal, illustrated by copper engravings executed by de Bry and his sons after the drawings, was published in Frankfurt am Main in 1591, under the title *Brevis Narratio eorum quae in Florida Americae provicia Gallis acciderunt*, generally known as the *Voyages*.

Le Moyne was the first professional artist to visit America, and from an ethnographical and geographical standpoint his work is of tremendous significance. In 1967, however, a new insight into his activities was gained from the discovery, and sale by auction in London, of an oil painting, *Indians Collecting Gold in the Streams Flowing out of the Apalachy Mountains*. The composition of this picture is the same as plate 41 of de Bry's *Voyages*, and it is now accepted generally that Le Moyne worked up the sketch, which subsequently served de Bry, into a finished oil painting. It is probable that this was done after the artist had settled in London. In technique it is crude and somewhat heavy, and the paint has oxidised giving the picture an overall dark brown colour. It is, nevertheless, a moving document, a closely observed and reasonably skilful picture, and the first oil painting that exists of an American subject.

John White was an English watercolourist specialising in botanical subjects, who in 1585 went

1 *Indians of Florida Collecting Gold in the Streams Flowing out of the Apalachy Mountains*
1564
Jacques Le Moyne
oil on canvas, 31½ × 42 in

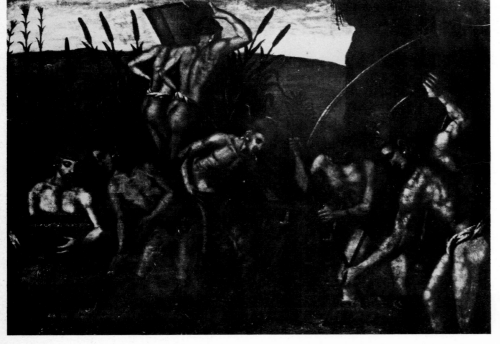

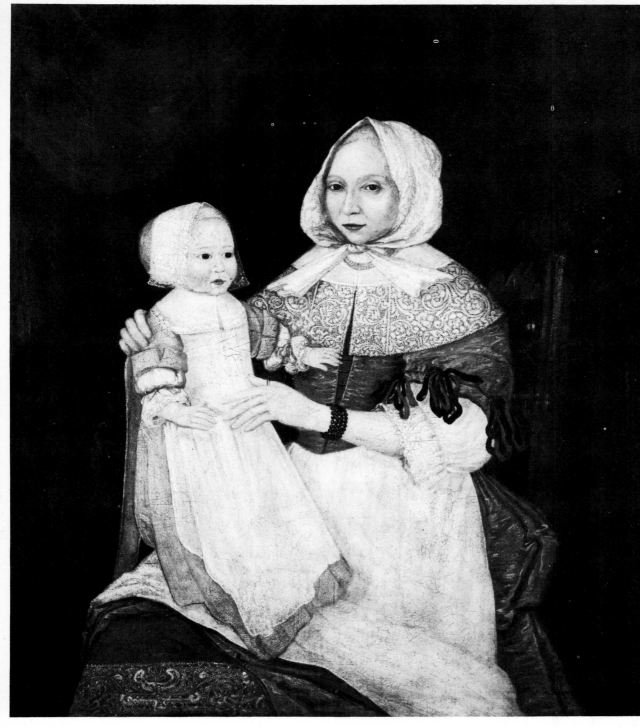

to Sir Walter Raleigh's colony at Roanoke in Virginia, where he made many watercolours of the local flora and fauna. In 1587, he returned to the colony as governor and, apart from his significant place in the prehistory of American painting, has the added distinction of being the grandfather of the first European child born in the New World. A group of sixty-five of the most important drawings by White are contained in an album in the British Museum. Somewhat whimsical in style, but of a great delicacy akin to the work of a miniaturist, they depict flowers, animals and fish, as well as the Indians themselves; many of the latter drawings are closely observed studies of great ethnographical interest.

After the permanent colonisation of America in the 17th century, the painter of portraits soon appeared, as natural an adjunct to the new and rapidly prospering society as the furniture-maker or silversmith. Indeed at this time, the painter would have been considered as little more than an artisan; over a century later, Copley could still complain in a letter to Benjamin West that in America painting was thought of as a humble occupation: 'People generally regard it as no more than any other usefull trade, as they sometimes term it, like that of a carpenter, tailor, or shewmaker, not one of the most noble Arts in the world. Which is not a little mortifiing to me.'

It has been estimated that more than four hundred portraits survive which were painted in America in the 17th century, although not one of these dates from before about 1660. The finest were executed by artists of Dutch extraction in the area

7

of New Amsterdam, whilst many good examples were painted in the prosperous communities of Boston and New England. The majority of these pictures are bust length portraits, although on rare occasions the much more difficult compositional task of a full length would be essayed, of which the most famous, and accomplished, is that

3 *Portrait of John Freake*
1674
artist unknown
oil on canvas, 42½ × 36¾ in
Worcester Art Museum

4 *Colonel Pieter Schuyler*
about 1720
Schuyler Limner
oil on canvas, 87¾ × 51 in
Collection Albany Institute
of History and Art

of Peter Schuyler, mayor of Albany from about 1686 to 1695, now in the Albany Institute of History and Art, New York. This, like most of the other American portraits of the period, is based, compositionally, upon European engravings, one of the main sources for such pictures right up until the end of the 18th century.

As with the applied arts, the primary source of inspiration for the English artists in the New World would have been English painting. Yet the state of English art at the end of the 16th century was, with the exception of the great miniaturists like Hilliard and Oliver, extremely low. Most of the finest late Tudor and early Stuart portraits were executed by Dutch and Flemish visitors such as Mytens and Gheeraerts, and it could be truthfully said that there was no flourishing, indigenous school of English easel painting, nurtured by a long and fruitful tradition, as there was in the Low Countries and Italy. Even the Dutch and Flemish painters who came to England were usually severely limited in their capabilities; they were splendid colourists and had a good idea of composition, but there their talents ended. They tended to produce stiff, wooden pictures – highly decorative cardboard cut-outs. Only occasionally did they rise to any great achievement.

In addition, the best English painting at this period was closely connected with the court and the aristocracy, a world with which the Puritan settlers would have had little contact. Thus it is that there is less difference between the paintings of the Dutch and English settlements in the 17th century than was the case with the applied arts. For both sets of painters were working from a common stock, although the Dutch, with their greater knowledge of the Baroque and their more developed sense of volume and perspective, managed, perhaps, to produce the more realistic portraits.

At this time was painted a remarkable group of portraits of three Bostonian families, the Freakes, the Gibbs and the Masons. This includes the *Portrait of John Freake* and *Mrs Elizabeth Freake and Baby Mary*, both now in the Worcester Art Museum, Worcester, Massachusetts. The *Portrait of John Freake* is known to have been commissioned in 1674, and it is assumed that that of his wife and child would have been executed exactly contemporaneously. The *Portrait of Alice Mason* and the *Portrait of Margaret Gibbs*, both in a private collection, are dated to about 1670. In all of these pictures, the influence of the late 16th-century Anglo-Dutch portrait style is uppermost. They have been likened to Elizabethan costume pieces, and it is certainly true that they exhibit a style some seventy or eighty years behind that prevailing in Europe. They are, nevertheless, strong and carefully composed pieces into which the anonymous artists have laboured to instil some individual realism. It may not be fanciful to suggest that even at this early date, the perennial American concern with a strictly delineated and accurate portrayal of 'the thing seen' is struggling to the fore.

In New Amsterdam (New York), several artists are recorded working in the second half of the 17th century, although few of the surviving portraits of this period can be safely attributed to any one of them. Evert Duyckinck, who came over to America in the army in 1638, has a significant place in the history of early colonial glassmaking, and he is also recorded as being a painter. His son, Gerret, was also a painter, and in about 1700 executed the famous *Self-portrait* and *Portrait of Mrs Gerret Duyckinck*, both now in the collection of the New York Historical Society. These portraits, whilst still being somewhat primitive and flat, show a definite awareness of Baroque modes which soften what would otherwise be rigid, geometrical compositions.

Also active in the late 17th century was Hendrick Couturier, a professional painter who had been elected to the Leiden Guild in 1648, and who is thought to have emigrated to America late in the 1650s. Although he is recorded as having painted a portrait of Governor Peter Stuyvesant and to have made drawings of the Governor's sons, unfortunately none of his pictures is known to have survived, or at least none of the New York pictures of this date can be attributed to his hand.

In New England, only one painter working in the 17th century has a well-defined personality: Captain Thomas Smith, a sailor, who arrived from Bermuda in 1650. In 1680, a certain 'Major' Thomas Smith was commissioned by Harvard University to paint a portrait of the Reverend William Ames, and historians are unanimous in their agreement that the Captain and the 'Major' are one and the same. Smith's known works, of which by far the most famous is his *Self-portrait* of about 1690 (Worcester Art Museum), include the *Portrait of Captain George Curwen* (Essex Institute, Salem) and the *Portrait of Major Thomas Savage* (private collection)—although the attribution of this latter picture is still a matter of some controversy. All of these show a degree of sophistication and an awareness of roughly contemporaneous European styles which is unusual in American painting at this date. In their handling of the problem of portraying the three dimensions, the paintings are amongst the most interesting and accomplished produced in 17th-century America. They make an obvious contrast with the more decorative but archaic Freake, Mason and Gibbs portraits painted in the same region and at about the same time; this contrast shows that Smith was a well-travelled man who had been a sensitive observer of the new developments in European art, whilst the anonymous painters were obviously unaware of all that had happened in European aesthetics over a period of many years.

The presence of Smith, and the obvious technological advances which his paintings represent, clearly demonstrate how important it was to the developing art of the New World that painters from Europe should come to America and bring with them their knowledge and abilities. Native artists could only learn from example. The history of early American painting, however, demonstrates one obvious truth—that great artists are born, not made. When the time came for America to produce a painter of genius, John Singleton Copley, that artist, by the force of his own innate ability, executed in the comparative backwoods of Boston pictures which can stand beside any painted in London, Paris or Rome at the same time. It was as if all the struggles of American painting throughout the 17th century, and the first half of the 18th, were but a preface to Copley's appearance, and that once America had produced him, she could go on to nurture other painters of greatness.

At the end of the 17th century and the beginning of the 18th, a number of Europeans came to America for various periods of time. In 1705, Henrietta Johnson, a pastellist from England, settled in Charleston, South Carolina. Six years later, two painters who were to have great effect upon the development of American painting arrived. From Germany came Justus Engelhardt Kühn, who settled in Annapolis, whilst the Swedish painter Gustavus Hesselius took up residence in Philadelphia. In 1714, John Watson, a portrait-painter from Scotland, settled at Perth Amboy. In the 1720s,

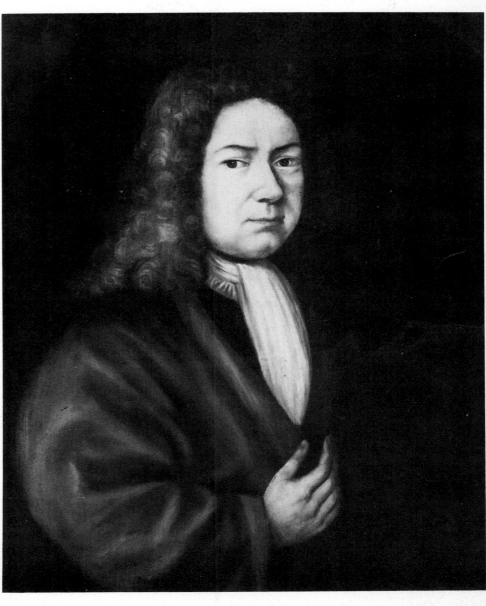

5 *Self-portrait*
about 1700
Gerret Duyckinck,
1660–about 1712
oil on panel, 30 × 25 in
New York Historical
Society, New York City

6 *The Bermuda Group:*
Dean George Berkeley
and His Family
1729
John Smibert 1688–1751
oil on canvas, 69½ × 93 in

Yale University Art Gallery,
New Haven, Connecticut
(Gift of Isaac Lothrop of
Plymouth, Massachusetts,
1808)

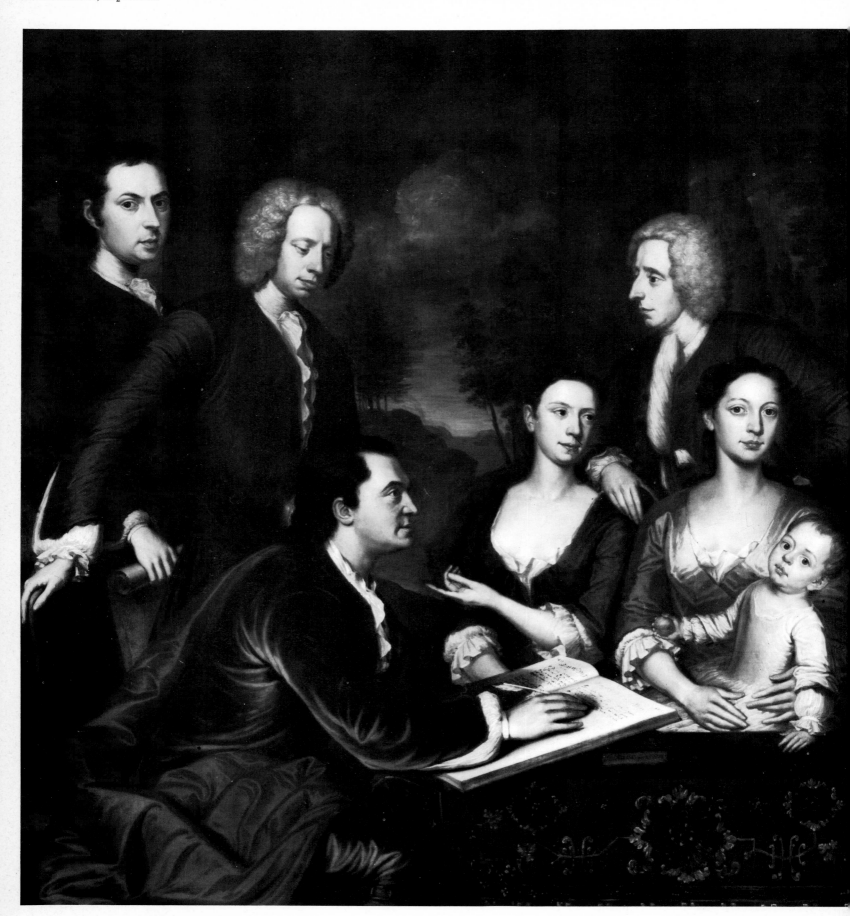

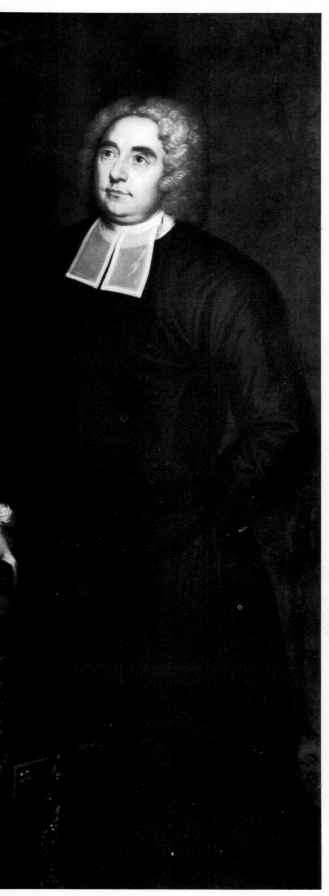

two other artists came over from Britain: Peter Pelham, a mezzotint engraver and, later, stepfather to John Singleton Copley; and possibly the most important of all the painters mentioned here, John Smibert.

The first thirty years of the 18th century also saw the birth of the first generation of native-born American painters, which included the Bostonians Nathaniel Emmons (1704), Joseph Badger (1708), John Greenwood (1728) and John Singleton Copley (1738); the Philadelphians James Claypoole (1720), John Hesselius, son of Gustavus (1728), and Benjamin West (1738); and the mysterious and elusive Robert Feke, who was born on Long Island in about 1707.

The earliest group of immigrant European painters brought with them a fuller knowledge of the Baroque style than had existed in America until then. In about 1735, Charles Bridges of London arrived in Virginia, and although his work executed in America has not been identified with absolute certainty (he left for England early in the 1740s), the various portraits of the Byrd family which have been attributed to him seem to show a vague knowledge of the decorative and more informal style of the early Rococo. Most interesting of these is the fine *Portrait of Anne Byrd*, painted

7 *Self-portrait*
17th century
Thomas Smith,
active 1650–90
oil on canvas, 24½ × 23¾ in
Worcester Art Museum

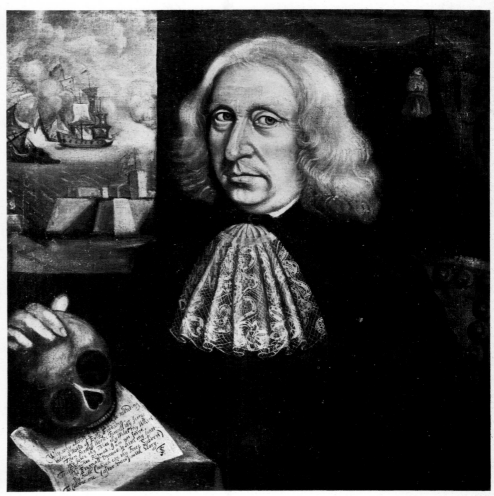

8 *Bacchus and Ariadne*
1720–30
Gustavus Hesselius
1682–1755
oil on canvas, 24½ × 32¼ in
Courtesy of the Detroit
Institute of Arts

in 1735 and now at Colonial Williamsburg.

In the mid century, three more English painters arrived: William Williams, who befriended the young Benjamin West in Philadelphia in the mid 1740s, John Wollaston in 1749 and Joseph Blackburn in 1753. These were artists working in a distinct Rococo manner, and their presence was just the boost American painting needed; none of them was particularly distinguished but they were capable enough portrait-painters whose examples were invaluable to the young generation in New England.

Also active at this time in America, in the area around New York, was a group of artists whom James Flexner, in his book *First Flowers of Our Wilderness* (1947), called 'the Patroon Painters'; working in the Hudson valley in the first three decades of the 18th century, they are a clearly definable and homogenous group, the first of its kind in America. Like earlier artists active in this area, the Schuyler Painter or Gerret Duyckinck, the Patroon Painters were greatly influenced by European engravings, and their pictures, whilst being flat, are splendidly decorative, with an almost sensuous use of colour and line. Flexner managed to differentiate a number of hands, and among the

influence a great American painter of the 19th century, George Inness, was born in 1682 in Sweden. He arrived in America in 1711, and after a brief stay in Wilmington, Delaware, settled in Philadelphia, where, apart from painting trips to Delaware, Maryland and Virginia, he remained until his death in 1755.

From the time he arrived in Philadelphia, Hesselius rapidly built up his reputation as the leading Colonial portrait-painter. His studies in Europe may well have taken him to Holland, France and Italy, and certainly he appears to have had a close working knowledge of the late Baroque. His religious and mythological subjects, including *The Last Supper* 1711, and *Bacchus and Ariadne* 1720 (Detroit Institute of Arts), were the first narrative pictures executed in America, and show a deeper attachment to European traditions than had previously been evinced by an artist in the New World. They are not paintings of particularly high quality, but they do show an ability to handle the more complicated Baroque style. Notable portraits include *Mrs Henry Darnall* 1722 (Maryland Historical Society, Baltimore), and the forceful picture of his wife painted in about 1740 (Historical Society of Pennsylvania, Philadelphia). In 1735, Hesselius was commissioned to paint portraits of the Indian chiefs Tishocan and Lapowinsa, the first time individual Indians were portrayed by a professional painter.

In 1729, Bishop George Berkeley, the Anglo-Irish cleric and philosopher, arrived in America with his expedition to found a university in Bermuda to educate the American Indians, and to convert them to Christianity, an enterprise which by its very nature was doomed to failure. (Berkeley's arrival in the New World was about the limit to which the project progressed.) In his entourage, as professor of art and architecture, was John Smibert, born in Scotland in 1688, one-time pupil of James Thornhill, coach-painter, copyist and moderately successful painter of portraits.

On his arrival, Smibert did not take long to abandon the party, and he settled in Boston where he was based until his death in 1751. In his studio was all the paraphernalia of a European painter and art teacher, probably the first time a sizeable amount of prints, paintings and sculptures after the Antique and the great European masters had been brought to America. Almost as significant as Smibert's paintings themselves, his studio pieces were to have tremendous influence on young American painters who, until they went to Europe for themselves, had little opportunity to see any important European art.

In the first year that Smibert arrived, he executed what is unquestionably his finest painting, *The Bermuda Group* (Yale University Art Gallery). Included in this splendid group portrait of Bishop Berkeley, his wife and family is, to the left, a self-portrait of the artist. Smibert never bettered the beautifully balanced composition and the sophisticated handling of colour obvious in this work; his portraits of women painted early in his American

individual artists he named are the 'Aetatis Suae' Painter, the Gansevoort Limner, and the Brodnax Painter. This group of artists, although strangely archaic, produced some of the most enduring and beautiful images of any portraitists working in America at this time; they are the last 'Dutch' paintings executed in what had recently been New Holland.

The two painters who were to do most for the development of painting in the Colonies during the first half of the 18th century were Gustavus Hesselius and John Smibert. Hesselius, a cousin of Emanuel Swedenborg whose teachings were to

9 *Portrait of*
Mrs Edward Dorsey
about 1760
John Wollaston,
active in America 1749–58
oil on canvas, 30 × 25 in

career are good workmanlike paintings based upon European engravings. But Smibert was a minor talent and, in order for his art to remain at peak, he needed contact with greater artists than himself, contact which was not forthcoming in the New World. He was not equipped to be a pacemaker and, cut off from the mainstream of creativity, his paintings became more and more wooden and lifeless. Yet no one can gainsay the achievement of *The Bermuda Group*, nor Smibert's prime importance as a teacher. American painting at this time would have been impoverished incalculably without him.

Amongst the first generation of native-born American painters, Robert Feke emerged briefly from obscurity, only to return equally suddenly to it. He was born in Oyster Bay, Long Island in about 1707, he then vanished from history for approximately thirty-five years, and appeared, as if by magic, in Boston in 1741 as a fully-fledged painter of mature talent. He worked in Boston, Newport and Philadelphia during the 1740s, and was never heard of again after about 1750 – truly the most enigmatic figure in the history of American art. His greatest painting, *The Isaac Royall Family* of 1741 (Harvard University Law School), is also the first painting of major significance by an indigenous American painter, as opposed to an immigrant. Obviously based upon Smibert's *Bermuda Group*, it demonstrates an astonishing ability to control light and depth within a complicated composition.

10 *Portrait of*
Edward Dorsey
about 1760
John Wollaston,
active in America 1749–58
oil on canvas, 30 × 25 in

In turn it seems obvious that Copley was aware of Feke's portraits. One thinks in particular of Feke's *Portrait of Josiah Martin* of about 1748 (Toledo Museum of Art, Toledo, Ohio), from which Copley may have derived the composition of his *Portrait of Thomas Gage* (private collection) or the companion *Portrait of Mrs Josiah Martin*, also executed in about 1748 (Detroit Institute of Arts), which appears to have much in common with later Copley portraits of women. Amongst other important Feke portraits executed at this time are *General Samuel Waldo* and the superb *Mrs James Bowdoin II*, both now in the Bowdoin College Museum of Art, Brunswick, Maine.

By the middle of the 1740s, the impact of the early immigrant painters had been absorbed, and American painting settled into a rut of second-class Baroque, with Joseph Badger, one of the earliest Colonial-born painters, taking over Smibert's place as the leading portraitist of Boston; and Badger, whilst being fairly able, was hardly endowed with sufficient talent to be the premier painter of a busy, rich, expanding sea port.

The arrival, therefore, of John Wollaston and Joseph Blackburn in the middle of the century, with their close knowledge of the English Rococo, came at a most opportune moment. Wollaston's light, frivolous portraits, in which he gave his sitters all the airs and graces of high-fashion London ladies, were, inevitably, successful, and within a short

15

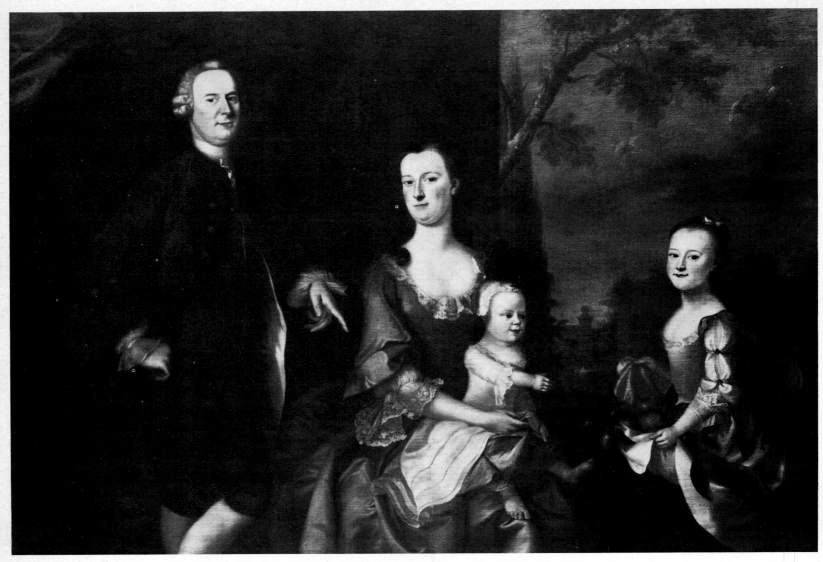

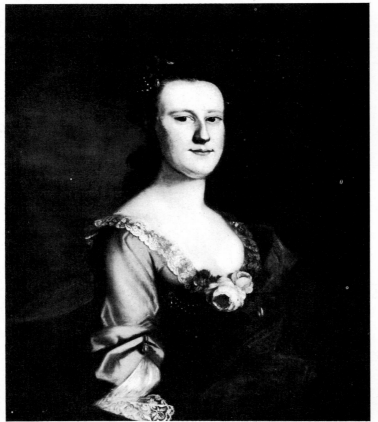

11 *The Winslow Family*
1757
Joseph Blackburn,
active 1752–74
oil on canvas, $54\frac{1}{2} \times 79\frac{1}{2}$ in
Courtesy Museum of Fine
Arts, Boston (Abraham
Shuman Fund)

12 *Portrait of
Mrs George St Loe*
Joseph Blackburn,
active in America 1753–63
oil on canvas, 30×25 in

13 *Portrait of
Colonel Dowdeswell*
1776
Joseph Blackburn,
active 1753–64
oil on canvas, $49\frac{1}{2} \times 41$ in
Richard Green (Fine
Paintings), London

16

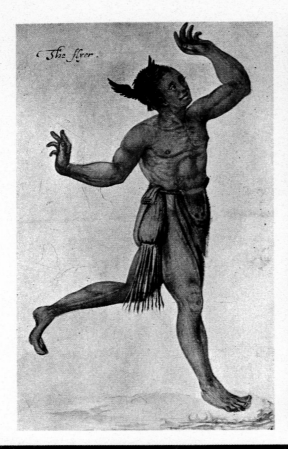

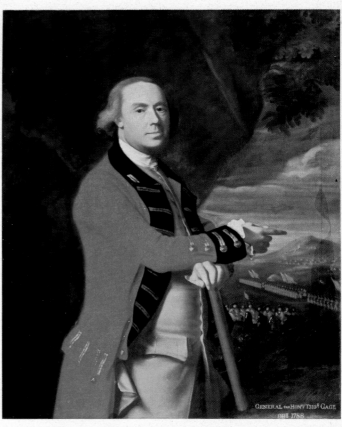

14 *The Flyer*
about 1585
John White
watercolour, 9¾ × 6 in
British Museum, London

15 *Portrait of*
General Thomas Gage
about 1768–69
John Singleton Copley
1738–1815
oil on canvas, 50 × 39¾ in

16 *The Isaac Royall Family*
1741
Robert Feke,
about 1706–after 1750
oil on canvas, 56 × 78 in
Harvard University Law
School, Cambridge,
Massachusetts

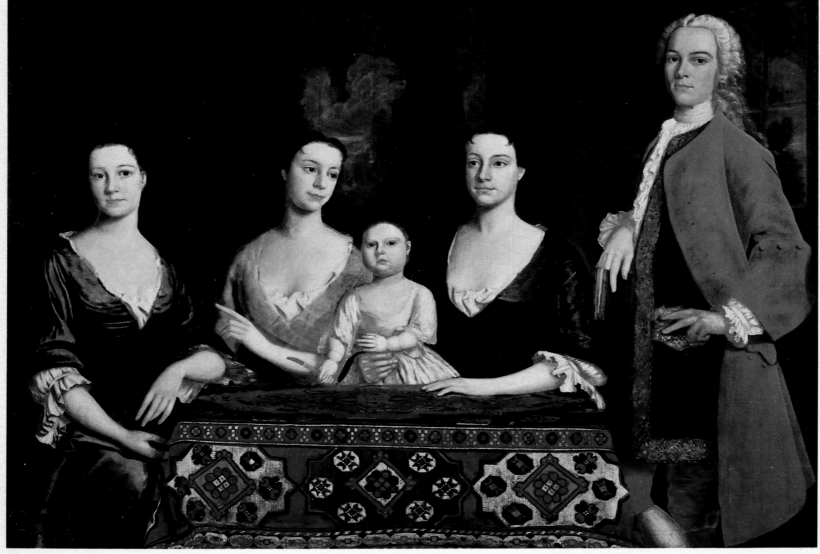

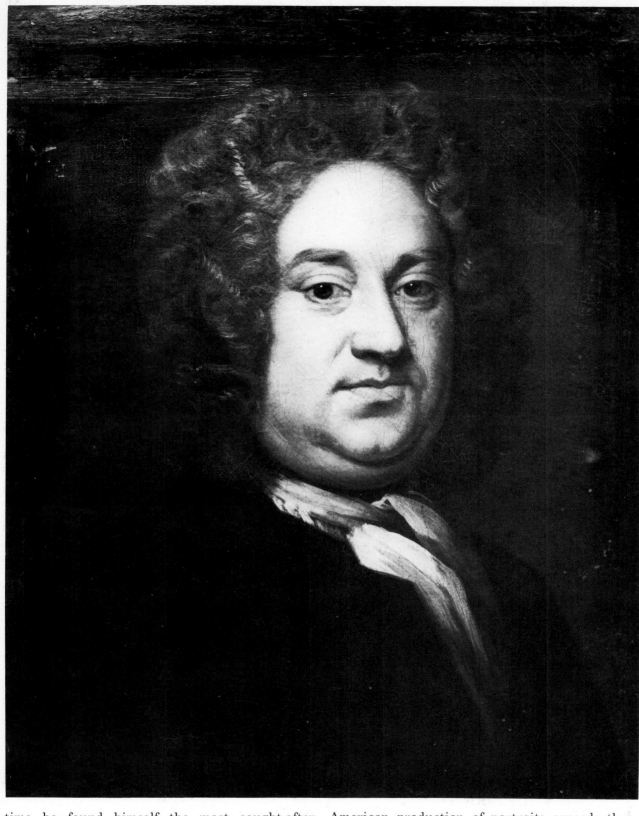

17 *Portrait of William Penn*
John Wollaston,
active in America 1749–58
oil on canvas, $23\frac{1}{4} \times 17\frac{3}{4}$ in

time he found himself the most sought-after painter in New York. He lived in that city between 1749 and 1752, in Annapolis during 1753–54, Virginia during 1754–57 and, for a year in 1758, in Philadelphia. At the end of the same year, he left America, to return to Charleston, Carolina, for a few months in 1767, when, according to many historians, he executed his best work. After this brief visit, he left the New World for ever.

It has been estimated that Wollaston's total American production of portraits exceeds three hundred, a number which, as Edgar Richardson has pointed out, is equal to the total *oeuvre* of Smibert, Feke and Blackburn together. Not only, therefore, was his work the most advanced that had been seen in America at that time, but also through its sheer ubiquity, it could not fail to impress and inspire young American painters in search of new styles.

Joseph Blackburn's effect upon the American scene was less decisive than that of Wollaston.

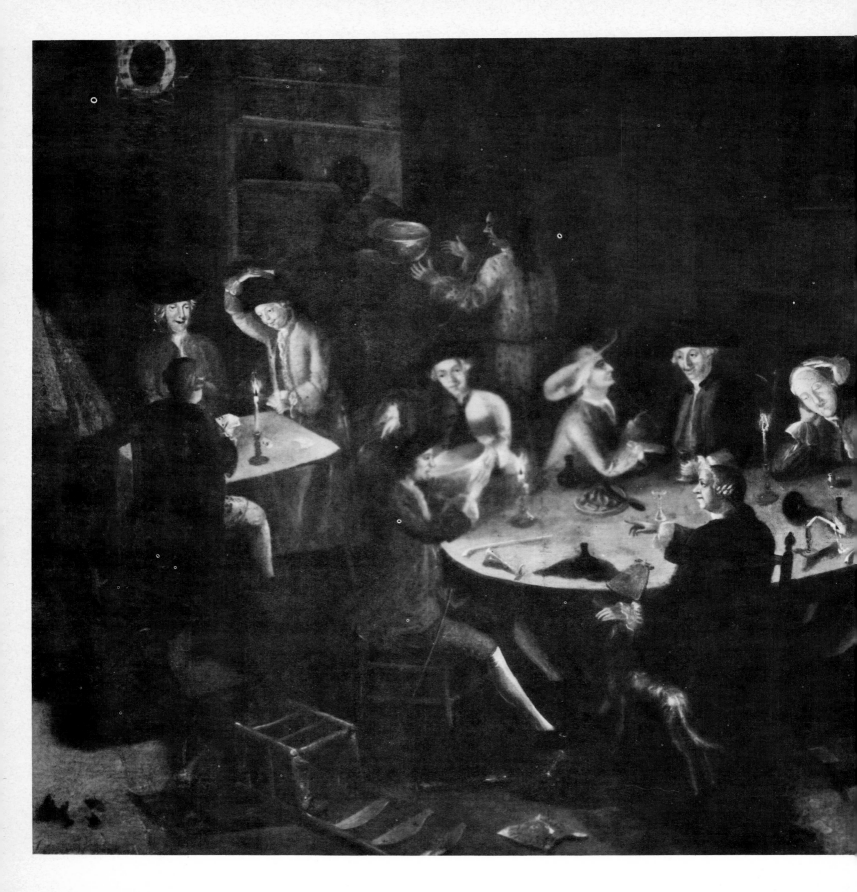

18 *Sea Captains Carousing
in Surinam*
about 1758
John Greenwood 1727–92
oil on bed ticking,
37¾ × 75¼ in
St Louis Art Museum

Arriving in America from Bermuda in about 1753, he was active in Boston from about 1755 to 1760, and between 1760 and 1763 he commuted from Boston to Portsmouth, Rhode Island. By 1764, he had left America, although he may have returned subsequently and stayed until the mid 1770s. His finest work is *The Winslow Family* of 1757 (Museum of Fine Arts, Boston), a painting executed in

20

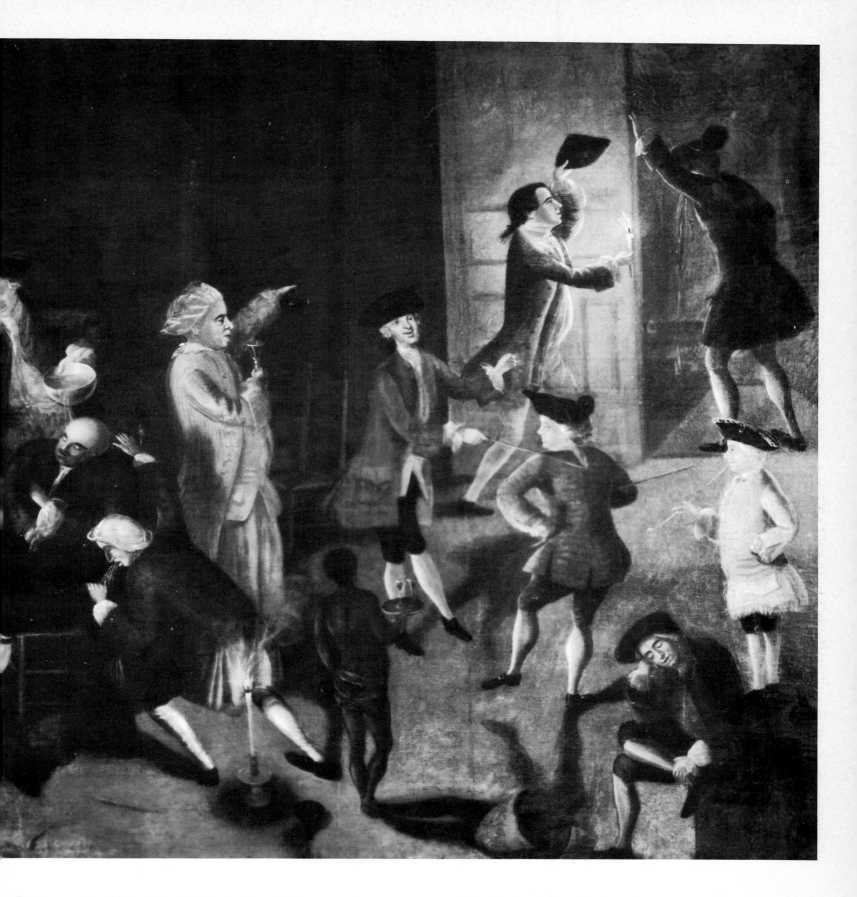

Boston and which, like Wollaston's paintings, strongly influenced the young Copley.

By the 1760s, American painting can be said to have served its apprenticeship. Paintings such as Feke's *The Isaac Royall Family* or John Greenwood's masterpiece *American Sea Captains Carousing in Surinam* of 1757–58 (City Art Museum of St Louis) are enough to show that in America painters were capable of absorbing all that the Europeans could teach them. But fine as these pictures may be, they are no better than the works of their masters, and of the Europeans who came to America, none was of the highest calibre. In the last quarter of the century, however, three artists of an entirely different stature appeared: Benjamin West, John Singleton Copley and Gilbert Stuart.

American painting comes of age

On November 12, 1766, John Singleton Copley wrote to Benjamin West in London:
'It would give me inexpressible pleasure to make a trip to Europe, where I shall see those fair examples of art that have stood so long the admiration of all the world, the Paintings, Sculptures and Basso Releivos that adjourn Italy, and which You have had the pleasure of making your studies from would, I am sure, animate my pencil and inable me to acquire that bold free gracefull stile of painting that will, if ever come much slower from the mere dictates of Nature, which has hither too been my only instructor.'

That Copley felt this great sense of inadequacy was prompted by the reception accorded to one of his masterpieces, *The Boy with the Squirrel*, which he sent, somewhat reluctantly, to the exhibition of the Society of Artists in London. The man who then ruled the world of art in the capital, and who was the final arbiter of fashionable taste, Joshua Reynolds, was greatly impressed by what was, after all, a provincial work by a provincial painter, and remarked that: 'with the advantages of example and instruction you would have in Europe you would be a valuable acquisition to the art and one of the first painters in the world, provided that you could receive these aids before it was too late in life, and before your manner and taste were completed or fixed by working in your little way in Boston.'

'Your little way in Boston'–the patronising humour must have deeply affected the young painter, who may have read into the phrase a hint of contempt. He was by then, although he did not know it, one of the great portraitists of his age, and was, in the next five years, to paint two of the supreme masterpieces of the 18th century, the *Portrait of Paul Revere* of about 1768, and the *Portrait of Mrs Ezekiel Goldthwait* of 1770–71, both in the Museum of Fine Arts, Boston. It was perhaps amongst the saddest ironies in the history of American painting that one of the most innately gifted painters that that country has ever produced should have left for Europe for the reason he did. His art, cut off from the environment in which it had developed almost miraculously, never recovered from this departure. In the sense that he was a painter who derived all the inspiration he

needed from his own ability to interpret what he saw with his own eyes, without reference to literary modes, in that he was truly Nature's child, Copley was, again without knowing it, a romantic in an anti-romantic age.

His dilemma, or rather his belief that the culture of America at that date was not able to support an artist who aspired to greatness, a belief in part supported by the knowledge that there was simply no market in America for any type of painting save the portrait, was one which was to beset American artists for many years to come. When Benjamin West, at the age of twenty-one, left for Italy in 1759, the first American painter to study in Europe, he set in motion a chain-reaction in the minds of Colonial artists, and by his success in London, which caused him never to return to the country of his birth, led them to believe that in order for them to become great, they had to spend considerable time in Europe. Although a perfectly reasonable theory, it was not, alas, always true. And of all the casualties of this attitude, Copley was the most substantial.

The career of Benjamin West himself is full of strange anomalies. Initially a purely 'primitive' painter, something which Copley never was, he became in Europe the most conservative of academics, the successor to Sir Joshua Reynolds as President of the Royal Academy. At least that is the surface impression. In fact, he was possibly the most sensitive of all late 18th-century painters, keenly aware of, and amenable to, the latest undercurrents of literary and aesthetic opinion. He was amongst the first artists in Europe to paint a Neoclassical picture, whilst he was also one of the earliest painters to embrace successfully the art of Romanticism. In addition, there is abundant evidence to prove that he was a kind and generous encourager of new talent–his studio in London became a haven for a whole generation of young American students abroad–and a successful teacher, whose example had tremendous effect upon the development of art in America, even though, as I have said, some of his pupils, because of their own natural ability, were hindered rather than helped by his advice.

In recent years, West's reputation has suffered by

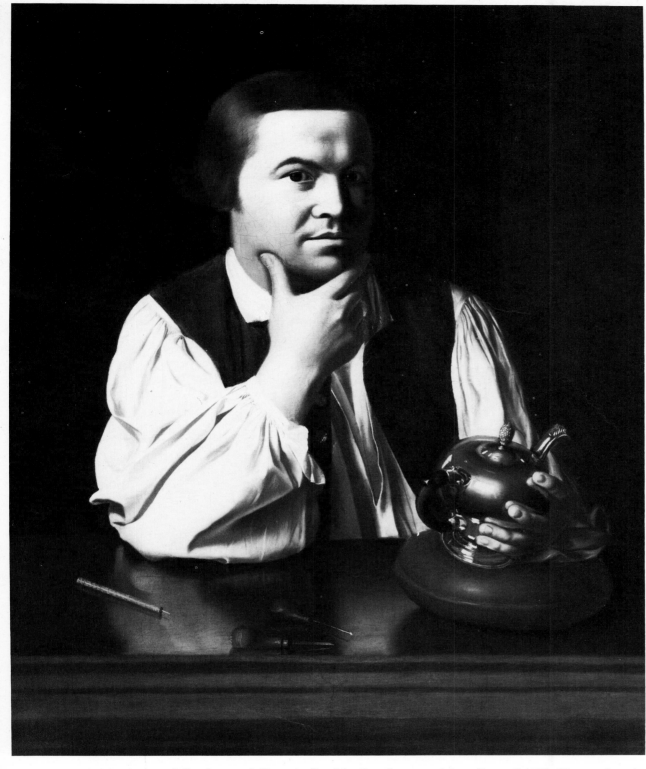

19 *Portrait of Paul Revere*
about 1768
John Singleton Copley
1738–1815
oil on canvas, 35 × 28½ in
Courtesy Museum of Fine
Arts, Boston (Gift of
Joseph W., William B., and
Edward H. R. Revere)

comparison with those of Copley and Stuart. It seems almost as if a generation of American critics has been unable to forgive him for totally abandoning his native environment. Even on a historical level, however, it is unlikely that the flowering which took place in American painting between roughly 1780 and 1830 would have happened if it were not for West's powerful presence in London. Just as every American boy is told today that he can become President of the United States, so every young painter in the late 18th century could aspire to be President of the Royal Academy.

Even West's American career, which was short-lived, is contradictory. On the one hand we have his *Landscape with a Cow* of 1750 (Pennsylvania Hospital, Philadelphia), admittedly painted when the artist was a mere twelve years old, and as such a fairly remarkable achievement, but one which gives us no indication, as we get with Copley's early work, of the artist's future greatness. And yet, a mere eight years later, he could produce the remarkable *Portrait of Thomas Mifflin as a Boy* (Historical Society of Pennsylvania) which, in its blue-toned strangeness, is a work of a deeply sensitive nature, and one which lasts in the mind long after the portraits of West's seniors at that time, Hesselius, Feke, Wollaston and the artists of the Rococo in America, have faded. Here again, an artist of

superabundant talent managed to produce, in what was by European standards something of a cultural vacuum, a painting which far surpasses any example of portrait-painting he had seen. Even more remarkable, he had executed a picture on a Classical theme, *The Death of Socrates*, a truly extraordinary act for a young American painter but an appropriate foretaste of the direction West's art was to take in Europe.

West sailed for Leghorn in 1759, and in his choice of Italy as the first essential place for study, he once again set a precedent which was to be followed by all the leading American painters of the early to mid 19th century. He remained in Italy, basing himself in Rome, for some four years, and it was here that he became imbued with that Neo-classical consciousness which was to affect his art for the rest of his life. As E. P. Richardson in his *Painting in America* has pointed out, West arrived at a time when the theories of Johann Winckelmann were new and avant-garde, and when Mengs was painting his fresco of *Parnassus* in the Villa Albani, an event taken by historians as the beginning of the

Neo-classical Age. Mengs, Winckelmann and the group around them aimed to produce paintings with noble themes, preferably scenes taken from Greek and Roman history, which would appeal to the intellect. They reacted against the light-hearted subject-matter of the Rococo artists, as well as their sensuous manner of painting, preferring a hard linear style.

West showed himself to be totally in sympathy with these new trends and, as many critics have since stated, there is ample evidence to show that this young American artist, coming fresh to a vast and complicated cultural world, absorbed and understood the Neo-classical ideal, and was able to translate it successfully into valid pictorial terms,

20 *Thomas Mifflin as a Boy*
about 1758
Benjamin West 1738–1820
oil on canvas, 51½ × 38½ in
Historical Society of
Pennsylvania, Philadelphia

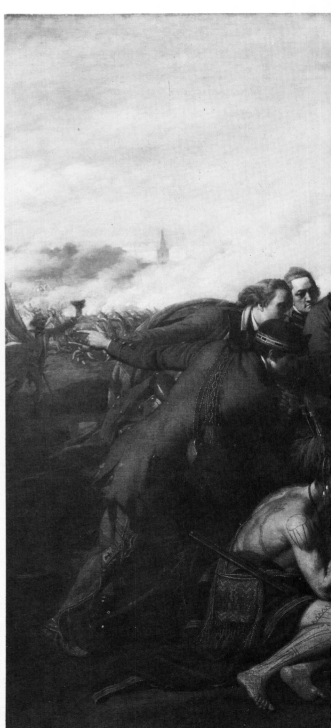

probably before any other painter in Europe.

In 1763, West moved to London where, gaining immediate success, he was to remain for the rest of his life. His pure Neo-classical subjects—ennobling and didactic scenes from Greek and Roman history—brought him to the attention of the Court. But it was his *Death of Wolfe*, completed in 1771 (National Gallery of Canada), which was his great triumph and he was made History Painter to the King. In this work, West created a new tradition within an ideal which was itself new. He took a recent event, the death of General Wolfe during the Battle of Quebec, and raised it to the level of a historical epic, and, instead of clothing the characters in ancient costume, he allowed them to wear contemporary dress. He demonstrated that it was the theme of heroism itself that was important, not the trappings of the protagonists; moreover he showed that heroism was not a virtue confined to the Greeks and Romans. The painting has its shortcomings. It is still a little too obviously staged—the actors frozen unnaturally whilst the 'great moment' is captured—but it is for all that a fine and splendid work and one which influenced artists for many years to come.

The following year, West repeated this theme of nobility and generosity in a recent historical event with *William Penn's Treaty with the Indians* (Pennsylvania Academy of Fine Arts). In this picture, West was closer in sympathy with the

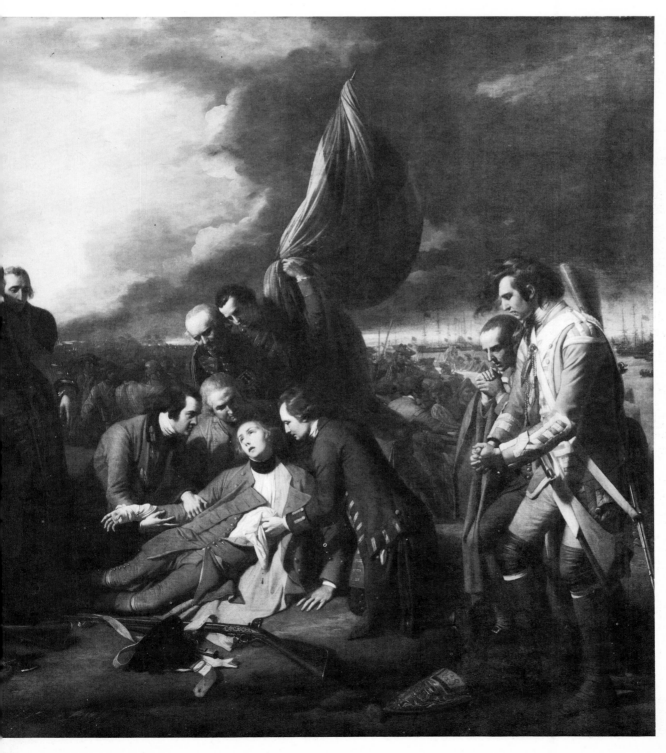

21 *The Death of Wolfe*
1770
Benjamin West 1738–1820
oil on canvas, 59½ × 84 in
National Gallery of Canada,
Ottawa (Gift of the Duke of
Westminster, 1918)

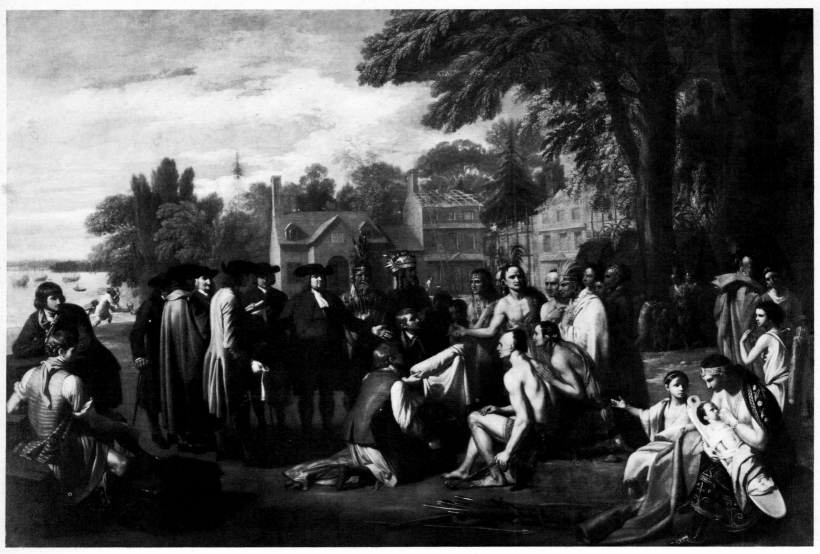

22 *Penn's Treaty with
the Indians*
1771
Benjamin West 1738–1820
oil on canvas, 75½ × 108¾ in
Pennsylvania Academy of
Fine Arts, Philadelphia

events portrayed than with *Wolfe*. Pennsylvania was his native state, and both now and for the rest of his life, the artist held a deep affection for America and her people. He may have chosen England for his home, and he steered a successful middle course between loyalty to his adopted country and to his birthplace through two wars, but we are never in doubt as to his sincere attachment to America. *Penn's Treaty* is a beautiful and moving statement which may suffer from the rhetoric which later in his career West was unable to resist, but which here at least is not obstructive.

In 1812, forty years later, West painted one of the finest of his late portraits, *John Eardley Wilmot Esq*. Wilmot was the commissioner appointed to settle the claims of American loyalists, and West depicted him as sitting in front of an allegorical scene of Peace uniting England and America. It is this ghastly, pretentious backcloth which makes us realise how sadly West's youthful talents were wasted, a waste made more poignant by the contrast in one picture between a Neo-classicist and history painter sunk to such a low level and a portrait-painter of still obvious greatness.

The Wilmot portrait is just one more facet of West's contradictory career. Apart from his importance in the history of Neo-classical painting, he has also a seminal position in the birth of the

Romantic Movement. In 1777, he painted *Saul and the Witch of Endor* (Wadsworth Atheneum, Hartford, Connecticut), and twenty-five years later produced *Death on a Pale Horse* (Philadelphia Museum of Arts). Both these works, especially the latter, which is one of the most haunting paintings in the history of American art, appear totally out of character for the artist. And yet in them, West, years before the Romantic Imagination became current, seemed to understand perfectly the predilection for the morbid, the mysterious and the supernatural which was to sweep through Europe in the 19th century, reaching its culmination with the Salon de la Rose Croix in Paris, and in America with Poe and Ryder.

When Reynolds died in 1792, West was the obvious choice for the Presidency of the Royal Academy, and was duly elected. In these years, West showed himself to be a consistent champion and friend to American artists abroad. It is by this, perhaps, that he made his major contribution to painting in the New World. Not only did Copley and the equally brilliant, but violently neurotic, Stuart receive help and encouragement from a man who must have been aware that they represented definite threats to his supremacy in the London art world, but he also taught Matthew Pratt, Abraham Delanoy, Henry Benbridge, William Dunlap,

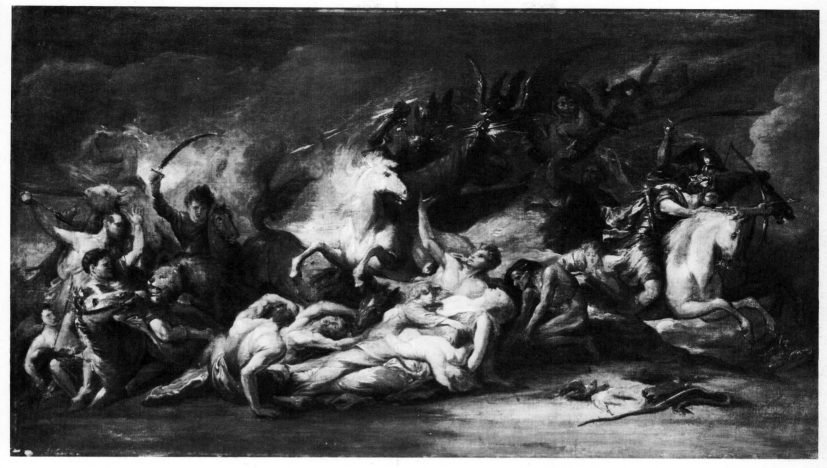

Charles Willson Peale, Ralph Earl, Wright, Trumbull and many others. The careers of the artists named here were not particularly distinguished once they returned to America, with the obvious exceptions of Peale and Stuart, but this was not the fault of the teacher. Rather it was the fault of America herself, in that she had, as yet, little place for the artist, and essentially, the fault of the artists themselves, who were not creators of much imagination.

John Singleton Copley was born in Boston in 1738. When he was ten, his mother married Peter Pelham, the leading engraver of the city. Joseph Blackburn, the principal artist of the Rococo in America, arrived in Boston in 1755. The young painter was, therefore, part of the richest cultural milieu that the Colonies had to offer at that date. There is, in his early work, considerable evidence to show that not only was Copley deeply influenced by Blackburn and Wollaston, but that he was also aware of Smibert, Feke and Badger.

The development of Copley's art is, as we have said before, a strange and partly inexplicable phenomenon. At the age of sixteen he was copying prints in his father-in-law's studio, such as Lazarini's *Galatea* and Ravenet's *The Return of Neptune*, themselves unusual subjects for an American painter at this time. His earliest portraits, painted

at the age of fifteen, are, as Jules David Prown has shown in his magnificent critical biography of the artist, frequently based upon the work of those artists with whom he was in contact. Thus the *Portrait of Mrs James Bowdoin II* by Robert Feke is the influence behind Copley's *Portrait of Mrs Joseph Mann* (Museum of Fine Arts, Boston), executed in 1753, although the latter did not copy the earlier artist but went direct to Feke's source, the famous *Portrait of Princess Anne* of 1683 by William Wissing which, through the medium of Isaac Beckett's print, was one of the most influential of all Dutch portrait compositions.

It is in the two large canvases of the brothers and sisters of Christopher Gage of about 1755 that Copley's own unique style first began to appear through the awkward Rococo mannerisms. In both there is a close attention to detail and to the different effects of light upon various materials and surfaces. For a seventeen-year-old, they are accomplishments of an extraordinarily high order. In the same year, Copley painted the splendid *Portrait of Joshua Winslow* (Santa Barbara Museum of Art, Santa Barbara, California), which is possibly open to the criticism that it is over-rhetorical, but which shows a surer handling of light and volume than had yet been demonstrated by an American painter working in the Colonies; it

23 *Death on a Pale Horse*
1802
Benjamin West 1738–1820
oil on canvas, 21 × 36 in
Philadelphia Museum of Art

27

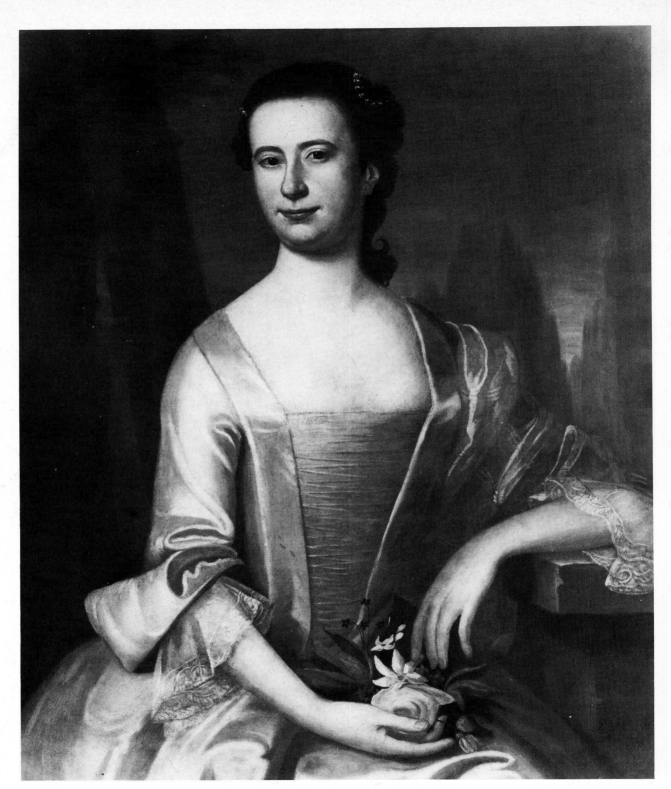

24 *Portrait of a Woman*
1755
John Singleton Copley
1738–1815
oil on canvas, 35 × 28 in

25 *Portrait of*
William Vassall and
His Son Leonard
1772–74
John Singleton Copley
1738–1815
oil on canvas, 49½ × 40 in

also reveals a truly remarkable technical mastery. Begun in the same year and finished in 1757 is the *Portrait of George Scott*, a more informal portrait than that previously mentioned but one which, with its beautiful, clear surface texture and heightened use of shadow, must certainly rank as one of the finest portraits painted in America at that date.

From then progress was fast and sure. We think of the 1757–58 *Portrait of Theodore Atkinson* (Museum of Art, Rhode Island School of Design, Providence), with the splendid virtuosity of that painted silk waistcoat, the rich blues and brown in the *Portrait of Thaddeus Burr*, painted in 1758–60

(City Art Museum, St Louis, Missouri) and the monumental portraits of Epes Sargent II and his wife, painted in 1764 (both in a private collection). In the years between 1765 and 1774, when Copley departed for Europe, it would be permissible to suggest that he had no superior in the world as a portrait-painter.

The one overwhelming quality of Copley's late American paintings is his complete truth to reality. He paints exactly what he sees, and although this is what most painters in America, following the dictates of their patrons, were attempting to do, only Copley had the sheer technical ability. In so doing he was the first of a long line of American

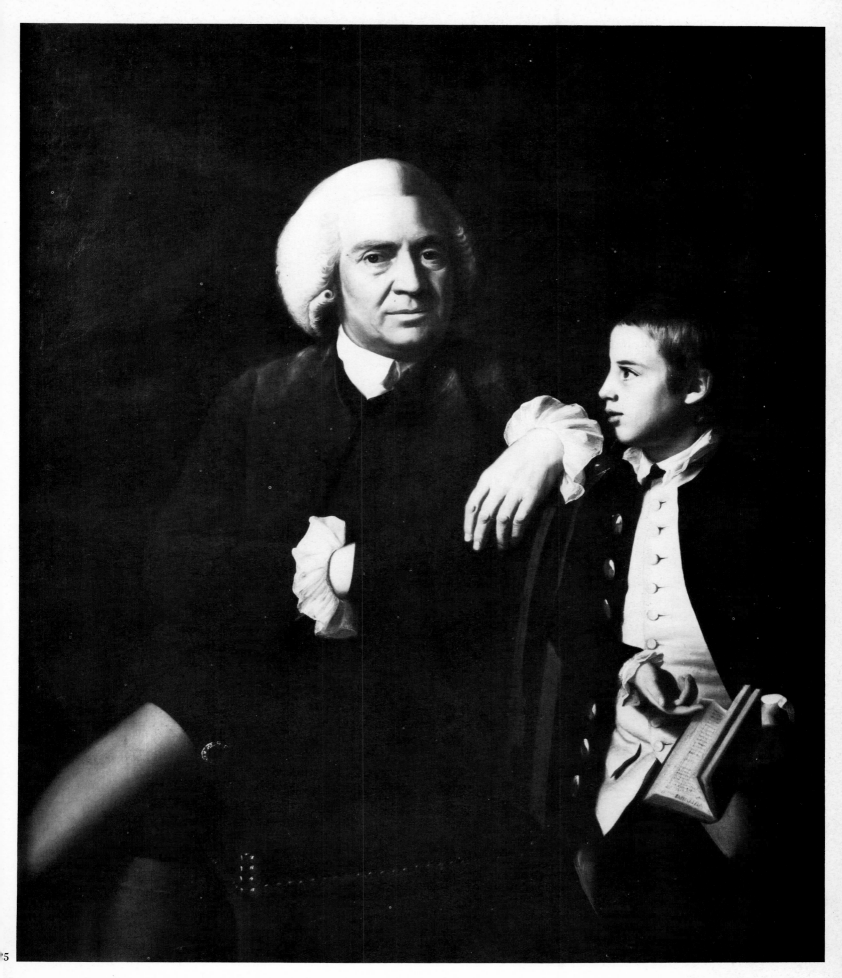

artists who have devoted themselves to absolute realism. It is not too fanciful to suggest that in Copley's masterpiece of this period, the *Portrait of Mrs Ezekiel Goldthwait* of 1770–71 (Museum of Fine Arts, Boston), with its rich luminous glow and perfect rendition of form and reflection – note especially the startling table-top still-life – we are seeing the ancestor of the 19th-century Luminists and the Philadelphia still-life painters, of the 20th-century Precisionists such as Sheeler and Wyeth, and of the fine Photo-realist school active today all over America. It is this quality of 'super-realism' which is the most specifically American thing about Copley's art.

In 1774, the painter left America for Europe, never to return. It would not be true to say, as some critics seem to have done, that this was the beginning of the end. Copley painted some great masterpieces in England – *Watson and the Shark* of 1778, *The Death of the Earl of Chatham* of 1779–81 and *The Death of Major Pierson* of 1783, to name but three – but it would be fair to suggest that under the pressures of fashionable London society, Copley lost that intimacy of vision, that total sympathy with his sitters, which makes many of his American portraits so memorable.

In 1778, he painted the magnificent *Portrait of Mrs Seymour Fort* (Wadsworth Atheneum, Hart-

26 *Mrs Ezekiel Goldthwait*
1770–71
John Singleton Copley
1738–1815
oil on canvas, 50 × 40 in
Courtesy Museum of Fine Arts, Boston (Bequest of John T. Bowen in memory of Eliza M. Bowen)

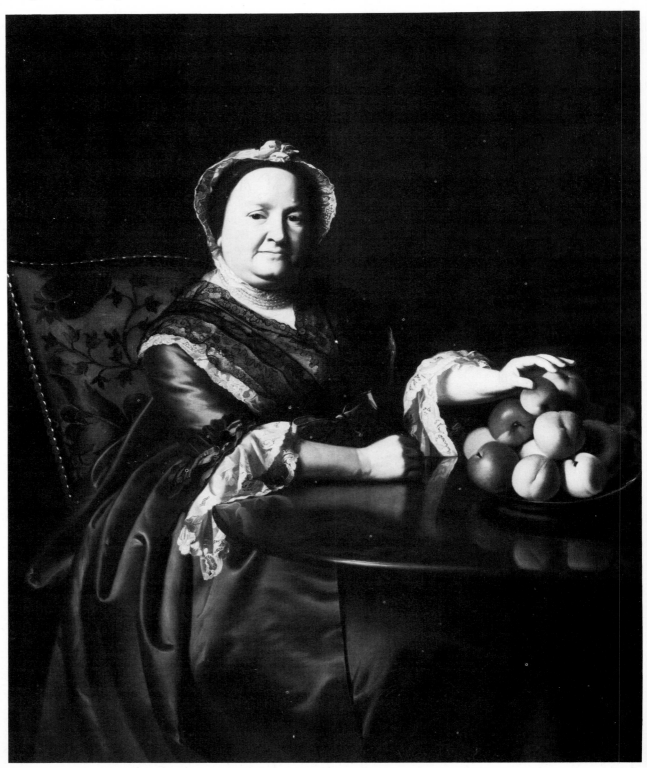

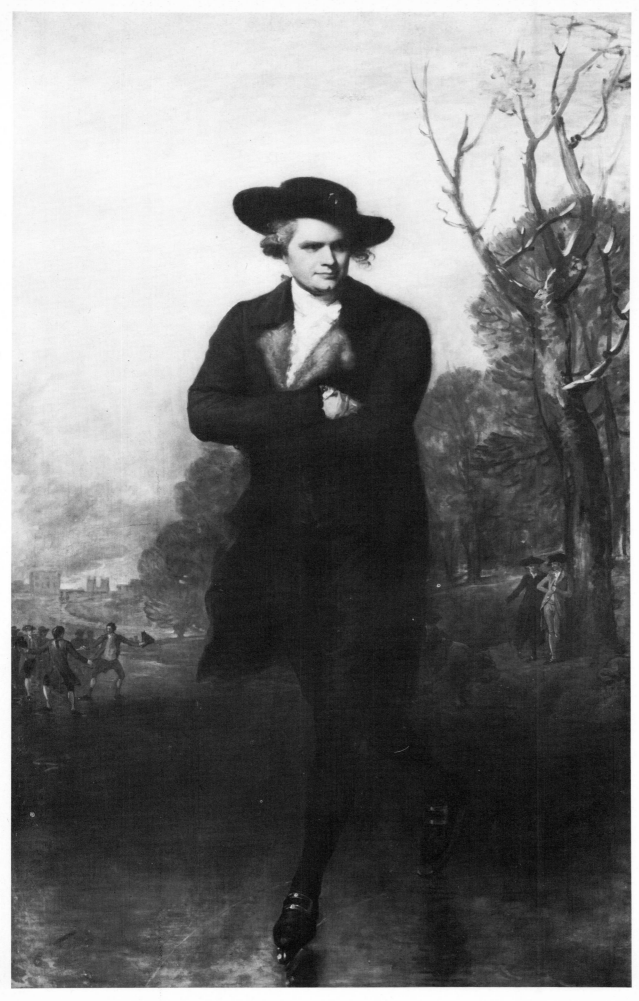

27 *The Skater*
1782
Gilbert Stuart 1755–1828
oil on canvas, $96\frac{1}{2} \times 58$ in
National Gallery of Art,
Washington (Andrew
Mellon Collection)

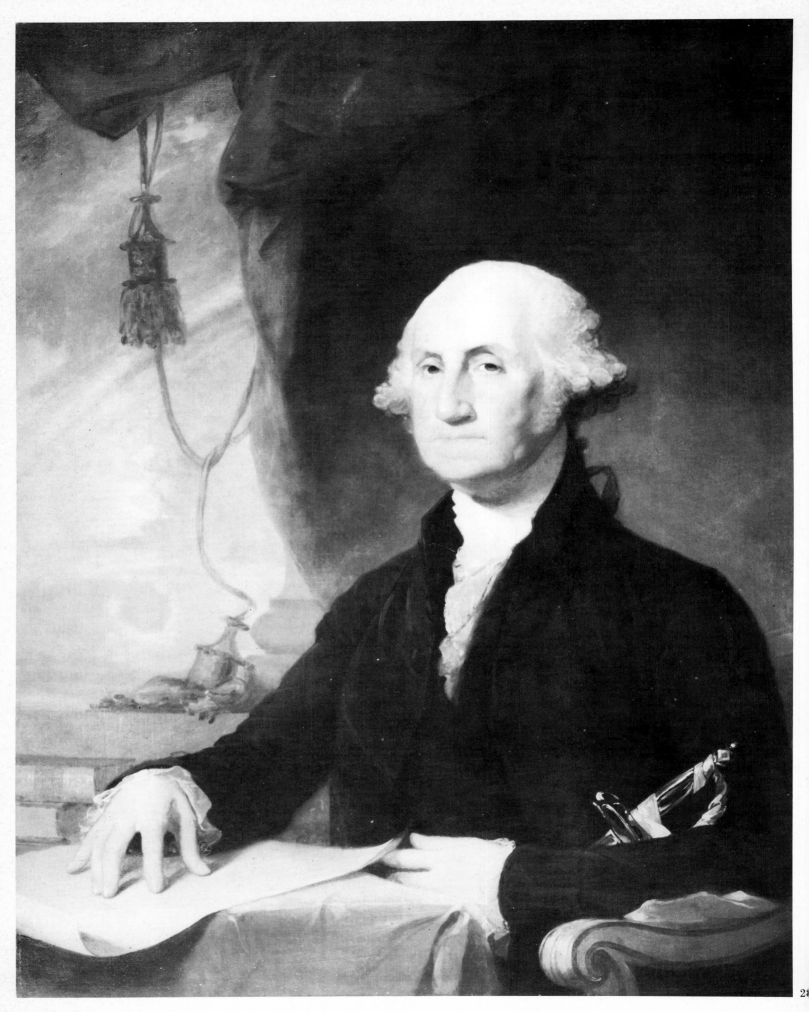

ford, Connecticut), and in so doing showed once again that he could still rise to great heights when painting women, especially elderly women, of whom he always appeared to have a unique understanding. Two years previously he had executed the regal, bust-length *Portrait of Mrs John Montresor* (private collection), but in general his portraits became more and more dry and unsympathetic, culminating in the turgid formalities of his last years. Even his history painting–and it is this for which his English period is most notable–became steadily worse and when he died in 1815, he had not managed to finish what would certainly have proved to be his least successful historical composition, *The Siege of Dunkirk*. However, his last American portraits and the monumental works of his first years in England are a glorious achievement which even his later decline cannot tarnish.

If Copley's English career was not entirely successful, the same cannot be said of the third artist to make up the great, late 18th-century American triumvirate, Gilbert Stuart. Stuart was born near Newport, Rhode Island, in 1755, twenty-three years after both Copley and West. Although he was of a different generation, however, his art had the greatest influence in America, whilst as a portrait-painter, he was more successful in London than either of the other two. Stuart is a limited artist; amongst his bust-length portraits and heads are some of the masterpieces of the great age of portraiture, and he painted three magnificent full-lengths, the portrait of William Grant, known as *The Skater*, executed in England and now in the National Gallery of Art, Washington, the 'Lansdowne' *Portrait of Washington*, in the collection of the Earl of Rosebery, and the great full-length of Washington now in the New York Public Library. In addition, he executed one great historical painting, the vast *Washington at Dorchester Heights* (Museum of Fine Arts, Boston), one of the few great works cast in the monumental Neo-classic mould by an American artist of an American subject. Stuart concentrated on portraying his subject's inner personality rather than a passing mood; typical portraits by him show his sitter against a plain background, without the trappings of office or station.

Stuart's career may be divided into three phases–his English period, from 1775 to 1787, the Irish period from 1787 to 1792, when he became the leading painter of Dublin society, and the final American phase from 1792 until his death in semi-retirement in 1828. Stuart's initial contact with Britain was hard; a neurotic young man, with many traits of a paranoiac personality, prone to almost manic-depressive fits of mood, he left America with a migrant Scottish portrait-painter, Cosmo Alexander, who came to work in Newport, Rhode Island, in 1765, and who, on his return to Edinburgh in 1772, took Stuart with him. They had been in Scotland only a short time, however, when Alexander died, and Stuart had to work his passage home. He sailed for London three years later and naturally made straight for Benjamin West.

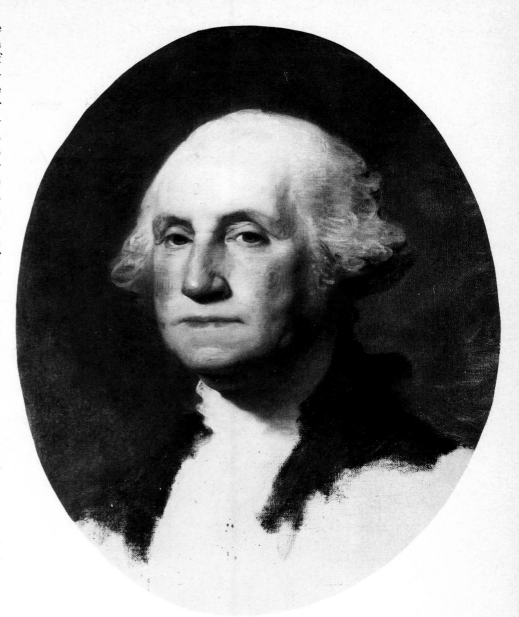

West, as he always seems to have done in such cases, took the young, and in this instance over-ambitious, painter into his studio. Stuart remained for five years, rising to the position of the latter's chief assistant. Then, in 1781, Stuart painted *The Skater* which, exhibited at the Royal Academy the following year, received a degree of loud and unanimous approbation rarely accorded to any painting shown in that institution before or since. Overnight Stuart found himself one of the most sought-after portraitists in London.

Unlike so many paintings excessively praised by contemporary critics, *The Skater* remains as much a masterpiece now as it was considered to be in its own day. Even by the end of the 19th century, however, Stuart's name had become so obscure that when this triumph of his art appeared at auction, it was sold as a Gainsborough, the latter being considered the only 18th-century painter who could have conceived such a composition and endowed it with so delicate, almost mysterious, a light. It stands with Copley's *Mrs Ezekiel Goldthwait* as one of the supreme achievements of American painting.

The three great portraits of Washington, the

29 *Portrait of George Washington* Gilbert Stuart 1755–1828 oil on canvas, 48 × 37 in Courtesy Museum of Fine Arts, Boston (Deposited by the Boston Athenaeum)

28 *Portrait of George Washington* Gilbert Stuart 1755–1828 oil on canvas, 44½ × 34½ in

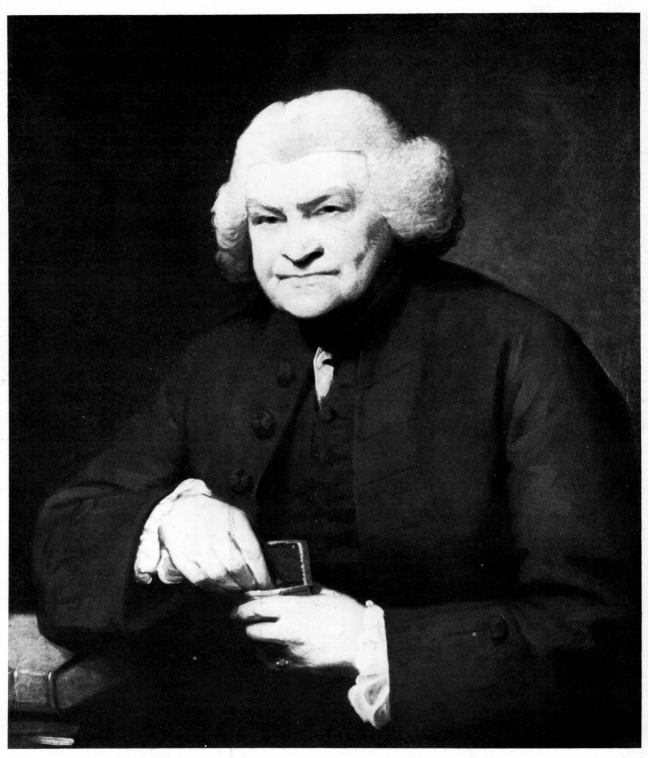

30 *Portrait of*
Christopher Springer
about 1780–82
Gilbert Stuart 1755–1828
oil on canvas, 30 × 25 in

'Vaughan' head of 1795, the 'Athenaeum' head (1796) and the 'Lansdowne' full-length (1797), together with some eighty to a hundred known replicas (Stuart being inundated with requests) are, with the New York Public Library full-length, the artist's chief claim to fame. They exercised a powerful fascination on Stuart's own generation, and still inspire a feeling of deep emotional sympathy in the minds of Americans which is not matched by any other picture executed in that country. Stuart's two heads, the originals of which he painted from the life, have remained for history the essential unarguable records of Washington's face, and in them, one of the greatest of portrait-painters has managed to capture much of the strength, power and stubbornness of the first President's character. Few portraits known to us have such abiding historical significance.

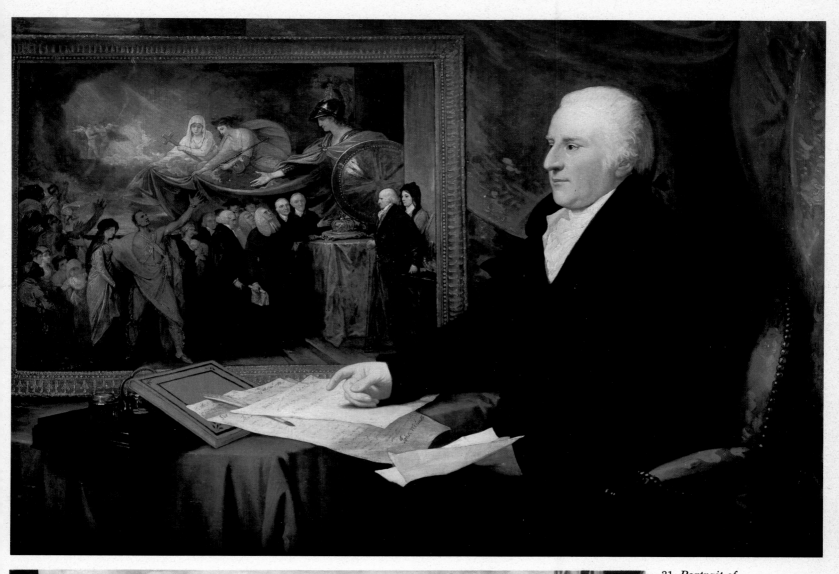

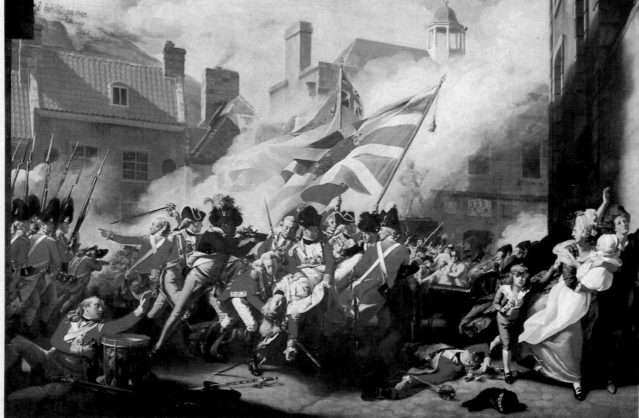

31 *Portrait of
John Eardley Wilmot Esqr*
1812
Benjamin West 1738–1820
oil on canvas, 40½ × 57¼ in

32 *The Death of
Major Pierson*
1783
John Singleton Copley
1738–1815
oil on canvas, 99 × 144 in
Tate Gallery, London

After the Revolution

American art in the post-Revolutionary, or Federal, period was not, in general, a happy affair. The real problem was that most of the leading American painters of the age had been to Europe, had studied the Old Masters, and worked with the greatest living artists and had returned to America filled with the high ideals and noble projects of the Neo-classic Age, only to find that in the still raw and chaotic world of the new republic, no-one had the time for them. They lacked that essential factor in the success of European painters–patronage. Only Stuart received such support as America had to offer, and it made him into the dominant figure of the period.

The three leading American painters of the Neo-classical Age, West, Copley and Stuart, had carved out substantial careers for themselves in Europe, and only one, Stuart, had bothered to return. And he succeeded only because he was too great to be ignored. Compared to him, the artists in America who attempted to establish a native school on a par with Europe–John Vanderlyn, John Trumbull, Samuel F. B. Morse, John Wesley Jarvis and Thomas Sully–were all second-rate painters of considerable talent but little genius. Only Charles Willson Peale, the father of the 19th-century school of Philadelphia painting, can claim special merit, whilst two very great artists of this period, Washington Allston and John James Laforest Audubon, had little interest in the strict precepts of Neo-classicism.

Charles Willson Peale (1741–1827) was born in Philadelphia. Between 1767 and 1769, he was a pupil of Benjamin West in London. He was, therefore, the only American painter of major significance to be present in his own country, and not that of the enemy, during the time of the Revolutionary war.

Apart from his career as a painter, Peale also founded a museum in Philadelphia in 1786, which was largely devoted to natural history. Some historians have seen this as Peale's own contribution to the Age of Reason, and indeed, throughout his career, he took part in a variety of activities; in this he resembles some of the greatest artists of the past to whom painting was an adjunct to a wider interest in scientific truth. It is not a coincidence

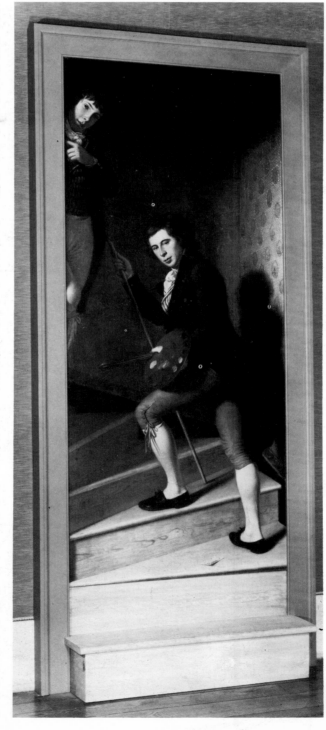

34 *The Staircase Group*
1795
Charles Willson Peale
1741–1827
oil on canvas, 89 × 39½ in
Philadelphia Museum of Art
(George W. Elkins
Collection)

33 *'Porthole' Portrait of
George Washington*
Rembrandt Peale 1778–1860
oil on canvas, 36 × 29 in

that one of Peale's greatest works, *The Exhuming of the First American Mastodon* 1806–08 (Peale Museum, Baltimore), depicts a key event in the study of evolution.

In another direction, Peale laid the foundation of what has become known as the Philadelphia School of still-life painting. In 1795, he exhibited his *Staircase Group* (Philadelphia Museum of Art) at the first show of a society of Philadelphian painters which he had been instrumental in founding, called the Columbianum. *The Staircase Group*, depicting his sons Raphaelle and Titian Ramsay Peale mounting a staircase, was framed in an actual doorway, and exhibited mounted on a real step, so as to give the illusion of total reality. This concern with *trompe-l'oeil* was to become the most distinguishing feature of the Philadelphian painters, culminating in the extraordinary productions of Harnett, Peto and Haberle at the end of the 19th century.

Peale was aware that he was witnessing historical events of universal significance during the Revolutionary war and, like Trumbull after him, he was determined to record many of the personalities connected with the formation of the new republic; between 1781 and 1784, therefore, he executed

35 *James Peale
(The Lamplight Portrait)*
Charles Willson Peale
1741–1827
oil on canvas, 24½ × 36 in
Detroit Institute of Arts
(Gift of Dexter M. Perry, Jnr)

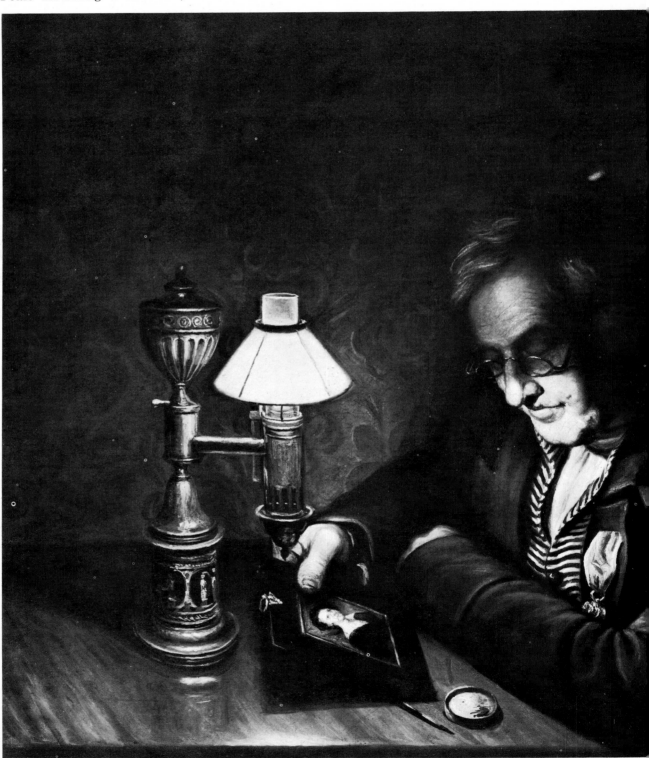

forty-three portraits of all the leading figures, soldiers, statesmen and diplomats. Many of these still hang in the Independence Hall, Philadelphia, the building to which Peale's museum and gallery was transferred in 1802.

Between about 1795, the date of the first Columbianum exhibition, and 1815, Peale was concerned mainly with his museum, and had little time for painting. In the last twelve years of his life, when he was a very old man, he began painting again. It is a sign of his undoubted greatness that in his eighties he was able to create fresh, new work in what was for him a totally new style; the most

36 *Self-portrait*
1822
Charles Willson Peale
1741–1827
oil on canvas, 26 × 22 in

37 *Portrait of Rubens Peale*
(*Mascot of*
'*The Macphersons Blues*')
1795
Raphaelle Peale 1774–1825
oil on canvas, 26 × 22 in

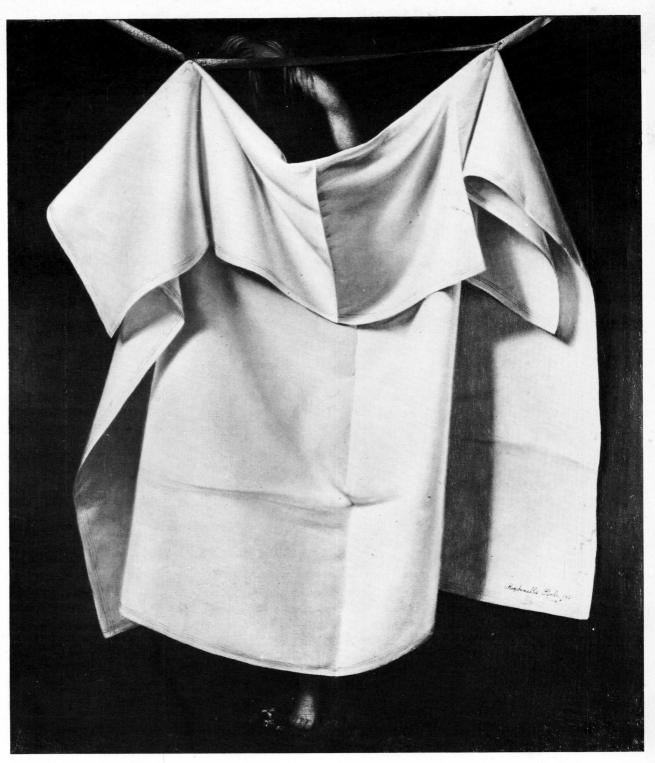

38 *After the Bath*
1823
Raphaelle Peale
1774–1825
oil on canvas, 29 × 24 in
Nelson Gallery–Atkins
Museum of Fine Arts,
Kansas City, Missouri

famous example is the *Portrait of James Peale*, his brother, which is usually called *The Lamplight Portrait* (Detroit Institute of Arts). A painting in the great tradition stretching back to Caravaggio and de la Tour in the 17th century, it was a work without precedent in America at that date, and bears the stamp of a painter of great individuality.

Charles Willson Peale and his brother James Peale (1749–1831), a miniaturist, portrait and still-life painter, founded a dynasty of artists unique in American history. James's artist children included Anne (1791–1878), James Jnr (1789–1876), Margaretta Angelica (1795–1882), Maria (1787–1877), Sarah Miriam (1800–85) and Washington (1825–68). All of these painted portraits, landscapes and, predominantly, still-lifes. Charles's far more distinguished children included Raphaelle (1774–1825), Rembrandt (1778–1860), Rubens (1784–1865) and Titian Ramsay (1779–1885), all of whom produced important work, again mainly portraits and still-lifes, during the 19th century. Another of Charles's sons, Franklin (1795–1870) became a medallist, rising to the post of Chief Coiner to the United States Mint between 1840 and 1854, whilst Charles's daughter Rosalba Carriera Peale (1799–1874) became a professional copyist of Old Masters. Mary Jane Peale (1827–1902), daughter of Rubens Peale, also became a moderately successful portraitist and still-life painter, as did Rembrandt's wife Harriet (1800–69).

40

Raphaelle and Rembrandt Peale were the two most distinguished of Charles's sons. In 1823, Raphaelle painted a picture which gained considerable notoriety at the time: *After the Bath* (Nelson Gallery, Atkins Museum, Kansas City, Missouri). Its notoriety sprang from its subject-matter—a (presumably) naked female holding up a towel. Its importance lies in its extraordinary wit and its exact rendition of reality—it is, apart from anything else, life-size, an amazing feat of *trompe l'oeil* which, like the earlier *Staircase Group*, was to have great influence on future painting in Philadelphia. Later in life Raphaelle devoted himself entirely to *trompe-l'oeil* still-lifes which, percipiently, he referred to as 'deceptions'.

Rembrandt was perhaps the more significant of the two; unlike his brother, he travelled and studied extensively in Europe, and like his father, he was interested in natural history. He spent most of the time between 1805 and 1810 absorbing Neo-classicism in Paris, and in 1820 painted one of the masterpieces of American Romanticism, *The Court of Death*. His most famous work, however, is the so-called *'Porthole' Portrait of George Washington* (Pennsylvania Academy of Fine Arts) which, rather over-ambitiously, he claimed to be superior to Stuart's 'Athenaeum' head, the 'official' likeness. Like Stuart he churned out replicas which number, according to his own evidence, seventy-six.

Charles's scientific interest was inherited by his

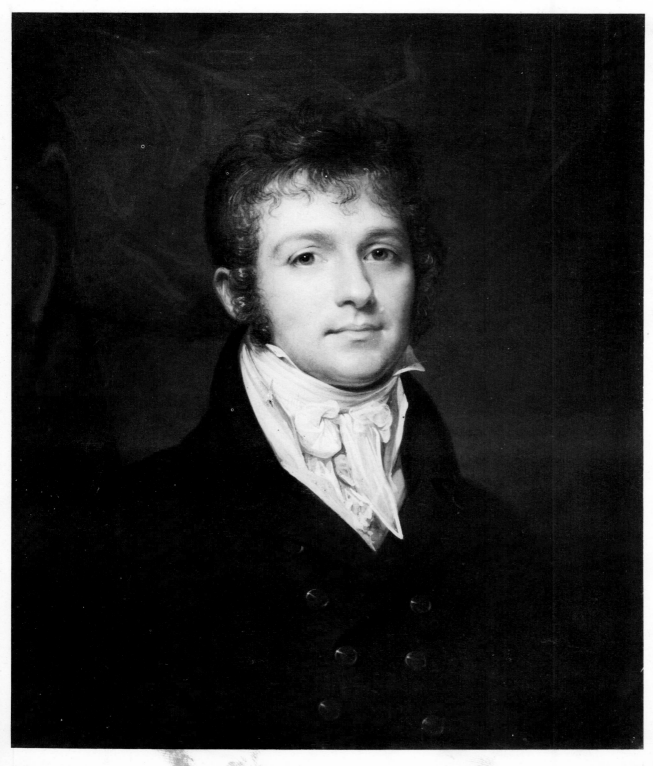

39 *Portrait of*
Edward Shipper Bird
of Philadelphia
about 1806
Rembrandt Peale 1778–1860
oil on canvas, $27\frac{1}{2} \times 22$ in

41

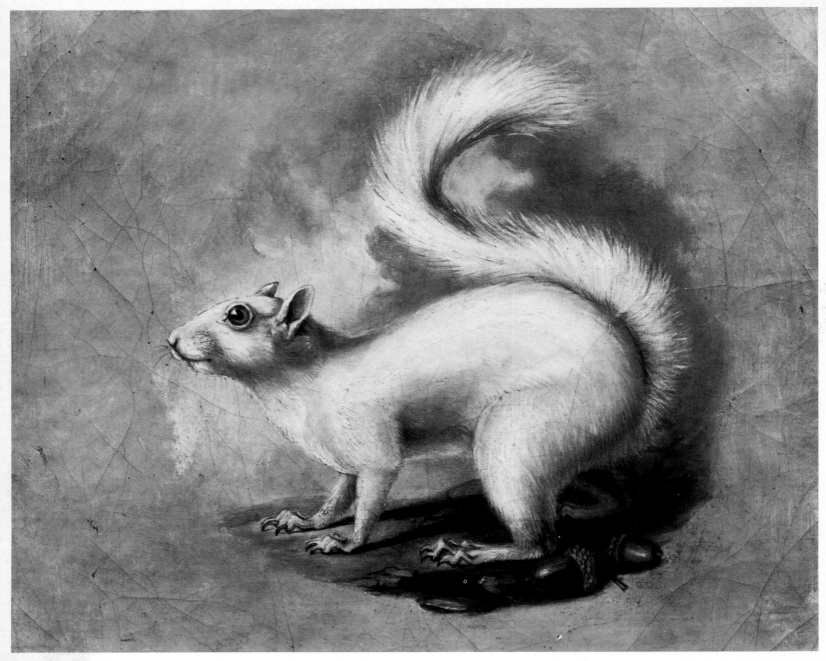

40 *Squirrel*
Titian Ramsay Peale
1799–1881
oil on canvas, 8 × 10 in

other two painter sons, Rubens and Titian Ramsay, both of whom managed the Peale Museum. Rubens in fact suffered from extremely poor eyesight and never became a professional painter, although some good early portraits and animal-paintings survive. He also took up still-life painting when he was in his seventies. Titian Ramsay is famous mainly as a naturalist, being one of the first specialists in American entomology. He accompanied several exploratory expeditions to the West and has left numerous fine sketches of American scenery and Indian life.

Perhaps the most significant of America's Neo-classical painters was John Vanderlyn (1775–1852). After studying with Gilbert Stuart in Philadelphia, he went to Paris in 1796, remaining there for five years. His work from this time shows that he absorbed quickly the style of French Neo-classicism and paintings such as *A Lady and Her Son* 1800 (Senate House Museum, Kingston, New York) owe much to David and Gros (one wonders if Vanderlyn

had seen the former's *Portrait of Madame Trudaine*, now in the Louvre). There is still a certain technical crudity about his work, however, which a few more years would erase.

In 1804, he painted his finest American subject, *The death of Jane McCrea* (Wadsworth Atheneum), which in its idealism and lofty tragic theme is a fine example of Neo-classicism. Between 1805 and 1808 Vanderlyn settled in Rome, and returned to Paris where he remained until 1815. During this second European stay, he painted pictures with Classical themes, including *Marius on the Ruins of Carthage* 1807 (M. H. de Young Memorial Museum, San Francisco), which was awarded a gold medal by Napoleon personally at the 1808 Paris Salon, and his masterpiece, *Ariadne* 1812–14 (Pennsylvania Academy of Fine Arts), one of the finest of all Neo-classical nudes.

Having achieved considerable success in Europe, Vanderlyn made the mistake of returning to America, believing that the same lofty idealism of

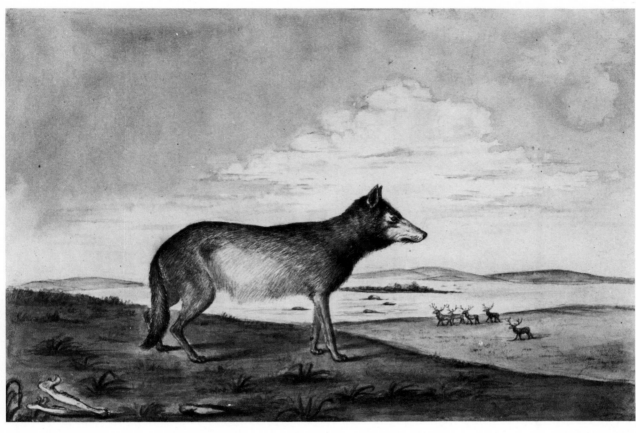

41 *Canis Lupis*
1819–20
Titian Ramsay Peale
1799–1881
watercolour, $5\frac{1}{2} \times 8$ in

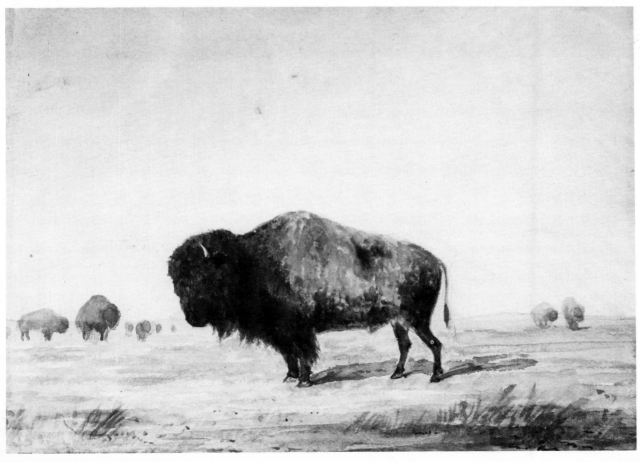

42 *Buffalo Bull*
about 1819
Titian Ramsay Peale
1799–1881
watercolour, $6 \times 8\frac{1}{4}$ in

43 *Fruit in Silver Basket*
Rubens Peale 1784–1865
oil on canvas, 18 × 24 in

the new republic of France would also be found in the new republic of the United States. It was a tragic error which, in actuality, marked the end of his career. He found little interest in his art and, in any case, the less talented John Trumbull was firmly entrenched as the leading exponent of history painting in America. Vanderlyn, in an attempt to raise money, painted a superb, cool, panorama of Versailles, panoramas being particularly popular at the time, and was inevitably reduced to painting portraits, few of which have the grace and charm of his earlier work. After years of being ignored officially, he was commissioned in 1832 to paint a full-length *Portrait of Washington* for the Capitol, and six years later, *The Landing of Columbus*. The years of bitterness had taken their toll, however, and both pictures are terrible failures.

John Trumbull (1756–1843) was a painter of limited ability who managed to seize upon the militant chauvinism of the immediate post-Revolutionary period, and by so doing achieved a measure of success greater than his talents deserved. Inevitably, he studied with Benjamin West in London, mainly between the years 1784 and 1789, and he also worked in Paris, where he was influenced by David

and Vigée-Lebrun in particular. It was at this time that he began his series of paintings depicting the most important incidents of the Revolutionary war, pictures which are his principal claim to immortality. Between 1786 and 1797, he produced, on small scale, such pictures as *The Battle of Bunker's Hill, General Washington before the Battle of Trenton* and *The Surrender of Lord Cornwallis at Yorktown, Virginia, 19th October 1781*. These are fine works, showing a sensitive historical insight; in each one, Trumbull manages to impart a sense of living history, and he is careful not to over-dramatise scenes which would easily lend themselves to such treatment.

On the small scale he could control his own obvious leanings towards melodrama. On the large scale, however, he lost his way. In 1817, he was commissioned by the Federal Government to translate four of his historical scenes into murals for the Capitol Rotunda, and was voted the enormous sum of $32,000. Such a commission in the great age of history painting would have been any artist's dream, and it is regrettable that, worthy artist though he was, Trumbull simply was not equal to such a task. Between 1817 and 1824 he

executed four scenes: *The Declaration of Independence* (1818), *The Surrender of Lord Cornwallis at Yorktown* (1817–20), *The Surrender of Burgoyne at Saratoga* (1817–1821) and *Washington Resigning His Commission* (1824). What had once been fine examples of historical reportage, carefully observed and balanced, became huge, overblown, grandiose melodramas, of which the best that can be said is that they served perfectly the purpose for which they were intended, to impress upon visitors the strength of the new republic. Even today, although we are capable of analysing their technical bombast, we cannot fail to see in these murals something of the pride which Americans felt in their country and their own achievements.

Officially, of course, the works were well received, a fact which boded ill for the future. As E. P. Richardson succinctly put it: 'When the question of decorating the Rotunda was taken up again in the next generation, it was accompanied by political bickering, carping jealousy, and a preference among politicians for safe mediocrity that have ever since been part of Congress's relations with American painters.' Trumbull himself benefited greatly from the commission. In 1817, he became President of the most powerful artistic body in America, the American Academy of Fine Arts, which had been founded in New York in 1802; from then until his retirement in 1835, he turned his back firmly on anything which did not concur with his

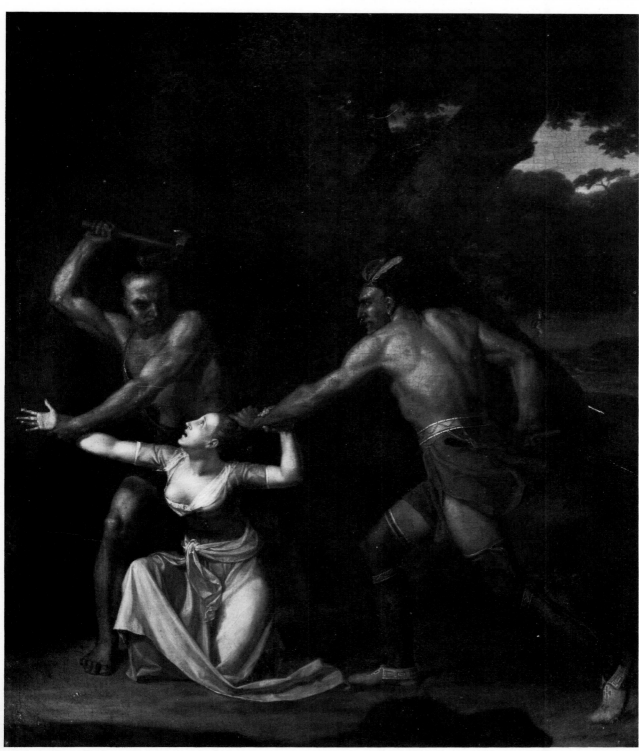

44 *The Death of Jane McCrea*
1804
John Vanderlyn 1775–1852
oil on canvas, $32\frac{1}{2} \times 26\frac{1}{2}$ in
Courtesy Wadsworth Athenaeum, Hartford

45 *The Battle of*
Bunker's Hill
1785
John Trumbull 1756–1843
oil on canvas, 25 × 34 in
Yale University Art Gallery,
New Haven, Connecticut

ideas about art. American painting might be said to have developed in spite of, not because of, him.

The transition from Neo-classicism to Romanticism in the 1820s was a gradual and hardly discernible process; indeed, it is probable that many American artists of the period were hardly aware themselves of the changing attitude. The years of the Classical ethos were over; the change was not so much away from the ideal, as idealism played as large a part in the Romantic imagination as it did in Neo-classicism; rather the move was away from a carefully organised didacticism to a freer world of imaginative interpretation.

This change can be seen in the work of some of the transitional American painters, notably Samuel Lovett Waldo (1783–1861), Samuel F. B. Morse (1791–1872), John Neagle (1796–1865), John Wesley Jarvis (1780–1840) and Thomas Sully (1783–1872). Of these Morse, although one of the youngest and a pupil of Washington Allston, was the closest to the Neo-classical ideal. Albeit a good portrait-painter, he was more interested in grandiose scenes of historical 'importance', and like other American painters seeking the same goal, he failed to see that there was no market for him.

Morse ceased to paint in the late 1830s, by which time he had executed two notable pictures, *Lafayette* 1826 (Art Commission of the City of New York), and the famous *Old House of Representatives* 1822 (Corcoran Gallery of Art, Washington); neither of these shows much imagination, and even less passion than Trumbull had managed to put into his Rotunda murals. They show a somewhat scientific detachment, to be expected from a man who was later to invent the telegraphic system known as the Morse code. It should not be thought, however, that Morse was entirely unaware of the new Romanticism. He realised that as long as the re-

46 *Study for the Portrait of Aaron Burr*
1809
John Vanderlyn 1775–1852
oil on canvas, $9\frac{1}{2} \times 7\frac{1}{2}$ in

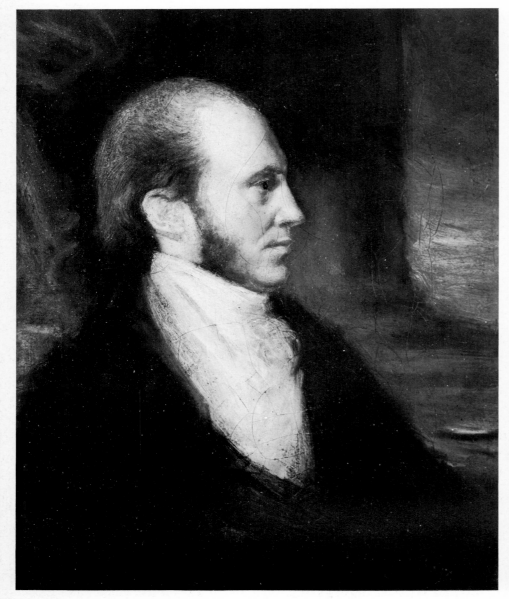

actionary Trumbull ruled the official kingdom of art there would be no progress, and he was one of the protagonists in the founding of the National Academy of the Fine Arts, a breakaway group opposed to Trumbull, which, as is the way of such institutions, was soon to become as reactionary itself as that body against which it had been formed in protest.

In Philadelphia, the leading portrait-painters were Thomas Sully and his son-in-law John Neagle, and in New York Samuel Lovett Waldo and John Wesley Jarvis, the last named having been born in the north of England. Sully's early career followed the usual pattern of study with West in London. He was more influenced by Sir Thomas Lawrence, however, and his delicate, feathery portraits show that beneath an unavoidable tendency towards sentimentality and sweetness lay a fine and sensitive painter. Some of his best portraits, of which the full-length *Colonel Thomas Handasyd Perkins* 1831–32 (Boston Athenaeum) is the finest, were rarely equalled. He also painted one important historical work, *Washington crossing the Delaware*, which was commissioned by the Legislature of North Carolina in 1818. Unfortunately the painting proved too large for the space allotted to it, and

47 *The Old House of Representatives*
1822
Samuel F. B. Morse
1791–1872
oil on canvas, $86\frac{1}{2} \times 130\frac{3}{4}$ in
In the Collection of the
Corcoran Gallery of Art,
Washington D.C.

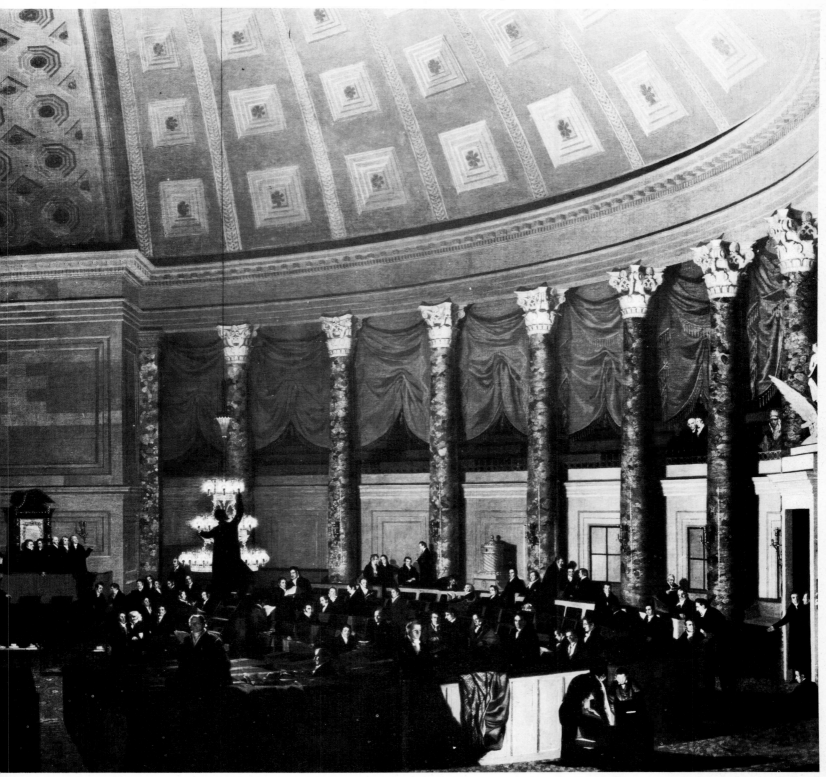

after a somewhat degrading history in a popular exhibition hall, it found a home eventually in the Boston Museum of Fine Arts. This painting is certainly one of the finest historical canvases undertaken by an American painter, and one of the last of its kind.

Two painters active around this time, but who cannot be satisfactorily placed in the main stream, are Ralph Earl and James Laforest Audubon. Earl was born in Massachusetts in 1751, and studied in London with Benjamin West between 1778 and 1785. In many ways Earl belongs to the primitive tradi-

48 *Portrait of a Lady with a Jewel*
Samuel L. Waldo 1783–1861
and William Jewett
1789/90–1874
oil on canvas, 36 × 29 in

49 *Portrait of Rosalie Kemble Sully*
Thomas Sully 1783–1872
oil on canvas, 24 × 20 in

50 *Portrait of John Wardell*
1833
John Neagle 1796–1865
oil on canvas on panel,
30 × 25 in

51 *Capuchin Chapel*
1821
Thomas Sully 1783–1872
oil on canvas, 68½ × 50 in

48

50

51

49

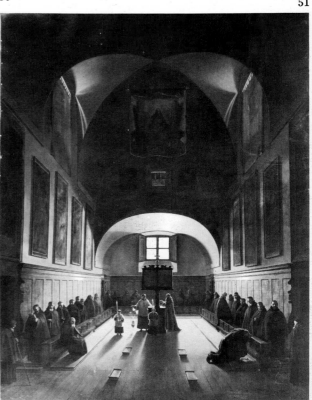

tion, yet he received a professional training totally at odds with his untrained style; surprisingly, his work was accepted for exhibition at the Royal Academy in 1783. Earl was a painter of little technical skill, almost totally incapable of imparting any three-dimensionality to his work. Yet, on a flat two-dimensional plane, he was a master of surface rhythm and more than compensated for his lack of rounded forms with the psychological depth of his finest portraits. His *Portrait of Roger Sherman* of about 1775–77 (Yale University Art Gallery) is one of the most striking images of Colonial America.

After his return to the United States his style remained totally unchanged, as can be seen from his *Portrait of Mrs William Taylor, née Abigail Starr, and Her Child Daniel Boardman* of 1790 (Albright-Knox Art Gallery, Buffalo, New York). Until his death in 1837 he was active in Connecticut, Kentucky and Tennessee. Today his work is regarded as displaying typically American characteristics.

Audubon was born in Haiti of French parents and was educated in France. He visited America for the first time in 1804, and after a brief return to France between 1805 and 1806, settled in the United States

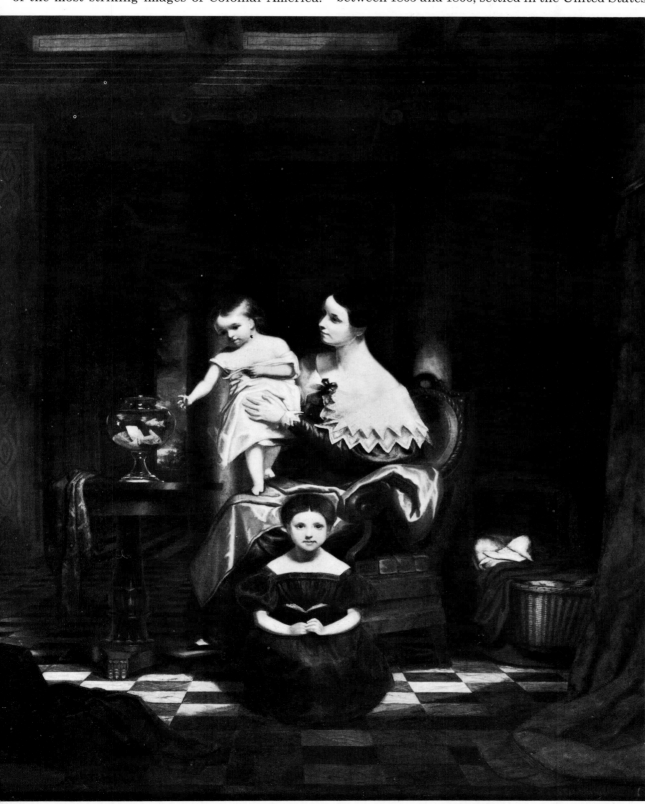

52 *Mrs Richard C. Morse and Her Two Children (The Goldfish)*
about 1832
Samuel F. B. Morse
1791–1872
oil on canvas, $29\frac{3}{4} \times 24\frac{3}{4}$ in

until 1826. He painted portraits in Kentucky, at the same time as working on the delineation of American bird life which has secured his reputation as the greatest of all artist-naturalists. He achieved little financial success in America, so left for England, where between 1827 and 1838 appeared those four legendary elephant folio volumes which constitute *The Birds of America, from Original Drawings, with 435 Plates showing 1,065 Figures*. Modern ornithological science has shown that the representation of many of these birds is inaccurate but the magnificence of the hand-coloured aqua-tints, the strength and power of the compositions, all of which depict their subjects life-size, makes the work one of the supreme achievements of modern art. After this great triumph, the *Quadrupeds of North America*, the first volume of which was published in England in 1845, is anti-climactic, but in some of the plates the magic is still apparent. The work was still in progress, Audubon being assisted by his two sons Victor (1809–60) and John Woodhouse (1812–62), when the artist died in New York City in 1851.

53 *Roger Sherman*
1775–77
Ralph Earl 1751–1801
oil on canvas, 64½ × 49½ in
Yale University Art Gallery,
New Haven, Connecticut
(Gift of Roger Sherman
White, 1918)

54 *Robin Perched on a
Mossy Stone*
John James Audubon
1785–1851
watercolour, 12½ × 17½ in

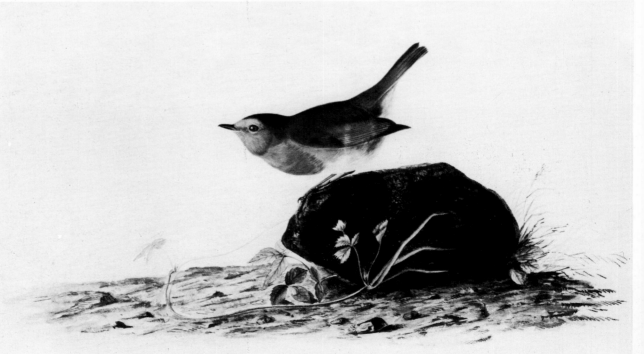

Romance, imagination and symbol

Samuel Taylor Coleridge, the friend of Washington Allston and prime mover in the Romantic Movement, wrote his *Essays on the Fine Arts* in 1818; in this work he crystallises the motivating force of the new art:
'The artist must imitate that which is within the thing, that which is active through form and figure, and discourses to us by symbols – the *natur-geist*, a spirit of nature, as we unconsciously imitate those whom we love; for so only can he hope to produce any work truly natural in the object and truly human in effect. The idea which puts the form together cannot itself be the form. It is above form and its essence, the universal in the individual, or the individuality itself – the glance and the exponent of the indwelling power.'

Symbolism has never been a major force in American painting, any more than it has been in other countries. America, however, has produced no substantial body of Symbolist art, or even of Romantic painting. There is of course a distinction. Symbolism, as the word applies to painting, has come to mean the representation of the world of the imagination, usually the supernatural, the ghostly, or the horrific. (As such it has little to do with the French literary movement of the 1870s and 1880s). Romanticism is not so easily defined. In general it may be described as the tendency to lay emphasis on personal and emotional expression as opposed to the systematic pursuit of formal beauty. But the Romantic Movement of the 19th century in particular is characterised by the love of wild landscape and of the majestic and awesome aspects of Nature (in which the artists saw the reflection of their own moods and feelings), a taste for the mysterious and the exotic, and a yearning for the past. Unlike the Neo-classical artists, the Romantics had complete freedom in their choice of subject-matter.

In painting, as in literature, the Symbolist and the Romantic merge to form a clearly definable genre. Vastly different though they may be, we can link together Fuseli, Palmer, Rossetti and the Pre-Raphaelites, Puvis de Chavannes, Bresdin, Moreau, Redon and the artists of the Rose Croix, Böcklin, Ensor, Hodler, Klimt, Munch and the early works of Kupka, Picasso and Kandinsky. In most European countries, there was throughout the 19th century a powerful concern with the world of the mind, the vision and the dream.

In America, this is not the case. In the years between 1800 and 1900, the United States produced only a small number of painters who could be described as true Romantics; these are Washington Allston (1779–1843), Thomas Cole (1801–48), John Quidor (1801–81), William Rimmer (1816–79), William Page (1811–85), John La Farge (1835–1910), Elihu Vedder (1836–1923), Albert Pinkham Ryder (1847–1917), Albert Blakelock (1847–1919) and Arthur B. Davies (1862–1920). Allston and Cole were mutually admiring colleagues, whilst it is doubtful if any of the remaining artists, with the exception of Arthur B. Davies, had more than a passing acquaintance with the others' work, if even that.

The greatest of all American Romantics was Washington Allston. In her book, *Modern Painters and their Painting* (1886), Sarah Tyler wrote: 'He shared with the writers, Hawthorne and Wendell Holmes, not merely the love of the supernatural, but the prediliction for what is abnormal and weird, which strikes us dwellers in the mother country as something in itself abnormal, when it springs up in the sons of a fresh young world, but which is notably the reaction from the very fresh materialism of their surroundings.' This is, of course, the crucial reason why there was no sustained Romantic Movement in America. It was a new country, and was firmly based in the realities of exploration and commerce. And because it was new, the disenchantment which was to colour so much of 20th-century painting had not yet appeared.

Born in Georgetown, South Carolina, Allston graduated from Harvard University, and in 1800 left for Europe to study art. Between 1801 and 1803, he worked in Benjamin West's studio in London and in 1804 left for the continent. He studied the Old Masters in the Louvre with John Vanderlyn, and received one of the great stimuli to his art when, for the first time, he saw important early works by the 16th and 17th-century Venetian masters. The rich, veiled glow of Giorgione particularly impressed him, as did the paintings of Titian and Veronese. (Vanderlyn was also deeply moved by Titian, as is shown by his *Ariadne*, which owes much of its style and colouring to the Venetian master.)

In 1805, Allston visited Italy, and returned for a second time in 1806. His choice of companions on each trip is instructive – the first time he went with

55 *Landscape Composition,*
Italian Scenery
Thomas Cole 1801–48
oil on canvas, 41 × 62 in

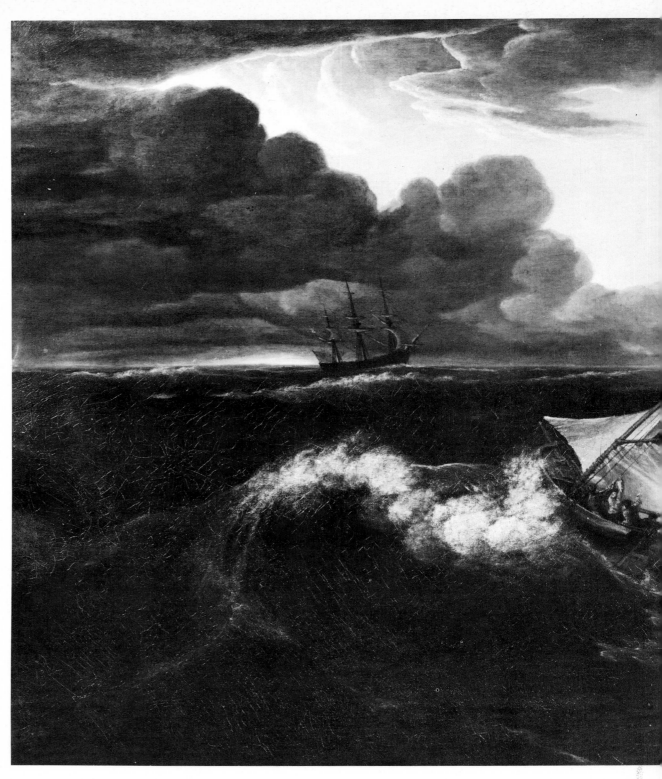

56 *The Rising of a
Thunderstorm at Sea*
1804
Washington Allston
1779–1843
oil on canvas, $38\frac{1}{2} \times 51$ in
Courtesy Museum of Fine
Arts, Boston (Everett Fund)

Washington Irving and the second time with Coleridge. Both these great Romantics had a strong and decisive influence upon Allston, especially the latter, with whom the painter retained a life-long friendship. Coleridge's supernatural mysticism was in perfect accord with Allston's own vision of the hidden life beneath the surface; as late as 1837 when he roughed out his chalk sketch *Ship in a Squall* (Fogg Art Museum), I cannot help feeling that the hypnotic rhythms of *The Ancient Mariner* were running through the painter's mind. The basis of their friendship was

one of Allston's finest early pictures, *Diana in the Chase* 1805 (private collection), which Coleridge had greatly admired. Even before they had met, Allston's magnificent, atmospheric landscapes, which include *The Rising of a Thunderstorm at Sea* 1804 (Museum of Fine Arts, Boston), *The Deluge* 1804 (The Metropolitan Museum, New York) and *Landscape with a Lake* 1804 (Museum of Fine Arts, Boston), showed that he was as aware of the manifold layers of meaning behind the surface appearance of nature as were Coleridge and Wordsworth in their *Lyrical Ballads*, published

56

phere of Romanticism, the subject being a key image of Romantic and Symbolist art; almost all the painters of this movement from Blake onwards painted a version of it.

In 1808, the foundation of his art clearly laid, Allston returned to America, but did not stay for long. In 1811, he was in Europe with his pupil Samuel Morse, and remained there for the next seven years. In this period, he executed one of his greatest masterpieces, *The Dead Man Revived in the Tomb by Touching the Bones of the Prophet Elisha* 1811–13 (Pennsylvania Academy of Fine Arts), a painting directly based upon one of the most famous pictures in the National Gallery, London, Sebastiano del Piombo's *Raising of Lazarus*, executed in Rome in 1519 in competition with Raphael's *Transfiguration* (this latter painting inspiring John Singleton Copley to execute an appalling work of the same subject).

In 1817, the year before he left Europe finally, Allston started on that picture which, like Michelangelo's tomb for Pope Julius II, was to remain a millstone around his neck for the rest of his life. *Belshazzar's Feast* 1817–43 (Detroit Institute of Art) is a picture of great power and nobility, even though, thanks to Gilbert Stuart's criticism, the artist could never finish it. It remains, even in the unsatisfactory state in which Allston despairingly left it, one of the greatest achievements of Romantic expression, and a masterpiece of American painting.

On his return to the United States Allston settled in Boston. In the years immediately following, he did some great work but from the mid 1820s until his death in 1843, he became more and more obsessed with *Belshazzar* to the detriment of his art generally. The great landscapes of 1819 to 1825, including the *Moonlit Landscape* of 1819 (Museum of Fine Arts, Boston), show that not only were the Italians of great importance to Allston, but that he had also absorbed the lessons of the great 17th-century Dutch and French landscapists, above all Claude. In these paintings Allston enters the mainstream of American Luminist painting, whilst at the same time imparting that deep sense of mystery which is lacking (intentionally) from the works of such artists as Fitzhugh Lane or Martin Johnson Heade.

Allston was not always successful – his imagination was often greater than his technical ability – but his position as the finest of American visionaries is assured. He created a new, romantic approach to American landscape which, unfortunately, few artists after him had the inclination to develop.

Allston had only one contemporary disciple, Thomas Cole, who was born in England in 1801, and who did not emigrate to America until he was nineteen. In fact, his professional career was fairly short. He started painting portraits in Philadelphia in 1822, moving to New York City later in the same year; he studied in Europe from 1829 until

just six years before these pictures were painted.

Although Allston was the first American painter to be committed totally to the Romantic vision, he was not the first American painter to execute Romantic or Symbolist pictures. As we have said before, Benjamin West was one of the first artists –European or American–whose work foreshadowed the new movement. In 1777, he painted *Saul and the Witch of Endor*, a subject which Allston depicted over forty years later. West's *Death on a Pale Horse* 1802 (Philadelphia Museum of Art) is also a picture painted in the pure atmos-

58

1832, returned to America, and after a few years in New York City settled in the Catskills, where he died in 1848 at the age of forty-seven.

Even before his trip to Europe, Cole had laid the foundations of his Romantic art. One of his earliest major works was the awesome *Expulsion from the Garden of Eden* of about 1827–28, which is based closely upon a mezzotint by one of the greatest of the English Romantics, John 'Mad' Martin. After his European trip, however, he was able to produce a series of extraordinary masterpieces. Writing about the vision behind *The Course of Empire* in 1836, in his *Essays on American Scenery*, Cole said: 'the waters shall reflect the temple and the tower, and dome, in every variety of picturesqueness and magnificence'. This search for the 'special effect' typifies the true Romantic spirit, and it is interesting to note the similarity of mood between this statement, and the Coleridge of *Kubla Khan*.

Cole's high place in the history of American art rests upon his series of paintings illustrative of didactic themes. Of these, the greatest is *The Course of Empire* (New York Historical Society) conceived during his visit to Italy. The five pictures which make up this set (*The Savage State, The Arcadian or Pastoral State, The Consummation of Empire, Destruction* and *Desolation*), executed during the 1830s, represent the artist's major achievement, and must rank amongst the most moving Romantic statements made by any artist of any country. Each scene is in itself a depiction of a particular view, a heroic composition but one which perhaps verges on the melodramatic. Taken as a whole, however, the series is a powerful statement of the transience of human achievement, a statement tinged with that melancholy which is one of the prime emotions of the Romantic Movement, the quiet solitude which characterises the work of all the major Romantic painters and poets.

Cole never achieved the same emotional impact in his other series: *The Departure and the Return, The Past and the Present, The Voyage of Life* and *The Cross and the World*, the last left unfinished at the time of his death. In them, the sentimental religiosity, to which Cole was always prone, becomes too obvious. He is trying to preach a sermon, and we become bored with the piety. The pictures lack the grand sweep of *The Course of Empire*. Only in the single image of *The Architect's Dream*

57 *Dead Man Restored to Life by Touching the Bones of the Prophet Elisha*
1811–13
Washington Allston
1779–1843
oil on canvas, 156 × 132 in
Pennsylvania Academy of Fine Arts, Philadelphia

58 *Belshazzar's Feast*
1817–43
Washington Allston
1779–1843
oil on canvas
Detroit Institute of Arts (Gift of the Allston Trust)

of 1840 (Toledo Museum of Art, Ohio), that weird and phantasmagorical vision of almost megalomaniac power, did Cole rise to the same heights.

Concurrently with the *Empire* series Cole was also painting some superb landscapes, of which *The Oxbow (the Connecticut river near Northampton)* 1836 (Metropolitan Museum of Art, New York) is possibly the most famous. Whereas the didacticism of his later series detracts from their obvious technical merit, his landscapes have a grace and strength which never flags. He was one of the first to sense the majesty of the American landscape, and his depictions of the scenes around the Hudson river were to have a decisive effect upon that group of landscape-painters which came to be known as the Hudson River School.

Also working at this time was John Quidor, who was born at Tappan, New York, and who spent most of his working life in New York City. Quidor was essentially a literary painter, but unlike most of the Romantics, who used as their common stock scenes from the Bible and Shakespeare, he concentrated on illustrating the American myths and fables of Washington Irving, published in 1820. The most famous of these is the whimsical *Ichabod Crane Pursued by the Headless Horseman* of 1828 (Yale University Art Gallery), and *The Devil and Tom Walker,* painted almost fifty years later (private collection). Quidor's work has little of the deeply felt horror of the true Symbolists, his works do not attempt to chart the close and gloomy world of Poe or Gustave Moreau. They have more in common with the 'fairy' pictures of an artist like Richard Doyle.

William Page (1811–85) studied under Allston's pupil Samuel Morse, and, like Allston, was greatly influenced by the colour tonalities of the Venetian Renaissance painters. Primarily a portrait-painter, his life was largely spent in New York, except for a stay in Boston between 1844 and 1847, and eleven years in Rome and various other Italian cities between 1849 and 1860.

His reputation today largely rests upon two pictures, both of which show how deeply committed he was to the Romantic vision. The *Portrait of Mrs Page* (Detroit Institute of Arts) is a strange, luminous picture, which clearly shows the influence of the Nazarenes and of Ingres. It is one of the finest of all 19th-century American portraits. The other is *Cupid and Psyche* (private collection), an extraordinary, magical evocation based upon Clas-

sical sculpture. In its plasticity it has much in common with Blake and Fuseli, both of whose works Page probably knew. It was a picture which gained a certain notoriety by being rejected by the National Academy on moral grounds.

William Rimmer (1816–79) was a self-taught artist who was born in England and taken by his parents to America at the age of two. He was restless and unsettled, turning his hand to a variety of occupations–doctor, shoemaker, lithographer, sculptor, teacher, and painter–all of which, surprisingly, he succeeded in doing fairly well. He also imagined himself to be the heir to the French throne!

Like Ryder after him, Rimmer was ignorant of the chemical properties of paint, and very little is now left of his work. Ironically, his reputation rests upon one painting which is, perhaps, a mirror image of his own personality. *Flight and Pursuit* 1872 (Museum of Fine Arts, Boston), is a nightmare picture in the great tradition of Symbolist art: a man pursuing endlessly his own shadow, the classic

59 *The Course of Empire:*
Desolation
1836
Thomas Cole 1801–48
oil on canvas, $39\frac{1}{2} \times 61$ in
New York Historical
Society, New York City

Doppelgänger image of the paranoid schizophrenic. There is only one other example of this image in art which carries such power, and that too is by an American. One wonders if Henry James, when he wrote *The Jolly Corner*, had seen Rimmer's picture.

Elihu Vedder (1836–1923) is, again, a painter widely known for only one painting, *The Lair of the Sea Serpent* (Museum of Fine Arts, Boston), executed in New York in 1864, the year before he left America permanently to make his home in Italy. He was not a painter of great talent, tending towards a dry academicism; the *Sea Serpent* is unquestionably his finest work, painted in a rich palette which Redon was later to use with such effect, and assures him a minor place in the history of Symbolism.

In the last decades of the 19th century, America produced two great visionary painters, Ralph A. Blakelock and Albert Pinkham Ryder. Both of these artists took Symbolist painting in America to a high and sustained level. It is a comment on the persistently materialistic attitude of the American public to art that both painters, after a brief period of popular acclaim, sank for many years into comparative obscurity.

Blakelock was born in New York City in 1847. He was, essentially, a self-taught painter, who was continually experimenting with materials and paints, a fact which has caused so many of his paintings, like Ryder's, to oxidize. He exhibited landscapes at the National Academy between 1867 and 1873; these early compositions are in the Hudson River tradition, closely observed scenes which owe much to such painters as Alvan Fisher, Asher B. Durand and Jasper Francis Cropsey.

Between 1869 and 1872, Blakelock joined expeditions west, and spent a considerable time in solitude amongst the Indians. It was at this time that his visionary idealism came to the fore. He painted two famous works, *Out of the Deepening Shadows* (Art Museum, Princeton University), which like many of his pictures, is extremely small in scale, measuring only $8\frac{1}{4} \times 12$ inches, and *The Chase* (Worcester Art Museum), in which an Indian

hunting is transformed into a ghostlike figure in a haunted landscape, reminiscent of the *Death on a Pale Horse* theme. From this period onwards, Blakelock's vision of the American landscape had a somewhat sinister quality which, although depicting the same scenery as the Hudson River paintings, was used as a surface upon which the visions of his unstable mind could play. Pictures such as *Moonlight and Clouds* (Los Angeles County Museum of Art), and the weird *Vision of Life* (Art Institute of Chicago), in which hardly discernible wraithlike figures inhabit the foreground of a deep and gloomy landscape, can be compared only with the works of Ryder in their emotional intensity.

Blakelock lived at a time when there was no demand for such pictures; the popular taste was for realism and melodrama. Bierstadt and Moran were riding high. Between his marriage in 1877, and 1899, Blakelock, always sensitive and neurotic, sank deeper into debt, and was tortured by the neglect which his works received. The strain was too great, and in 1899 he was confined to a mental institution, suffering from *dementia praecox*. As is the way of history, this tragedy focused attention on his work which, at no benefit to himself or his family, began to fetch high prices. He remained confined until 1916, when he was released into the guardianship of Mrs Van Rensselaer Adams, chairwoman of a charitable committee set up on his behalf. Until his death in 1919, Blakelock continued to paint, producing pictures which are gentler in tone than his earlier works. Paintings such as *The Fountain in the Park* (collection of the

artist's family) still retain, however, a deep visionary element. His last work, a sunset, is closer to the grim mood of his pre-confinement paintings.

Albert Pinkham Ryder is one of the greatest of all Symbolist painters, and although this fact is recognised, albeit belatedly, in his own country, he is still ignored totally by European writers on the subject. It is strange that at a time when there is more interest in Symbolism that ever before, few, if any, of the many books and exhibition catalogues which have appeared in the last two or three years even mention Ryder's name. He is worthy to be compared with Moreau, Redon, Bresdin and the great European visionaries, and he has none of the slick superficiality which is overlooked in the work of so many currently fashionable French and German Symbolist painters.

Born in 1847 in New Bedford, Massachusetts, Ryder came to New York City in the 1860s, visited London in 1877 and 1896, and Holland in 1882. His paintings, like those of Blakelock, have been severely damaged by time, since his lack of knowledge of pigments and glazes caused him to use bitumen to such an extent that many of his late works have become virtually monochrome. Nevertheless, we can still see enough to recognise the presence of a unique and forceful genius.

It has been said that with his ability to produce images which exist as entities in themselves, Ryder was more in tune with such movements as Post-Impressionism and early Expressionism than many of his contemporaries. We can add that paintings such as *Moonlight Marine* 1870–90 (Metropolitan

61 *Mrs William Page*
William Page 1811–85
oil on canvas, $60\frac{1}{4} \times 36\frac{1}{4}$ in
Detroit Institute of Arts
(Gift of Mr and Mrs George
S. Page, Blinn S. Page,
Lowell B. Page and Mrs
Lesslie S. Howell)

62 *The Lair of the Sea Serpent*
1864
Elihu Vedder 1836–1923
oil on canvas, 21 × 36 in
Courtesy Museum of Fine Arts, Boston (Bequest of Thomas G. Appleton)

63 *A Lake, Moonlight*
Ralph Albert Blakelock 1847–1919
oil on canvas, $19\frac{1}{2} \times 24\frac{1}{2}$ in

Museum of Art, New York), *Toilers of the Sea* 1884 (Metropolitan Museum of Art, New York), and *The Flying Dutchman* 1887 (Smithsonian Institution, Washington), show a concern with a careful geometricity of space which has much in common with the Abstract Expressionist and colour-field painters of the 1950s, especially Motherwell and Rothko.

Ryder's world was small; he lived the life of a recluse, he painted small pictures and only a few of them–not more than about 150. His vision was concerned with a minute observation of human experience; he put the world under a microscope and chose to depict the tiniest fragments. As he said in his famous letter explaining what he was trying to do: 'Have you ever seen an inch worm crawl up a leaf or twig, and then clinging to the very end, revolve in the air, feeling for something to reach? That's like me. I am trying to find something out there beyond the place on which I have a footing.'

Like other Romantics, Ryder used themes from myth and literature. We have mentioned *The*

64 *The Sun*
Ralph Albert Blakelock
1847–1919
oil on canvas, 15 × 15 in

65 *Flight and Pursuit*
1872
William Rimmer 1816–79
oil on canvas, 18 × 26¼ in
Courtesy Museum of Fine Arts, Boston (Bequest of Miss Edith Nichols)

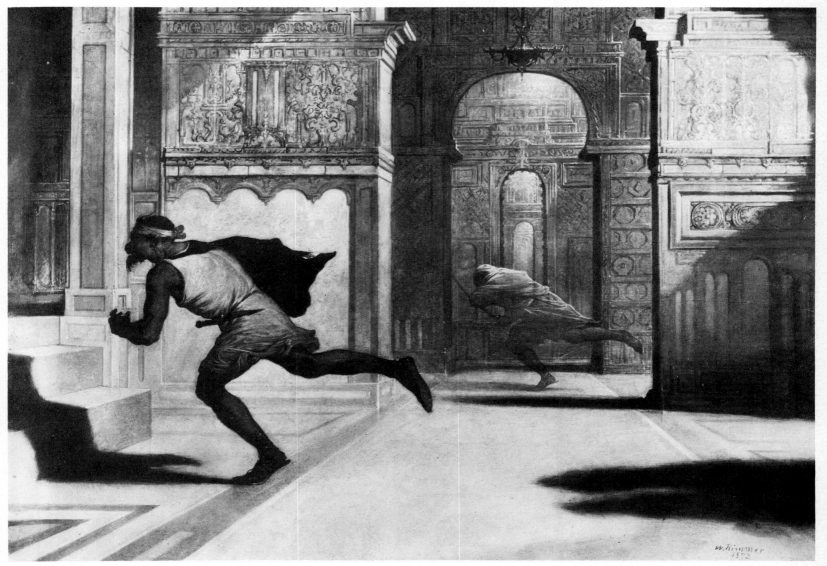

66 *The Strange Thing Little Kiosai Saw in the River*
John La Farge 1835–1910
watercolour, $12\frac{3}{4} \times 18\frac{1}{2}$ in
Metropolitan Museum of
Art, New York
(Rogers Fund, 1917)

67 *The Nearer Forest*
Arthur B. Davies 1862–1928
oil on canvas, 17¼ × 29¼ in

Flying Dutchman; he also painted a famous version of *Siegfried and the Rhine Maidens* (National Gallery of Art, Washington), *Macbeth and the Witches* 1890–1908 (Phillips Collection, Washington, D.C.) and a terrifying composition of *Death on a Pale Horse (The Race Track)* (Cleveland Museum of Art). He was also strangely attracted by the mystery of the sea, and many of his finest pictures are simple studies of ships under lowering skies, pictures laden with a sense of immanent doom. At times the forms are so schematised as to cause the composition to come close to total abstraction. And then he could produce rich pastoral works such as *Evening Glow, the Old Red Cow* of about 1885 (Brooklyn Museum), which bears some resemblance to late pictures by Inness, but which reminds one strongly of the visionary landscapes of Samuel Palmer's Shoreham period.

In the 1870s, William Morris Hunt (1824–79), after nearly ten years in Europe during which time he studied in Düsseldorf and in Paris under Couture and Corot, established himself in Boston, and was soon acclaimed as a leading painter and an outstanding teacher. Although greatly indebted to the pastoral elegies of Corot and Millet, Hunt's own work was more visionary and Romantic. In 1875, he was commissioned by the Government in New York to paint two murals for the Capitol, and he took as his subject a Persian poem about the Goddess of Night. *The Flight of Night* is, admittedly, a didactic work symbolising the triumph of civilisation over barbarism, but although didacticism played little part in Symbolist painting, Hunt created a work completely in accord with the visionary style in vogue in Europe. The mural took three years to complete, and so great was the physical strain that his health collapsed and he died prematurely in 1879.

His most talented pupil was John La Farge

(1835–1910), who, like his master, studied under Thomas Couture in Paris (Couture's work, essentially academic, had a strong Romantic flavour, being greatly influenced by Ingres and Delacroix). In many ways, La Farge was a proto-Impressionist, as were the Barbizon artists he admired. Commenting on his *Paradise Valley, Newport* of about 1866–1868 (private collection) he remarked, 'I wished . . . to indicate . . . the exact time of day and circumstance of light', an idea which exactly expresses, and in almost the same words, what Monet was to attempt a few years later. At the same time, he was capable of a classicising art which brought him close to such English painters as Albert Moore, Edward Poynter, Alma Tadema and Lord Leighton. Pictures like *Ideal Head* 1872 (private collection), *Greek Love Token* 1866 (Smithsonian Institution) or *Athens* 1898 (Bowdoin College Museum of Fine Arts) have little in common with French landscape-painting, and place La Farge fairly in the ranks of the Romantics. Even more strange, however, is that Japanese-inspired hallucination of 1897 called *The Strange Thing Little Kiosai Saw in the River* (Metropolitan Museum of Art), in which a severed head floats in the water – as morbid an image as anything created in France by Redon or Rops.

Our survey of Symbolism in America should not end without a mention of Arthur B. Davies (1862–1920), although his story really belongs to the 20th century. His art is gentle and peaceful and has little psychological depth. His beautiful Arcadian friezes stand midway between the works of the Pont Aven School (especially those of Maurice Denis and Serusier) and the enamel-like paintings of an artist like Armand Point. Of all the Romantics and Symbolist painters we have discussed, he is the least satisfying. Compared to Allston or Ryder, his work is fey and gutless. It does, nevertheless, have a certain decorative appeal.

68 *Toilers of the Sea*
before 1884
Albert Pinkham Ryder
1847–1917
oil on wood, $11\frac{1}{2} \times 12$ in
Metropolitan Museum of
Art, New York
(George A. Hearn Fund,
1915)

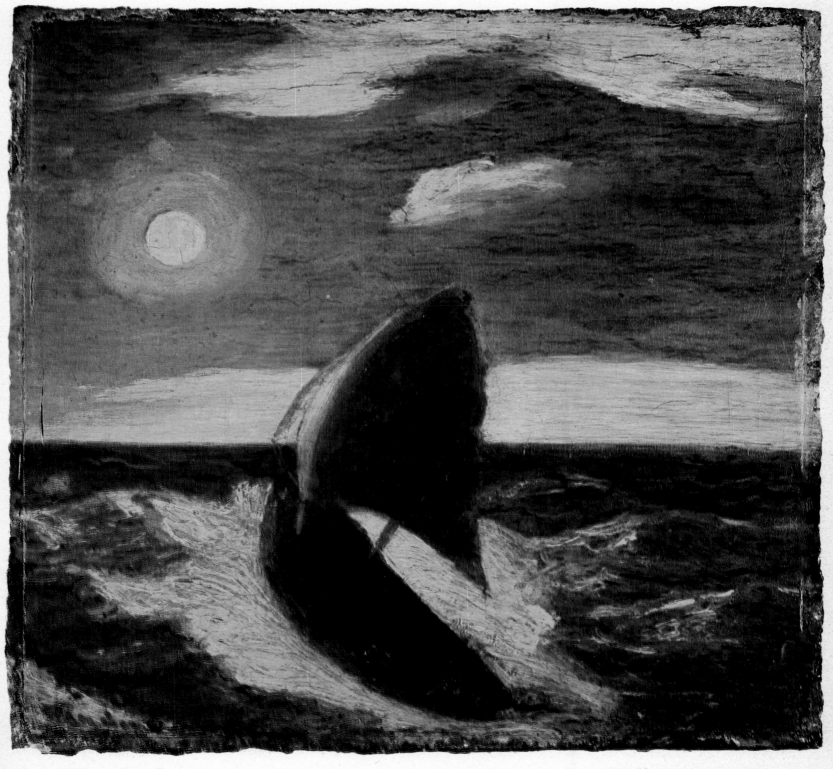

Landscape in the 19th century

The Hudson River School of landscape-painting flourished during the middle decades of the 19th century. It might be said that Thomas Cole's intensely romantic view of the American landscape, as evinced by his famous composition *In the Catskills* of 1837, inspired a whole generation of young American painters with the belief that the land which they inhabited, its splendour and beauty, afforded them a subject which could raise the standards of American painting to those of the European masters. In the beginning, Claude was the inspiration behind much of the American landscape school, but during the course of the century, the French Barbizon painters Corot, Daubigny and Theodore Rousseau came to exert a direct influence, as did the realism of Courbet.

But in many respects the Hudson River painters created a unique vision of landscape. At their worst, as in the bombastic effusions of Albert Bierstadt and Thomas Moran, American pictures of this type were melodramatic affairs in which the majesty of the scenery overawed the artist, but at their best they rose to a level rarely equalled by the landscape-painters of any country. There is some excuse for the chauvinism of many contemporary critics; when in 1867 H. T. Tuckerman wrote in his *Book of the Artists* that the elements of a landscape by Asher B. Durand 'are thoroughly and minutely American', he was only speaking the truth.

Thomas Cole's sole pupil was Frederick Edwin Church (1826–1900), who studied under Cole at the age of seventeen. Like Martin Johnson Heade, Church visited South America, being greatly influenced by the writings of the German explorer and naturalist Frederick Humboldt. However Church cannot properly be described as a Hudson River painter, since most of his major work either dates from his stay in South America in the late 1850s (*The Heart of the Andes, Cotopaxi, The Mountains of Ecuador*) or from his trip to Europe and the Middle East in the 1870s. It was only on his return from this second trip that he joined the loosely knit community on the banks of the Hudson river, by which time his main creative force was spent.

Church's South American landscapes are the pictures for which he is best remembered today. Although we would not echo the wildly exaggerated eulogies of his contemporaries, his masterpiece, *The Heart of the Andes*, is one of the few successful attempts by an American painter of this period to come to terms with a scene of such awesome dramatic power. Although the colour is raw and violent, it never falls to that level of vulgarity of which Bierstadt was so often capable. It is a painting by an artist of a deeply Romantic sensibility.

Far more influential in the founding of a coherent school of American landscape-painting was Asher B. Durand (1796–1886), who was born in New Jersey, and like the majority of the Hudson River painters, received his initial training as an engraver. As with Cole, Durand's first success came through the good offices of Trumbull, who, reactionary as he may have been, should be remembered with gratitude as a man who helped and encouraged two of America's finest 19th-century painters. Durand's engraving of Trumbull's *The Declaration of Independence* won him immediate fame, and enabled him to pursue his studies as a painter. In 1823, Durand declared his admiration for his fellow artists by purchasing one of the masterpieces of American Neo-classicism, Vanderlyn's *Ariadne*, which remained in his possession until the mid 1850s.

In 1840, Durand left for a tour of Europe in company with three other landscape-painters, John Kensett, John W. Casilear and Thomas P. Rossiter. Until then he had painted very few landscapes, having earned considerable success as a portraitist. The European trip was to alter the direction of his art completely. In France he admitted to being disappointed with Claude, although there can be little doubt of the tremendous influence the French master had upon him; as late as 1878, in his *Sunset* (New York Historical Society), Durand was executing profoundly Claudian compositions.

In 1848, Thomas Cole died, and with him ended a period in the history of American art. Durand was aware of the significance of Cole's death and commemorated it with his painting called *Kindred Spirits* (New York Public Library), as fine an epitaph as any artist has ever received. Cole and

69 *The Rainbow in the Berkshire Hills*
1869
George Inness 1825–94
oil on panel, 20 × 28¾ in

70 *Western Landscape*
about 1870–80
Albert Bierstadt 1830–1902
oil on canvas, 7¼ × 10¼ in

71 *In the Catskills*
1837
Thomas Cole 1801–48
oil on canvas, 39 × 63 in
Metropolitan Museum of
Art, New York (Gift in the
memory of Jonathan Sturges
by his children, 1895)

72 *Ruins at Baalbek*
Frederick Edwin Church
1826–1900
oil on canvas

73 *Girl Seated by a River*
1880
Frederick Edwin Church
1826–1900
oil on canvas, $19\frac{1}{4} \times 15\frac{1}{4}$ in

his close friend, the poet William Cullen Bryant, stand on a wooded bluff, overlooking a deep gorge, with the landscape stretching into the far hazy distance. This moving testimonial is at once one of the finest mid 19th-century landscapes, and possibly the last great Romantic painting executed in America.

In the mid 1850s, Durand occasioned a new mode of painting landscapes. Hitherto, the artist had gone out and sketched from actual scenery, only to return to the studio to paint a picture which, more often than not, became an ideal view, almost a *capriccio*. Durand encouraged the practice of painting on the spot, making direct contact, as it were, between the landscape and the canvas, a way of painting which was advocated in France by the Barbizon painters, especially Daubigny.

In one other respect, too, is Durand's career essential to a study of the development of painting in the 19th century. Hitherto, the noblest branches of the art of painting had been the depiction of historical scenes and portraiture. Landscape was considered a distinctly minor pastime, especially in America. After the United States was formed, however, and explorations west began to open up new territory for settlement and industrial exploitation, the American people became aware for the first time of the vast extent of their land. This caused an unprecedented demand for paintings of the American landscape. Durand and his colleagues satisfied this longing, and in so doing made landscape-painting worthy of the attention of the serious artist. This fact was recognised when on the retirement of Samuel Morse in 1845 the National Academy of Design elected a landscape-painter to the position of President, a post Durand occupied until 1861.

Besides Cole, Church and Durand, one other painter, Thomas Doughty, holds a seminal position in the history of 19th-century landscape-painting in America. Like Durand, Doughty was deeply influenced by Claude, indeed was even referred to by the *Knickerbocker Magazine* as 'the all-American Claude Lorraine'! Born in Philadelphia in

1796, Doughty was essentially a self-taught painter, although his work was considered professional enough for the Pennsylvania Academy of Fine Arts to accept it for exhibition in 1822, an exhibition which also included paintings by Cole and two other artists who were to become distinguished landscape-painters, Thomas Birch and Alvan Fisher. The *Knickerbocker Magazine* employed a surprisingly percipient art critic, for in 1833 he described Doughty as infusing into his work 'all that is quiet and lovely, romantic and beautiful in nature', a description of these gentle early paintings which cannot be bettered.

By the mid 1830s, Doughty was the most respected landscape-painter in America, with vast sums being paid for his work. In 1837 and 1845, he visited London, where his paintings were given a warm reception by the critics, and in the latter year he was invited to exhibit two works at the Royal Academy, *A Summer Shower in New Hamp-*

74 *Clearing Up*
1854
Asher B. Durand 1796–1886
oil on canvas, 31½ × 45½ in

shire and *A View on the Hudson River*. When he returned to America after this triumph, he settled permanently in New York, in a community which then included Fisher, Durand, Casilear and John F. Kensett.

Alvan Fisher was born at Needham, Massachusetts in 1792 and studied with a minor history painter called John R. Penniman, who, in the normal way, executed large and melodramatic views of Roman ruins in his studio. This practice had a lifelong effect on Fisher who continued to paint studio pictures, rather than working directly from nature; he felt that an artist with the necessary measure of sensitivity should be able to imprint the image of a scene clearly on his brain, to be reproduced later at leisure and in the comfort of a studio.

Fisher's early career was as a portrait-painter, but in the early 1820s, he began painting landscapes under the influence of Thomas Doughty. These

75 *A Lily Pond*
1861
Asher B. Durand 1796–1886
oil on canvas, 16 × 23 in

early works are well-defined and clearly lit compositions, and are amongst the artist's best works. He travelled through Europe between 1825 and 1827, visiting England, France, Italy and Switzerland, and on his return settled in Boston, where he remained for the rest of his life. His was not a major talent although his pictures have a sense of firmly grasped reality which was to become a characteristic of the finest Hudson River landscapes.

In the 1830s and 1840s, the leading painters among the young generation of American artists began to devote a considerable amount of time to landscape-painting. Apart from Thomas Church, the artists who came to maturity during this period included John William Casilear (1811–93), John Frederick Kensett (1818–72), T. Worthington Whittredge (1820–1910), George Inness (1825–94) and Jasper Francis Cropsey (1823–1900); a slightly later generation included Albert Bierstadt (1830–1902), Alexander Wynant (1836–92) and Thomas Moran (1837–1926).

In the 1840s, most of these artists were studying in a tightly knit group in Rome; their heroes were still the French classical landscapists of the 17th century, as is clearly shown by William Dunlap, painter and author, who wrote in his *History of the Rise of the Arts of Design in the United States* that the house where he lived 'was situated opposite to that which had been occupied by Claude Lorraine and between those known as Salvator

76 *Fishing*
Thomas Doughty 1793–1856
oil on canvas, 28 × 36 in

77 *Lake George*
John William Casilear
1811–93
oil on canvas, 38 × 60 in

Rosa's and Nicolas Poussin's . . . You may imagine that in the midst of such, to us, "Holy Ground", our enthusiasm was not a little excited.'

John Kensett was one of the finest painters of this group. He, too, started his career as an engraver, but changed to oil painting under the influence of Doughty and Casilear. He spent seven years in Europe between 1840 and 1847, much of it in England, and joined the American community in Italy in 1845. Although he established a considerable reputation for himself as a landscape-painter in England, his Roman views were the paintings which brought him fame in his own country.

On his return to the United States, Kensett was elected a member of the National Academy. Settling in the region of New York, he travelled extensively around the mountains and coasts of New England. In 1872, he purchased a plot of land on Contentment Island, in the Hudson river, in partnership with the topographical painter Vincent Colyer; it was whilst vainly attempting to save the latter's wife from drowning in the same

year that Kensett contracted fatal pneumonia.

Matthew Baigell, in his recent book on the history of American painting, has pointed to three distinct phases in the development of Kensett's art, starting with the somewhat crude, uncontrolled style of his pre-European period. There can be little doubt that Kensett was affected by direct contact with German academic painting, but whereas most American painters succumbed to a heavy, melodramatic mood as a result of such contact, Kensett used the great technical abilities which he learnt from the Germans to his own ends and on his return to America began painting more open and tranquil landscapes, which towards the end of his career became extremely close to the work of the Luminists; the brushstrokes became finer, the colours more bland and placid. These pictures certainly represent the artist at his best.

Jasper Francis Cropsey was born in New York in 1823. He entered an architect's office at an early age but was sufficiently proficient as a landscape-painter by the age of twenty-one to be made an associate member of the National Academy (he

78 *Shipwreck*
1833
Thomas Birch 1755–1834
oil on canvas, 20 × 30 in

79 *Landscape with a Figure*
John Frederick Kensett
1818–72
oil on canvas, 12½ × 22 in

80 *Indian Summer on*
Lake George
1861
Jasper Francis Cropsey
1823–1900
oil on canvas, 23¼ × 38 in

was made a full member in 1851). Between 1847 and 1850 he toured Europe, studying in London, Paris, and Rome, and meeting many of the leading Barbizon painters; they did not have great effect upon his art, however, although Cropsey is one of the most sympathetic depictors of small, almost intimate landscapes of great atmosphere and delicacy.

He returned to America in 1850, but six years later sailed for Europe once again, staying in London for six years. He exhibited regularly at the Royal Academy and met with considerable success. In many ways Cropsey resembles his English contemporary Atkinson Grimshaw. In both cases, the artists found a formula which perfectly suited their abilities: small, carefully delineated scenes, usually dominated by the rich brown-gold tones of autumn, or the cold grey of winter. In 1862, Cropsey exhibited a typical picture at the Royal Academy, *Autumn on the Hudson*, and the London *Times* commented:

'The painting is a perfectly faithful view of the locality. The singularly vivid colours of an American autumn scene–the endless contrasts of purples and yellows, scarlets and browns, running into every conceivable shade between the extremes–might easily tempt a painter to exaggerate or revel in variety of hue and effect, like a Turner of the forest. But Mr Cropsey has resisted the temptation and even a little tempered the capricious tinting of nature; his autumn is still brilliant, but not quite lost to sobriety, as we have sometimes, we think, seen in that Western world. The result is a fine picture, full of points that are new, without being wholly foreign to the European eye.'

Although intended to be praise at the time, the author unwittingly points to Cropsey's main defects, defects which place him in the second rank of American landscape-painters. He was a studio painter whose vision was limited to one scene–most of his compositions depict a sedge-lined, tree-encircled lake, the ground being covered with fallen autumn leaves. So often did he paint such

81 *The Flume,
Franconia Notch, N.H.*
John Frederick Kensett
1818–72
oil on canvas, 12 × 18½ in

79

83 *After the Storm*
1861
William Bradford
oil on canvas, $24\frac{1}{4} \times 36\frac{1}{4}$ in

84 *Tivoli, Italy*
about 1871–74
George Inness 1825–94
oil on canvas, 12×16 in

82 *Under the Palisades
in October*
1895
Jasper Francis Cropsey
1823–1900
oil on canvas, 60×48 in

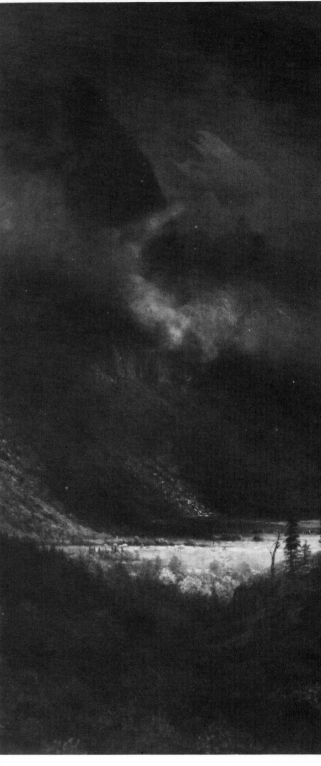

85 *A June Day*
1881
George Inness 1825–94
oil on canvas, $22\frac{1}{4} \times 28\frac{3}{4}$ in

86 *Farallon Island*
about 1873
Albert Bierstadt 1830–1902
oil on canvas, $34\frac{3}{4} \times 52\frac{1}{2}$ in

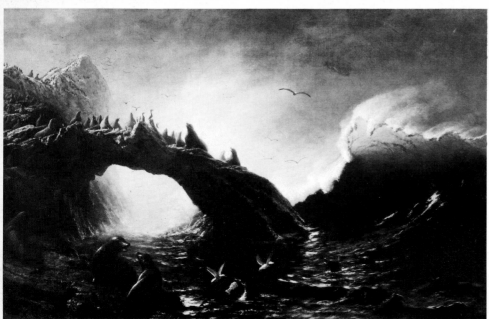

pictures that he became mechanical and obvious in his approach. Each painting is a carefully planned exercise often totally lacking in emotion; so often they look like tasteful Christmas cards. Such criticism is certainly true of the many variations on this theme that Cropsey painted after his return to America in 1863 until his death in 1900.

George Inness is at once the greatest of the Hudson River painters and one of the finest of all 19th-century American landscape artists. In his career, we can trace the developing history of the painter in that most revolutionary of times. Born in New York, he moved with his family at an early age to Newark, New Jersey; he studied engraving under

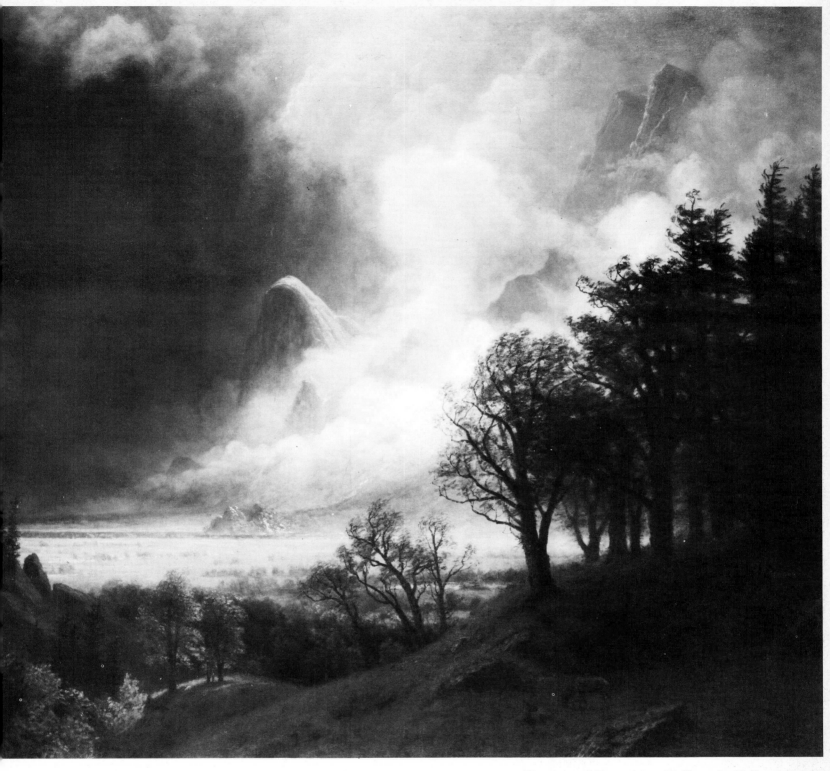

Regis Gignoux in New York City but turned to painting in the early 1840s, exhibiting at the National Academy from 1844 onwards. He studied in Rome between 1847 and 1848 and from 1851 to 1853; he visited Paris in 1854, where he was deeply influenced by the Barbizon painters, an influence which was to alter his style drastically. He spent the majority of the years between 1870 and 1874 in France and Italy, and died whilst on a visit to Scotland in 1894.

Such is a brief outline of his life. Inness began painting at a time when the Romantic consciousness was still strong and his early works have a bold, clear light with carefully defined space, a schema which owes much to Claude and Poussin. At this point his aims were purely Romantic. In his own words: 'Every artist who, without reference to external circumstances, aims truly to represent the ideas and emotions that come to him in the presence of nature, is in the process of his own spiritual development, and is a benefactor to his race. His environment affects him, but the true artistic impulse is divine.'

His paintings of the late 1840s and 1850s, especially those views of Roman hills, are merely vehicles for Inness's inner beliefs, the mysticism of Swedenborgian philosophy which so deeply affected his life. This mysticism grew stronger in

87 *Yosemite Valley (Apotheosis of the West)* about 1898
Albert Bierstadt 1830–1902
oil on canvas, 54 × 84 in

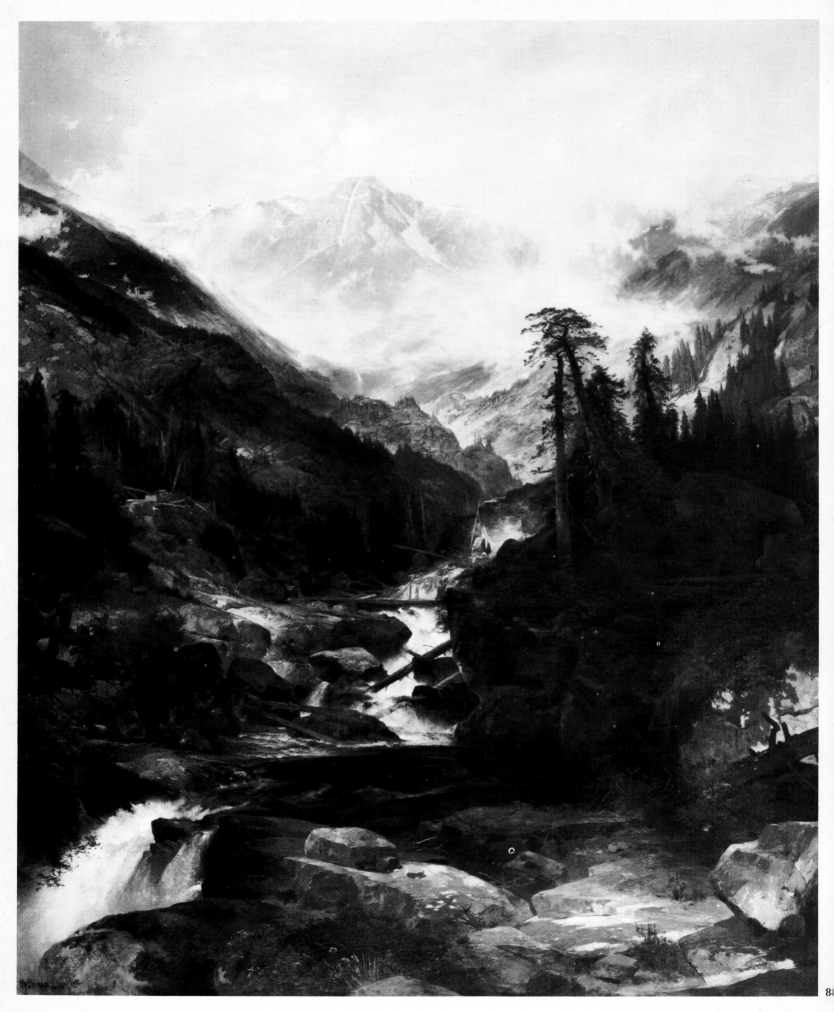

the late 1850s, culminating in those strange Symbolist landscapes painted at Medfield, near Boston, and at Eagleswood, New Jersey.

At the same time, we can see clearly the influence of Corot, whose almost contemporaneous career has a stylistic similarity to that of Inness. Although the approach to landscape was still subjective, Inness's late paintings were trying to come to terms with visual form in the same way as the Impressionists. Again, in Inness's own words, which show how remarkably attuned he was to the current mood of the avant-garde in France: 'In art–true art–we are not seeking to deceive. We do not pretend that this is a real tree, a real river, but we use the tree or the river as a means to giving you the feeling or impression that through them a certain effect is produced upon us.' Monet could not have phrased it better.

Inness's last works, painted around New York and at Montclair, New Jersey, show him to be moving in the same direction as the Impressionists in France. They have, I believe, more strength and emotion than those late feathery effusions of Corot; they are imbued with that same shimmering, vaporous quality associated with the great Impressionist paintings of the 1870s, behind which lies a strong, broad massing of shapes. In these works Inness proved himself to be the most vital, pioneering, and indeed influential, landscape-painter of his age.

In contrast to the deep introversion of Inness, Albert Bierstadt's massive panoramas of American scenery are bold and brassy things. Born in Düsseldorf, Bierstadt was the only one of the Hudson River painters to journey west with the various expeditions sent out to explore and map new territory. In 1858 he joined General Lander's expedition to the Rockies, which resulted in a series of vast paintings, averaging between sixty and ninety square feet. The various views of the valley of the Yosemite and the surrounding peaks appealed to the Victorian love of size, visible power and spine-tingling awe; Bierstadt became internationally famous, being decorated by no less than five European governments. After years of eclipse, his reputation is today being reconsidered.

There can be little doubt that those early landscapes, painted in the 1860s, do impress one still with the awe-inspiring magnificence of the Rocky Mountain scenery, and that Bierstadt, for all his limited sense of colour and his apparent lack of subtlety, produced some of the most memorable images of the newly discovered West; what we find hard to forgive are the commercial pot-boilers which he continued to produce for another forty years. By the time he died in 1902 he had become, in artistic terms, his own worst enemy.

The same may be said of Thomas Moran who, born in Bolton, England in 1857, arrived in America at the age of seven. Like Bierstadt, Moran specialised in vast overpowering views of the Yosemite valley and the Grand Canyon, which apparently attempt to bludgeon the beholder into a state of bemused insensibility–a task in which they are successful all too often. Moran, in fact, was a painter of considerable gifts; he could paint moving and subtle compositions in a well-controlled, sensitive palette. Like Bierstadt, however, he found it difficult to resist the grandiose and obvious, although today's critics have been generous in their praise of his last melodramatic pieces. He continued to paint in a monumental style, which became gradually weaker and more flaccid, until his death in 1926 at the age of eighty-nine.

88 *The Mountain of the Holy Cross*
1875
Thomas Moran 1837–1926
oil on canvas, 80 × 63 in

89 *San Juan Abajo*
1884
Thomas Moran 1837–1926
oil on canvas, 17¼ × 27¾ in

Luminism

In 1942, Jean Lipman, in *American Primitive Painting*, pointed to a peculiar paradox: 'Extreme fidelity to the mental picture results in extreme perversion of reality.' Nowhere can this paradox be seen more clearly than in that particular type of American painting called 'Luminism'. We may compare the above-quoted statement with Barbara Novak's description of Martin Johnson Heade's *Approaching Storm, Beach near Newport*, about 1860–70 (Museum of Fine Arts, Boston): 'The rocks at the left, perhaps more responsible than either storm or space for the ominous tone of the picture, are executed in relentless detail, each concavity and convexity wriggling with a curious presence. They are the rocks of fantasy.'

Luminism flourished in the period between roughly 1845 and 1860. It has certain characteristics, the most obvious of which is an attempt at an absolutely accurate and perfect rendition of a given object or scene. In this respect it could not be further removed from Impressionism. In the Luminist landscape, the artist seeks to withdraw his own presence as far as possible from the work; not a brushstroke nor blemish shall mar the smooth, immaculate surface. The paintings are, or aim to be, mirror images and there is no place for the interpretative personality of the painter. In our own day, the Photo-realists have returned to this perfectly static image, many of them using an air-brush to remove all traces of personal contact with the canvas.

The two most eminent exponents of Luminism were Martin Johnson Heade and FitzHugh Lane. Other painters were attracted to it—indeed it could be said to be one of the most pervasive elements in American painting from Copley's perfectly rendered portraits to Richard Estes' vertiginously exact views of New York streets two hundred years later. One of the 20th century's most distinguished painters in the Luminist tradition, Andrew Wyeth, has stated that FitzHugh Lane is his favourite marine painter. Wyeth lives on the Maine coast, near Penobscot Bay, the scene of Lane's major compositions.

The masterpieces of Luminism, however, are by William Sidney Mount and George Caleb Bingham. Mount's *Eel Spearing at Setauket* 1845 (New York State Historical Association Museum, Cooperstown) and Bingham's *Fur Traders Descending the Missouri* 1845 (Metropolitan Museum of Art), together with the smaller version of the same subject executed in 1851, and entitled *The Trapper's Return* (Detroit Institute of Arts), are amongst the best-known American 19th-century paintings, and are three of the very small number of paintings by American artists who had no career outside their native country to be widely known in Europe.

In all three pictures, we see most of the characteristics which constitute a Luminist composition. The image is made up of a low flat stretch of land, behind which is a wider expanse of water, surmounted by a high, and even wider, area of sky. The surface of the water in these pictures, as in the majority of Luminist compositions, is perfectly smooth, and mirrors the sky and land as perfectly in itself as the whole picture mirrors the scene in its entirety. In these works, more especially in those by Bingham, the result is a strange, totally still monumentality in which the meticulously rendered details merge to form a composition of almost dizzy unreality.

Bingham was born in 1811 in Virginia, but in 1819 left with his family for Missouri, where he spent most of the rest of his life. After studying in Philadelphia at the Pennsylvania Academy, and then a spell of portrait-painting in Washington, he returned to Missouri, and painted *The Fur Traders Descending the Missouri*, described by Richardson as 'one of the most original and striking works of its age'.

The development of Bingham's art over the next ten years is a phenomenon almost as inexplicable as that of Copley eighty years earlier. In the 1830s, Bingham was painting stiff, cardboard portraits, with only the occasional touch of his future magic. His *Self-portrait* of 1834–35 (City Art Museum, St Louis, Missouri) is probably the finest example, in which the meticulously rendered features, with an almost glassy play of light on the nose, cheek bones and wavy brown hair, do give some indication of the fascination with light and detail which characterises his mature work.

Then suddenly comes the *Fur Traders*, which

90 *Fur Traders Descending
the Missouri*
1845
George Caleb Bingham
1811–79
oil on canvas, 29 × 36½ in
Metropolitan Museum of
Art, New York
(Morris K. Jessup Fund,
1933)

91 *Orchids and*
Hummingbirds
Martin Johnson Heade
1819–1904
oil on canvas, 15 × 20 in

92 *Eel Spearing at Setauket*
1845
William Sidney Mount
1807–68
oil on canvas, 29 × 36 in
New York State Historical Association, Cooperstown, New York

93 *Approaching Storm, Beach near Newport*
1860–70
Martin Johnson Heade
1819–1904
oil on canvas, 28 × 58¼ in
Courtesy Museum of Fine Arts, Boston
(M. and M. Karolik Collection)

was followed by a whole series of views of life on the Missouri river: *Boatmen on the Missouri* 1846 (private collection), *The Jolly Flatboatmen* 1846 (private collection), another version of *The Jolly Flatboatmen* 1847 and the *Raftsmen Playing Cards* 1847 (both in the City Art Museum, St Louis, Missouri), and many others. He also executed many genre scenes, Indian subjects and one superb historical composition, *The Emigration of Daniel Boone* 1851 (Washington University, St Louis, Missouri), executed in a grand manner which harks back both in mood and style to the work of West and Copley. Also in 1851, Bingham embarked upon a series of pictures illustrating political life in Missouri, and paintings such as *The County Election* in the City Art Museum, St Louis, Missouri, are perhaps the finest genre scenes ever executed by an American painter. In all these works, the compositional structure is the same—a central focal point in the foreground spreading out to a microscopically perfect distance.

The years between 1856 and 1859 were largely spent in Düsseldorf, by then the Mecca for American artists which London had once been. After his return to the United States, however, Bingham's style showed evidence of having been spoiled by the dry academic technique which he had learnt in Germany and, until his death in 1879, he painted few pictures which can be said to add anything to his pre-Düsseldorf career. Yet in the years between 1845 and 1855, in one single decade, Bingham created some of the most enduring and triumphant images of 19th-century America, showing the everyday activities of a frontier and rural society.

William Sidney Mount was born in 1807 at Setauket, Long Island. He spent a year at the National Academy in New York in 1827, and for the next ten years supported himself in New York painting portraits. In 1837, he settled in Stony Brook, New York, where he remained until his death in 1868. He is generally considered to be the founder of an indigenous school of genre painting, and with his contemporary, Bingham, he imbued the ordinary life of ordinary people with a monumental dignity and understanding. Both artists showed a keen sense of the beauty of simple things and in this they revealed their kinship with the Dutch masters of the 17th century, de Hooch, Vermeer, Steen and Cuyp.

FitzHugh Lane was born Nathaniel Rogers Lane in Gloucester, Massachusetts, in 1804. At the age of twenty-eight he began studying lithography in Boston, and it has been said that this training may have channelled his art into the extreme Luminism it was later to show. He is also thought to have studied briefly with the English-born painter Robert Salmon, who himself produced splendid, light-filled views of ships at sea around Boston; this experience again may have influenced the future direction of Lane's painting towards those hot, still, brilliant views of the sea for which he is most famous.

His views of the Massachusetts coastline, largely executed in the years immediately preceding his

94 *Raftsmen Playing Cards*
1847
George Caleb Bingham
1811–79
oil on canvas, 28 × 36 in
St Louis Art Museum

95 *The County Election*
about 1851
George Caleb Bingham
1811–79
St Louis Art Museum

96 *Portrait of
William R. Clapp*
1854
Martin Johnson Heade
1819–1904
oil on canvas, 29 × 24½ in

following pages
97 *Owl's Head,
Penobscot Bay, Maine*
1862
FitzHugh Lane 1804–65
oil on canvas, 16 × 26 in
Museum of Fine Arts, Boston
(M. and M. Karolik
Collection)

death in 1865, are perfect examples of Luminism. *Owl's Head, Penobscot Bay, Maine* 1862 (Museum of Fine Arts, Boston) and *Brace's Rock, Eastern Point, Gloucester* 1863 (private collection) are two of the most famous of these marine subjects. Their polished surfaces are reminiscent of the hard, opalescent canvases of the Venetian view-painters of the 18th century, Canaletto and Bellotto, and, like them, Lane was fascinated by optical instruments with which he rendered his already splendid sight even more exact. He also used what Canaletto himself would almost certainly have employed had they been available to him, namely photographs. His work illustrates perfectly that well-known saying of Ralph Waldo Emerson: 'There is no object so foul that intense light will not make it beautiful.'

Martin Johnson Heade was born in 1819 in Bucks County, Pennsylvania, and before journeying through Italy, France and England between 1837 and 1840, studied under the portrait-painter Thomas Hicks. The first phase of his art, when he was a landscape-painter and portraitist, started with his return to America in 1840 and lasted until his first South American trip, to Brazil, in 1863; the second phase, during which time he visited several South American countries, including Nicaragua, Colum-

bia and Puerto Rico, as well as Jamaica in 1870, lasted until he settled in Florida in 1885. The third phase lasted from 1885 until his death in 1904.

Heade's portraits of the first phase clearly show his attention to detail. One of the most famous is the closely observed *Portrait of William R. Clapp* of 1854 (private collection), in which the face of the sitter is treated as a fine and superbly delineated map; but it is not just a photographically exact rendition–there is a psychological presence behind the smooth surface appearance. His landscapes of this period tend to be standard, Romantic products, closely allied in character to the Hudson River School, although around 1860, the Luminist idiom came to the fore. *Spouting Rock Beach, Newport, Rhode Island* 1861 (private collection), *Lake George* 1862 (Museum of Fine Arts, Boston), and *The Stranded Boat* 1863 (Museum of Fine Arts, Boston), are three of Heade's earliest and finest Luminist masterpieces, whilst *Two Owls at Sunset*, about 1860 (private collection), is a strangely Surrealist image, having an affinity to the sinister mood of many of Max Ernst's weird landscapes.

In 1863, Heade's first phase came to full maturity. We have already mentioned *The Stranded Boat*; also executed in that year were *Sunrise on the Marshes*

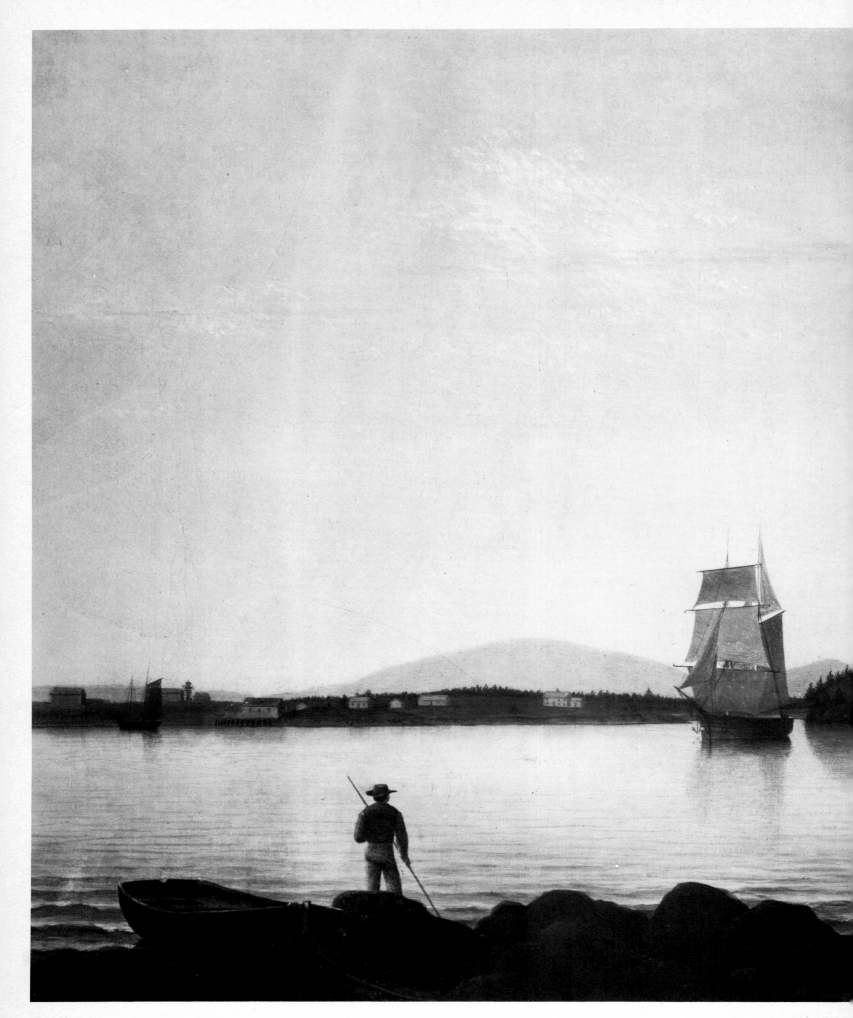

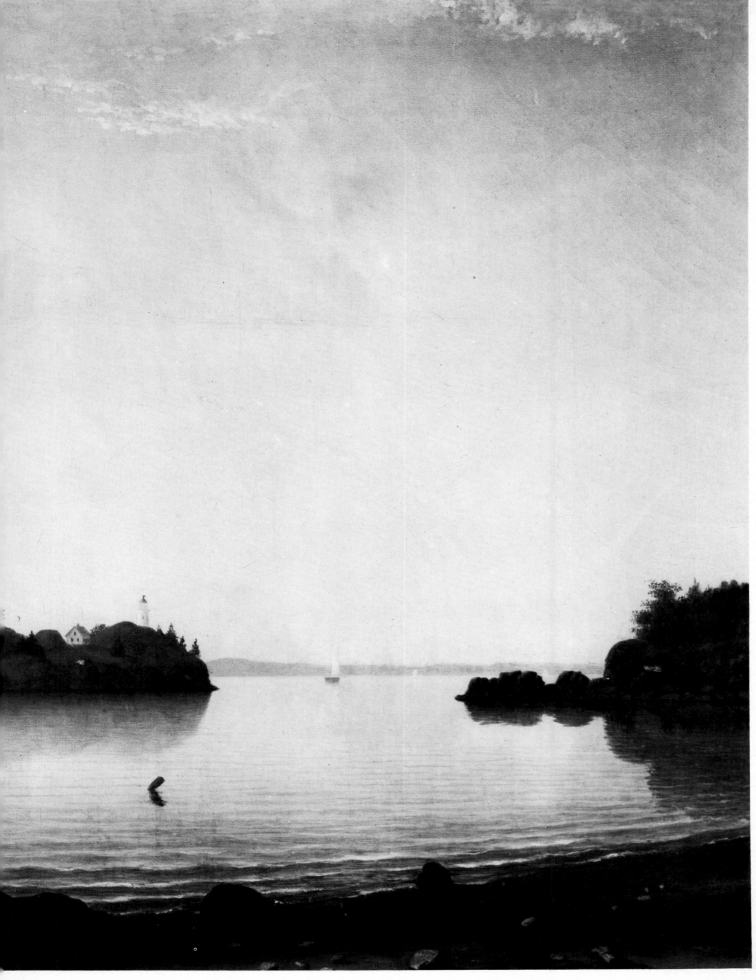

98 *The Stranded Boat*
1863
Martin Johnson Heade
1819–1904
oil on canvas, $22\frac{3}{4} \times 36\frac{1}{2}$ in
Courtesy Museum of Fine
Arts, Boston
(M. and M. Karolik
Collection)

99 *Meditation by the Sea*
1850–60
artist unknown
oil on canvas, $13\frac{1}{2} \times 19\frac{1}{2}$ in
Courtesy Museum of Fine
Arts, Boston
(M. and M. Karolik
Collection)

100 *The Customs House
at Greenock*
1825
Robert Salmon,
about 1775–about 1842
oil on panel, $16\frac{1}{2} \times 25\frac{1}{4}$ in

(Flint Institute of Arts), a subject which fascinated Heade and of which he made a number of superb almost *pointilliste* charcoal studies, and *Twilight, Spouting Rock Beach* (private collection), perhaps the artist's finest painting of this period, a haunting image of desolate beauty.

The second phase begins with a number of studies of tropical birds, and still-lifes of flowers which are not particularly distinguished. The major works begin to be executed about 1867, starting with two storm-laden images of Surrealist intensity, *Approaching Storm, Beach near Newport* and the even more extraordinary *Thunderstorm over Narragansett Bay* of 1868 (private collection), a picture which seems to owe something to Japanese prints. These are followed by some magnificent storm studies of haystacks on the marshes, and in the 1870s, beautiful studies of orchids and hummingbirds in tropical landscapes, rendered with all the exactitude of a trained botanist.

In the late 1870s, Heade painted some fine coastal scenes around Long Island, including a classic Luminist image, *Becalmed Long Island* 1876 (private collection), which allowed him to display to the full the peculiarly misty light which is a feature of his later works, and some minor studies of individual plants. After Heade settled in Florida his art gradually weakened, although in 1887, he painted one splendid Jamaican landscape, *View From Fern Tree Walk* (private collection), and in about 1890, some startling hard-edged realist studies of plants, of which the finest is *Giant Magnolia on a Blue Velvet Cloth* (private collection).

Perhaps Heade's best epitaph has been written by Theodore Stebbins Jnr, who, in the introduction to the catalogue of the first major retrospective of the artist's work in 1969, wrote:
'Heade must be considered a major talent of the 19th century. As an artist his range and talent were unique . . . he was never a member of the

101 *Florida Sunrise*
about 1890
Martin Johnson Heade
1819–1904
oil on canvas, 28 × 54 in

National Academy . . . he was a misfit . . . a humble, shy man in a time of breast beating. He was a romantic who thought of himself as a naturalist, a compulsive traveller who missed the great sights of the world, a speculator who was always too late. His personality and his art were both out of place in their time, and they made his worldly failure inevitable; perhaps only now can

his art be given its due.'

These, then, were the great masters of Luminism; others dabbled with it, or produced a small group of work which may be categorised as Luminist. The Hudson River painter John F. Kensett executed a few notable works in this vein including *Coast Scene with Figures* of 1869 (Wadsworth Atheneum), which is similar in many ways to Heade's *Approach-*

ing Storm, Beach near Newport painted at about the same time. (It is interesting to note the similarity of these paintings to a strange anonymous primitive picture in the Museum of Fine Arts, Boston, *Meditation by the Sea* of about 1850–60, although this is probably nothing more than a peculiar coincidence.) Frederick Church and Albert Bierstadt have also been linked with Luminism although the former's *The Heart of the Andes* 1859 (Metropolitan Museum, New York), whilst being an exact visual record, has little of the placidity which is, in general, one of the characteristics of Luminist painting. It was not until Charles Sheeler began his views of the American industrial landscape in the 1920s that the Luminist tradition once again came to the fore.

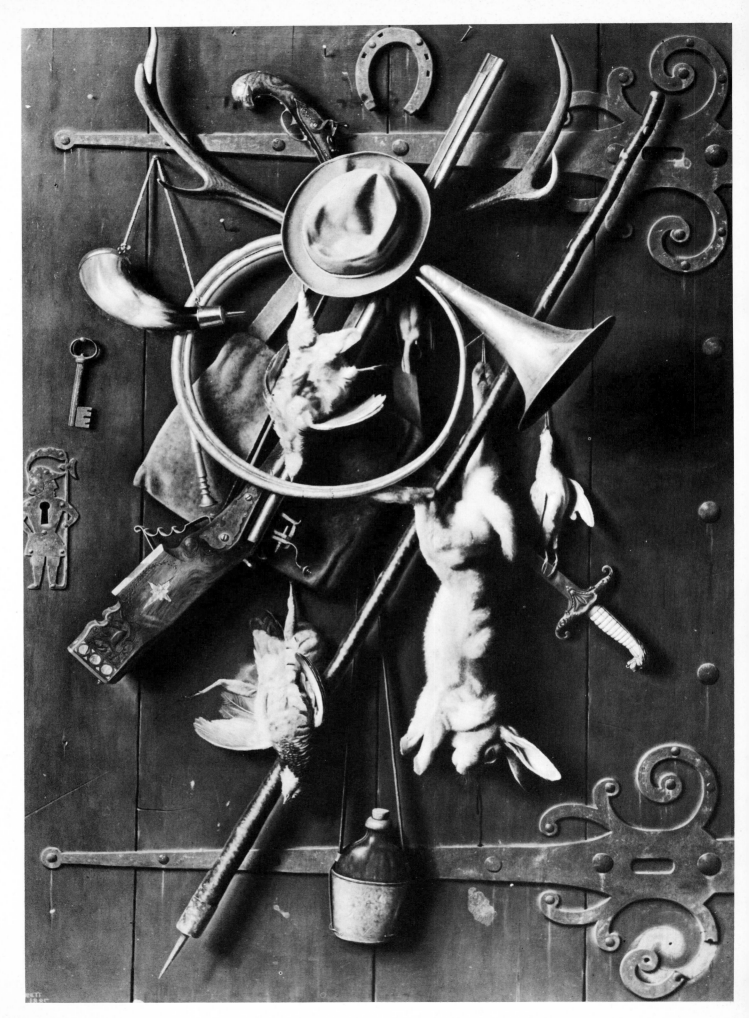

Still-life painting in the 19th century

The 19th-century school of American still-life painting, centred mainly in the city of Philadelphia, has received tremendous attention from the critics in the last few years, mainly because of the detailed researches of Alfred Frankenstein, whose splendid monograph on the subject, *After the Hunt*, first published in 1953, remains the standard reference work. In this monument of scholarly detection, Frankenstein pieces together the lives and careers of many artists who had fallen into almost total obscurity. It is largely because of this book that many of America's most important still-life painters, of whom William M. Harnett and John F. Peto are the most outstanding, are known today.

It may be that the rise of Impressionism, as well as the various art movements which followed, was the key factor behind the eclipse of this distinctive manner of painting. Certainly when we recall George Inness's words on landscape-painting, we can see that the work of the Philadelphian *trompe l'oeil* artists was considered to be totally at variance with what was then accepted as 'new'. Inness said, we remember: 'In art–true art–we are not seeking to deceive. We do not pretend that this is a real tree, a real river . . .' The Philadelphians, of course, took exactly the opposite view–they were 'seeking to deceive'. Indeed Raphaelle Peale referred to his *trompe l'oeil* compositions as 'deceptions', and the mark of a picture's success was the degree to which the beholder could be fooled into believing that he was not looking at a painting, but at an actual arrangement of objects.

The ability of a painting to deceive the beholder is, of course, one of the most traditionally accepted signs of excellence. In the foreword to *The Reality of Appearance* exhibition catalogue, a show held at four major American museums in 1970, Frankenstein quotes a well-known story from Pliny's *Natural History* concerning a painting competition held in Athens in the fifth century B.C.: 'Parrhasios, it is recorded, entered into a competition with Zeuxis, who produced a picture of grapes so successfully represented that birds flew up . . . whereupon Parrhasios himself produced such a realistic picture of a curtain that Zeuxis, proud of the verdict of the birds, requested that the curtain should now be drawn

and the picture displayed; and when he realised his mistake, with a modesty that did him honour, he yielded up the prize saying that whereas he had deceived birds, Parrhasios had deceived him an artist.'

This story is one of the earliest in the literature of *trompe l'oeil* painting, but we note that these were not artists working within a small specialised genre; they were the greatest painters of their day, and were considered so just because of their ability to paint illusionistically. The number of painters who experimented with optical devices, from Leonardo to the 17th-century Dutch painters, the 18th-century Italian *vedutisti* and the mid 19th-century landscape-painters, culminating in the great interest shown by painters in the invention of photography, is testimony to this interest in realism throughout the history of painting in modern times. The *trompe l'oeil* painters took the matter a stage further. They did not want the audience to say, 'This looks like a bowl of flowers'; rather the hoped for reaction was, 'This *is* a bowl of flowers'.

The interest in illusionistic still-life in America dates back to the beginning of the 19th century. As we have noted before, the first Columbianum exhibition, held in Philadelphia in 1795, contained Charles Willson Peale's *Staircase Group*, which although not a still-life, was certainly an extremely successful attempt at *trompe l'oeil*. The catalogue of the exhibition lists a number of still-lifes by other leading painters, including a group by John Singleton Copley. Copley himself was concerned with the problem of tangible reality and his American portraits, most notably that of Mrs Ezekiel Goldthwait, with its minutely detailed and intricately painted surface giving a satisfactory illusion of the three-dimensional world, may be considered direct ancestors to the American *trompe l'oeil* tradition.

We remember also how Charles Willson's son Raphaelle continued the illusionistic mode in Philadelphia with his *After the Bath* of 1823, again not a still-life but a painting intended to deceive. Even before this time, however, Raphaelle had produced *trompe l'oeil* pictures of old labels, tickets and miscellaneous pieces of paper (a pen and ink drawing tentatively dated to 1802 exists, entitled

102 *After the Hunt*
1885
William Harnett 1848–92
oil on canvas, 71 × 48 in
California Palace of the Legion of Honor (Gift of H. K. S. Williams to the Mildred Anna Williams Collection)

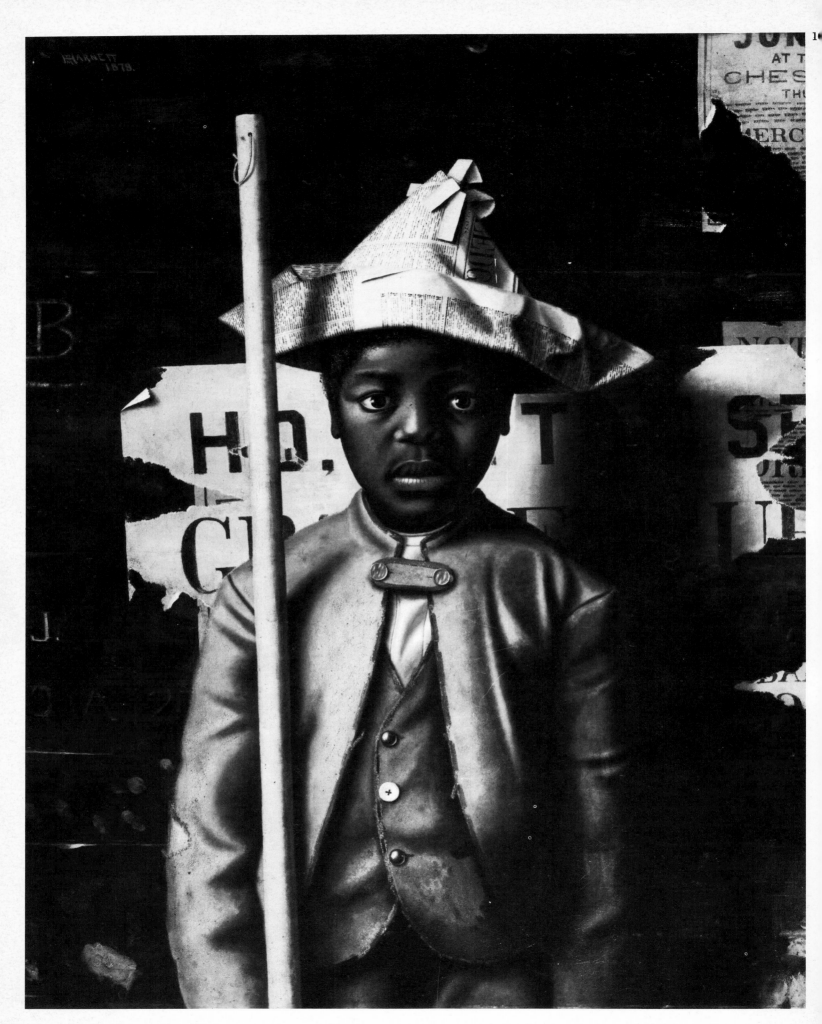

A Deception) which were the direct predecessors of the so-called rack pictures, in which Harnett and Peto specialised at the end of the century. Rubens Peale also began painting still-lifes towards the end of his life, although his work is not *trompe l'oeil* but is close to the jewel-like flower pieces of the 16th and 17th-century Flemish painters such as Ambrosius Bosschaert and Jan Breughel the Elder. Although there is no significance in it, it is interesting to note that Rubens Peale died in 1865, the year in which Harnett took up his apprenticeship as an engraver in Philadelphia.

Charles Bird King (1785–1862) was, as we shall see in the next chapter, an important painter of Indian portraits, but he also has an important

place in the history of American *trompe l'oeil* painting. In 1806, he executed a composition of dead birds, probably the earliest of its kind executed by an American artist, although a subject which, in Dr Frankenstein's words, was 'ultimately to become so excessively common as to constitute a public nuisance'. This painting, in a private collection, certainly could not be described as illusionistic, and, painted as it was in England, is close to the dead-bird pictures of 17th-century Flemish painters such as Jan Weenix and Frans Snyders.

In about 1815, probably when he was living in Philadelphia, King painted a far more illusionistic piece, depicting a dirty, unkempt cabinet filled with old books and various items of bric-a-brac. Given the

103 *Attention Company!*
(Front Face)
1878
William Harnett 1814–92
oil on canvas, 36 × 28 in

104 *The Vanity of an
Artist's Dream*
1830
Charles Bird King
1785–1862
oil on canvas, 36 × 30 in
Fogg Art Museum,
Cambridge, Massachusetts
(Gift of Grenville L.
Winthrop Esq.)

105 *Still-life with Three Castles Tobacco, Number 2*
1880
William Harnett 1814–92
oil on canvas, 11¾ × 16¾ in

106 *The Richmond Still-life*
1885
William Harnett 1848–92
oil on canvas, 13 × 10 in

didactic title of *The Vanity of an Artist's Dream*, this picture, in the Fogg Art Museum, Cambridge, Massachusetts, is again the direct forerunner of those studies of worn-out, useless and discarded objects which Harnett, Peto and Haberle executed with such care, and which Peto especially imbued with such a strong sense of pathos.

William Michael Harnett was born at Clonakilty, Ireland, in 1848, and emigrated to America with his parents the following year; the family settled in Philadelphia, and at the age of seventeen he was apprenticed to an engraver. For the next ten years he engraved silver and one bronze medallion of the head of Dante survives from this period. Dating from 1873, the year in which he began to paint, this small relief, 2½ inches in diameter, shows all the meticulous care and attention to detail which was to be the hallmark of Harnett's art in later years. In this same year, he produced a watercolour, the subject again being Dante; the handling of the perspective – the way the books the poet is reading appear to jut out of the picture – already shows a great interest in *trompe l'oeil*.

Between 1874 and 1880, when he left for Europe, Harnett produced his first major series of oil still-lifes, including several examples of that particular still-life genre which he introduced into America,

the stoneware jug, pipe and newspaper. There are also several still-lifes of old books, possibly based upon the Charles Bird King example discussed above. All of these pictures are painted in a clear, precise style, with great emphasis given to surface textures, especially those of the jugs. Although painted with great exactitude, however, the intention does not yet seem to be to deceive; we are not fooled into believing that we are looking at something other than a painting.

Between 1880 and 1886 Harnett lived abroad, mainly in Munich but also in Paris and London, where he exhibited at the Royal Academy. In Munich Harnett met with a mixed reception. In a newspaper interview given in America after his return, he said:

'During the four years I lived in Munich, I did very well, comparatively speaking. I sold pictures to American travellers; Germans, Frenchmen and even Englishmen were numbered amongst the purchasers. In 1884, I determined to test the merits of my work . . . Some of the Munich professors and students had criticised me severely, and I wanted to refer the question of my ability as a painter to a higher court. Accordingly I went to Paris and spent three months painting one picture.'

This one picture was the fourth and largest version of the subject considered to be the artist's masterpiece, *After the Hunt*. Each of the four pictures shows dead game and hunting equipment–knife, gun, stick, hat, game bag, horn–somewhat precariously hung on nails on the back of an old, iron-hinged door. The idea for the composition was derived from a remarkable series of photographs by the Alsatian photographer Adolphe Braun, taken in about 1860, which have all the items included in the first Harnett versions. These first two examples were painted in 1883 (private collection and Gallery of Fine Arts, Columbus, Ohio); the third version, executed in 1884 (Butler Institute of American Art, Youngstown, Ohio), is larger and more ambitious, whilst the fourth Paris version of 1885 (California Palace of the Legion of Honor, San Francisco), is the final amazing culmination of the theme. In a canvas nearly six-foot high, in other words life-size, Harnett painted a still-life which is one of the most perfect *trompe l'oeils* in the history of art. The painting was brought back to America by the artist, and it is probably true to say that the majority of important still-life painters who worked in America in the next few years painted a version of it.

At the same time as he was working in Paris, Harnett sent a number of detailed still-lifes to London, one of which, depicting a favourite subject of the artist–sheet music, a vase, books, a brass lamp, and a flute on a cupboard top–was purchased by George Richardson R.A. at the Royal Academy in 1885 and which, after years in limbo, has recently come to light in England. When it was exhibited, *The Times* critic referred to it as 'one of the most miraculous representations we have ever seen'. These rich, crowded compositions may owe something to those still-lifes of musical instruments by the 17th-century Italians Evaristo Baschenis and Bartolomeo Bettera, which Harnett could have seen during his European travels.

The compositional qualities of his still-lifes most concerned Harnett after he returned to America in 1886 and settled in New York. He painted a number of superb *trompe l'oeils* from this time on, which have as their theme an object–horseshoe, musical instrument, Colt revolver, letters–nailed or tacked to the back of a door or board. He painted two rack pictures similar to the one painted by Raphaelle Peale earlier in the century, and to those painted by a number of European artists in the 17th and 18th centuries, notably the Dutchman Evert Colyer. One of the most famous of Harnett's rack pictures is the recently discovered *Mr Huling's Rack Picture*, painted in 1888. Until Dr Frankenstein's researches showed it to be by Peto, another rack picture in the Metropolitan Museum of Art, New York, with a forged Harnett signature and a faked inscription on one of the envelopes, had been thought to be the actual Harnett painting, the existence of which was then known only from contemporary newspaper reports. The Harnett painting was not discovered until 1970.

Harnett lived only six more years after his return to America but, apart from the *After the Hunt* series and some of the pre-Europe 'pipe' still-lifes, the last years of his life were the most creative. He had perfected his illusionistic techniques over a long period and the work of the late 1880s and 1890s is amongst the finest of its type ever painted. One of his last masterpieces, *The Faithful Colt* of 1890 (Wadsworth Atheneum, Hartford, Connecticut), depicting a Colt 45 hanging from a nail, was one of the chief causes why Harnett, and indeed the whole American *trompe l'oeil* movement, after years of obscurity, was discovered in the middle years of this century. This particular painting was purchased by the Downtown Gallery in New York in 1935 and, in Dr Frankenstein's words, 'Mrs Halpert realized ... that a man who painted that well didn't paint only one picture. She decided to investigate, and ...'

John Frederick Peto was born in Philadelphia in

107 *Lincoln and the Star of David*
1904
John Frederick Peto
1854–1907
oil on canvas, 20 × 14 in

108 *Japanese Doll*
about 1889
John Haberle 1856–1933
oil on canvas, 15 × 6½ in

109 *Old Companions*
John F. Peto 1854–1907
oil on canvas, 22 × 31 in

1845 and met Harnett when they were both studying at the Pennsylvania Academy of Fine Arts. They were obviously sympathetic to each other's work, and Peto adopted a number of Harnett's motifs, the 'pipe' still-life, piles of old books, and the rack picture, the latter becoming one of his favourite

compositions. The most famous painting of this last-named type is *Old Time Letter Rack* of 1894 in the Museum of Modern Art, New York; this picture is the one I mentioned above as having at one time received a number of fake inscriptions so as to make it look like a long-lost Harnett. In 1948,

Peto's style differs from Harnett's in a number of ways, the most significant being its far more delicate and soft outlining. Unlike Harnett's work, Peto's is rarely illusionistic–he was not in other words a true *trompe l'oeil* painter–and his work is often imbued with a strong sense of pathos. Whilst not so technically gifted as Harnett, Peto is perhaps the finer artist of the two. His work has that element which Harnett's so consistently lacks–an emotional commitment which gives it a more moving, personal quality than the older painter's often mechanical excercises.

Peto then was a far more idiosyncratic painter, and his last years, from 1887 to 1907, were spent in hermetic solitude (similar to Ryder, the emotionality of whose work may be compared to that of Peto) at Island Heights. After his death, his eclipse was absolute and much of his best work was adorned with fake Harnett signatures to give it at least a small measure of commercial viability. So often did this happen that Peto's reputation, not to mention his signature, was completely hidden behind that of Harnett, and it took the splendid detective work of Alfred Frankenstein to rediscover him; the full story of that amazing visit to Peto's studio in 1947, still lived in by the artist's daughter, is graphically described in his monograph *After the Hunt*. There, a large collection of paintings, plus the models used in them, proved beyond doubt that many of the so-called Harnetts in some of America's leading museums and private collections were not in fact by Harnett at all.

The third of the great late 19th-century still-life painters was John Haberle. He was not from Philadelphia but from New Haven, where he lived all his life (he was born in 1858 and died in 1933). Of the three, Haberle was perhaps the most consistently involved in the *trompe l'oeil* technique. It could be said that there is something extremely eccentric about the whole idea of *trompe l'oeil*, something fey and rather humorous; certainly Haberle's work lives up to this interpretation. Many of his paintings are of two-dimensional objects (he specialised in the depiction of bank notes) since a painting, by its physical nature, can best hope to create an illusion of reality if it depicts things which are two-dimensional themselves. And yet he could produce that extraordinary work *Grandma's Hearthstone* of 1890 (Detroit Institute of Arts), the largest *trompe l'oeil* still-life ever painted in America, in which a whole fireplace and its cluttered overmantel is portrayed, or that bizarre eccentricity, *Night* of 1909, possibly a mocking dig at the artist's own diminishing eyesight. Of this painting Frankenstein writes:

'One of Haberle's best inventions is the use of paintings which are not in the *trompe l'oeil* style as *trompe l'oeil* objects in *trompe l'oeil* settings. Here he carries the diabolical paradox one step further to its grand finale . . . the trick is to make you think, on encountering the picture for the first time, that it has not been completed. Then you suddenly realise that this is not the case at all; it is a completely finished picture of an

however, Dr Frankenstein, in a brilliant stylistic analysis, demonstrated that it could not be by Harnett, and this was born out by the discovery of an overpainted signature and, in 1967, by the finding of an inscription at the back of the original canvas, which had been covered by re-lining.

110 *Ten Pound Note*
1898
Victor Dubreuil
Oil on canvas, 10 × 11¾ in

unfinished picture. The *oeil* has been *trompe'd* twice in a row.'

The subject of *Night* is an unfinished painting of a nude woman in Art Nouveau taste, set into vulgar marble panels, in front of which hangs a lamp and a superbly painted velvet curtain (the idea of a *trompe l'oeil* curtain 'hiding' part of an otherwise normal painting goes back at least to 17th-century Holland – Rembrandt and Nicolaes Maes used it, amongst others). Haberle's is a truly 'diabolical' painting, full of impish wit, and must rank with *After the Hunt* as one of the greatest of all 'deceptions'.

A number of minor figures produced good *trompe l'oeils* towards the end of the 19th century and the beginning of the 20th. The peripatetic Richard La Barre Goodwin (1840–1910) painted several *After the Hunt* type compositions, including a famous example entitled *Theodore Roosevelt's Cabin Door* 1905 (private collection), which are all obviously based upon Harnett's work. Goodwin's paintings depict far more modern equipment than Harnett's and he is probably the finest of the latter's numerous followers.

Other such painters, many of whom, like Goodwin, copied the Harnettian *After the Hunt* motif, include the Bostonian Alexander Pope (1849–1924); William Keane of whose life we have no details, but who painted one fine parody of *After the Hunt* entitled *Still-life with Banjo* (California Palace of the Legion of Honor, San Francisco); Claude Raguet Hirst (1855–1942), a late watercolourist who lived next door to Harnett in New York between 1886 and 1889, and who painted technically accomplished but highly derivative table-top still-lifes of pipes and books; Victor Dubreuil whose dates are unknown and who specialised in painting money in every conceivable form (in 1900 he even painted a *trompe l'oeil* canvas of it being stolen, entitled *Don't make a move!*); and Jefferson David Chalfont (1856–1931) from Wilmington, Delaware, who executed beautiful *trompe l'oeils* usually of one object – a gun or a violin – hanging on the back of a door. Many of these artists painted individual minor masterpieces which have rescued their names from obscurity, and all of them were part of a strong tradition of illusionistic painting in America which continues to our own day.

110

The art of the West

The American Indian is indigenous to the country; it is not surprising, therefore, that he should have exerted a particular influence over the consciousness of American settlers and that they should have regarded him with a peculiar mixture of chauvinistic pride in that he was an inseparable part of that country which its immigrant population rapidly came to see as the greatest on earth, and hatred and fear because he did not appear to appreciate the superiority of the white race, was not prepared to yield up his land like the child so many white Americans considered him to be, and in many cases had the effrontery actually to resent the white man's presence and to resist him by force of arms.

Every schoolboy in the Western world knows the names of the great Indian tribes–the Commanche, Sioux, Apache and many others–whilst certain chiefs, Sitting Bull, Crazy Horse, Geronimo, Chief Joseph, have become equally famous universally. In point of fact, until comparatively recently, the true history of what happened on the Western plains of America has hardly been known. Such recent literary works as *Little Big Man, Bury My Heart at Wounded Knee* and films like *Soldier Blue* came as shocking revelations to people who had come to believe that the Indian was a ferocious, dishonest, filthy savage, against whom the gallant U.S. Cavalry strove valiantly to win God's country for God's people. Only now can we begin to see the incredible extent of the humiliation and slaughter committed against both human and animal life by the Western 'Pioneers'.

There can be distinguished three varying attitudes towards the Indian on the part of artists active in America during the 19th century and earlier. The first and prime interest is what could be described as the ethnographic. From what may be the earliest painting depicting the Indians, Jacques Le Moyne's *Florida Indians Panning for Gold*, the earliest views of the native tribes were concerned with describing their appearances, customs, and ways of life. This attitude colours the work of the mid 19th-century artists George Catlin, Alfred Jacob Miller, Charles Bodmer and many other artist-illustrators who joined the numerous exploratory expeditions to record officially the sights seen along the way.

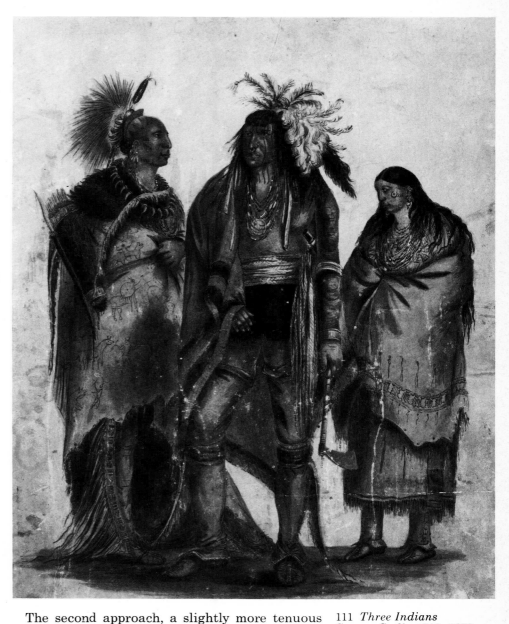

The second approach, a slightly more tenuous one, may be described as the effect upon the painter of Jean-Jacques Rousseau's philosophical theory of the 'Noble Savage', with whom the Indian became identified. This is exemplified by George Catlin's account of how he, a young portrait-painter from Philadelphia, witnessed the visit of some Indians who were passing through on their

111 *Three Indians*
George Catlin 1796–1872
watercolour, 15¼ × 12 in

112 *Death of a Gambler*
1904
Charles Marion Russell
1864–1926
oil on canvas, 24 × 36 in

113 *Portrait of Mia-hu of the Amuripa Tribe* George Catlin 1796–1872 watercolour, 3½ × 3 in

way to Washington and how he was overcome by their dignity and nobility. On the spot, apparently, he decided that, 'The history and customs of such a people, preserved by pictorial illustrations, are themes worthy of the ability of one man, and nothing short of the loss of my life shall prevent me from visiting their country, and becoming their historian.'

At this point, Catlin's roles as portrayer of the 'Noble Savage' and as ethnographical illustrator merge, possibly because he was not a good enough artist to be much more than an illustrator. His sketches are lively, on-the-spot observations; he was involved intimately with what he saw, and dedicated himself to his task. He left St Louis in 1832 to spend eight years amongst the tribes of the western Mississipi river. He was a prolific artist, some six hundred sketches being preserved in the Smithsonian Institution alone, whilst innumerable watercolours are scattered amongst museums and collectors in the United States and Europe. His great book, *Letters and Notes on the Manners, Customs, and Conditions of the North American Indians*, published in New York in 1841, is a lasting monument to his achievement as one of the earliest and most informative specialists on the Indian way of life. And yet, despite all this, he was a painter of extremely limited ability who, were it not for his

interest in Indians, would have become, by the time he died in 1872, a minor portrait-painter amongst many. This lack of talent in Catlin is mirrored by many of the other painters who specialised in the American West, and leads one to the regrettable conclusion that, of all the truly great works of art to come out of the area, the majority are by the Indians themselves.

The third attitude to the West may be described as the romantic. It was this attitude, dominant towards the end of the 19th century and the begin-

114

ning of the 20th, which produced the most famous Western, or 'Cowboy' artists, and which was responsible for the best-known images of Western life. It was also, perhaps, partly to blame for the myth, described earlier, of 'How the West was won'.

Whilst the most important painters of this time, Frederick Remington and Charles Marion Russell, were certainly sympathetic towards the Indians, their paintings, at least those of Russell, make little attempt to depict history. They are technically accurate, but sensational, scenes of cowboys and

Indians, gamblers, gunfighters, saloons and all the paraphernalia of the Hollywood Western. Russell was without doubt a painter of panache who could imbue his oils and watercolours with a driving sense of excitement, which more than compensates for his poor colour sense. Yet one is consistently left with the disturbing impression that one is looking at a still from a rather melodramatic movie.

Born in 1864 in St Louis, Missouri, Russell spent his early years as a ranch hand in Montana and it was at this time that he first began painting

114 *Coming to the Call*
about 1904
Frederick Remington
1861–1909
oil on canvas, $27\frac{1}{4} \times 40\frac{1}{4}$ in

115 *Nesquaquoit (Bear in the Fork of a Tree)*
about 1830
Charles Bird King
1785–1862
oil on canvas, $35\frac{1}{2} \times 29\frac{1}{2}$ in

116 *Wabaunsee (Causer of Paleness)*
1835
Charles Bird King
1785–1862
oil on canvas, $17\frac{1}{2} \times 13\frac{3}{4}$ in

scenes of Western life. He was an extremely prolific painter, intuitive and self-taught. By European standards and by those of the cultured East Coast, he was not a technically accomplished painter but his best canvases are touched with a sense of excitement which it is difficult to ignore. It is his work, signed with his famous symbol of a buffalo skull, which typifies for many people 'the art of the West'. It should be noted that many of his most famous works were originally conceived as illustrations to magazine stories and books, some of them of his own writing. Thus, like the majority of Western artists of this period, and indeed like so many before, Russell was primarily an illustrator, a fact which is responsible for the qualities of excite-

ment in his work which we admire, and those of crude colour and sensationalism which spoil them. He died in Montana in 1926.

Frederick Remington, born in Canton, New York, in 1861, had formal training at the Yale School of Art and at the Art Students' League before, for health reasons, he went West. Like Russell, he too was primarily an illustrator, working for many magazines such as *Harper's Weekly* and *Outing*; many of his pictures for this reason are *en grisaille*. With Remington, however, we are discussing an artist of real quality, who was capable, on occasion, of achieving haunting images of obvious greatness.

He had an unusual approach to colour; he used it

116

extremely successfully to set a mood, to strike an atmospheric note. Applying paint richly and roughly, he often chose a single dominant colour, around which the rest of the picture was composed. In that weird picture called *Coming to the Call* of about 1904 (private collection), almost abstract in its formal severity, he used a brilliant orange-yellow which suffuses the whole canvas with a powerful glare, blurring the edges of the image so that it is difficult to be immediately aware of what is actually being shown. It is such paintings as this, as well as the powerful series of twenty-four bronzes executed during the last twenty years of his life, which raise Remington to a position of real significance in the history of 19th-century American painting. He died in 1909, having produced nearly three thousand paintings.

The first half of the century produced many artists who, moved by the exploratory spirit or a sense of wonderment at the Indian, attempted to delineate his way of life. James Otto Lewis joined the expedition to the confluence of the Mississipi and Missouri rivers as the government artist in 1825, and ten years later published his

117 *Assiniboin Camp*
about 1852
John Mix Stanley 1814–72
oil on canvas, $8 \times 10\frac{1}{4}$ in

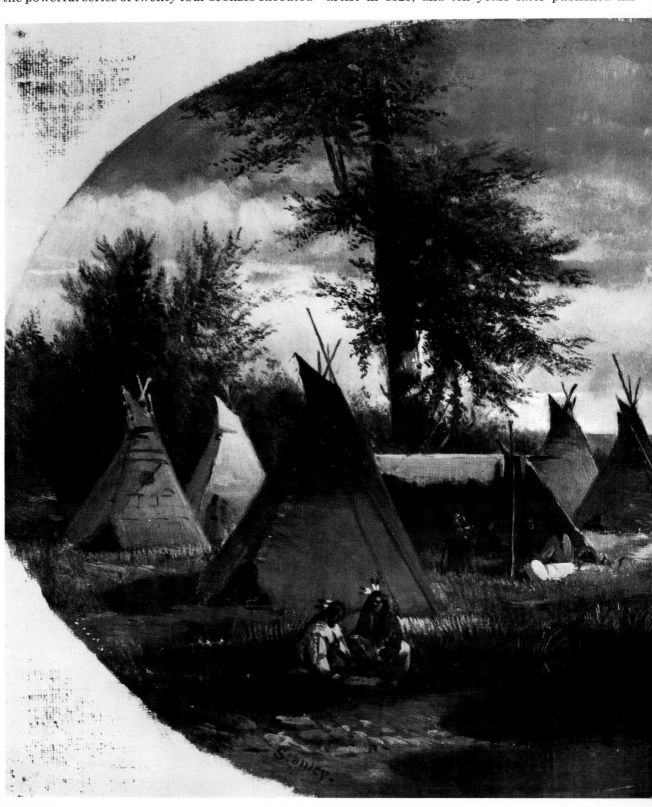

Aboriginal Portfolio. Charles Bodmer was responsible for the drawings after which were produced the lithographic illustrations of Prince Maximilien of Wied's account of his expedition up the Missouri river in 1833. This was originally published in Germany under the title *Reise in das innere Nord-Amerika in den Jahren 1832 bis 1834.*

Between 1836 and 1844 was produced the classic work on the subject of the American Indian and one of the great colour-plate books of the 19th century, McKenney and Hall's *History of the Indian Tribes of North America*, published in three

folio volumes. This work contained 120 portraits by, amongst others, James Otto Lewis, Charles Bird King, and Henry Inman. All but twelve of the originals for these plates were destroyed with the works of many other artists concerned with western America, including the almost complete *oeuvre* of John Mix Stanley, in the great fire at the Smithsonian Institution in 1865.

One of the joint authors of this work, Thomas L. McKenney, was first Superintendent of the Indian Trade Office and later founder of the Bureau of Indian Affairs. Sympathetic to the tribal way of life, he was moved to undertake this monumental project in part out of his prophetic certainty that within a few years the Indian as a free inhabitant of the great plains of America would no longer exist.

By the time McKenney and Hall commissioned the most important painter involved with the creation of the National Indian Portrait Gallery, Charles Bird King, to commence work in 1821, the Atlantic coast tribes were already suffering from the depredations of land-grabbing traders, the western expansion, and the social chaos brought about by the introduction of guns, whisky and European diseases against which they had no immunity. The initial impetus towards the creation of a gallery of Indian portraits was provided by the visit of a delegation of sixteen tribal chiefs to President James Munroe in 1821, the same delegation which had so impressed George Catlin, and by 1858, 147 portraits, mostly by King, had been completed, a unique historical record of a great culture. Together with two hundred works by Stanley of Indian subjects, these paintings, like the people portrayed, were soon to be almost completely destroyed. Luckily Inman made a complete set of copies, whilst King made several replicas of his Indian portraits, the most important group of which, twenty-one works which he presented to the Redwood Library of Newport, Rhode Island, was dispersed by public auction in 1970.

King himself was born in Newport in 1785. He received tuition in painting from Samuel King, who also taught Gilbert Stuart and Washington Allston; Charles Bird King subsequently studied with Benjamin West in London. On his return to America in 1812, he settled initially in Philadelphia and then in Washington, where he was based for the rest of his life; he died in 1862.

He was, therefore, a well-trained and capable painter. Certainly he had learned Neo-classical ideals from West and it is in King's work that the beauty and nobility of the Indian is best described. It could not be said that he was either a draughtsman or colourist of outstanding ability, but in his Indian portraits he excelled himself. It appeared to many of his contemporaries, as it appears to us now, that he had managed to capture those qualities in the Indians which so impressed all who saw them at that time. In the surviving examples of his work, we can see that not only did King produce an enduring historic record but also a significant addition to the art and ideals of Neo-classicism.

John Mix Stanley, who has been mentioned be-

118 *A Dangerous Trail*
Henry F. Farny
watercolour, 8 × 13 in

fore in connection with the Smithsonian fire of 1865, was born in New York in 1814. A landscape and portrait-painter, his first contact with the Indians came in 1842 when he visited the Cherokee capital of Tahlequah. Three years later he joined a wagon train bound for Santa Fe and subsequently travelled to San Diego, California, as an artist on the staff of Colonel Stephen Kearny. For the next seven years he led a peripatetic existence in what are now the western states of America. As an artist, he was essentially a Romantic; his paintings have neither the ethnographic accuracy of Catlin's work nor the noble idealism of King's. But he was what so many Western artists were not, a true painter, who brought a sympathetic view of life and landscape to his portrayal of picturesque scenes and events. The destruction of the majority of his paintings is a great loss to our knowledge of 19th-century American art.

In addition to Catlin, King and Stanley, the fourth important 'Indian' artist of this period was Alfred Jacob Miller. Like Catlin, he was primarily a recorder, and his works have perhaps more interest for the ethnographer and social historian than for the student of art history.

Born in Baltimore in 1810, Miller received

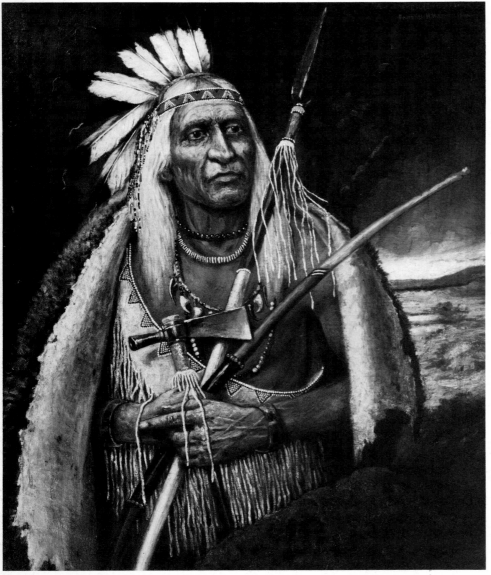

119 *A.e.che.ga (Intrest)*
Sioux
1862
Henry Cross
oil on canvas, 36 × 29 in

formal training under Thomas Sully and was subsequently a student at the Ecole des Beaux Arts in Paris. The Romantic Movement was then in full swing in Europe and Miller would certainly have known and admired the works of Delacroix, Chassériau and Horace Vernet. After leaving Paris, he settled in Switzerland and Rome, and returned to America in about 1834. It is a matter of regret that the man who was unquestionably the best-trained and experienced painter ever to devote himself to depicting the American Indian should have been invested with such a small measure of natural talent. In 1837, Miller joined the expedition of Captain William Drummond Stewart, a thirty-seven-year-old member of the Scottish aristocracy, to the Rocky Mountains. Stewart, a born adventurer, had not only fought at the Battle of Waterloo, but, after his first expedition with the American Fur Trading Company in 1833, was to make six more annual expeditions to the Rockies, then a little-known and extremely dangerous area.

Miller's numerous sketches of the 1837 expedition, and the subsequent paintings based upon them which he continued to produce with decreasing artistic success until his death in 1874, are amongst the most famous and significant documentary paintings by an American artist. Although Catlin and Bodmer had travelled and sketched west of the Mississippi, Miller was the first painter to visit the Rockies, that rich source of imagery for subsequent generations of American painters. The sketches made en route, and the series of large paintings executed for Stewart around 1840 (the year in which the artist visited his patron in Scotland), have a delicate, romantic colour sense and a spontaneity lacking in his later, commercial, stereotyped productions. It is on these first excited and vivid glimpses of a new land that Miller's reputation rests.

Apart from Remington and Russell later in the century, there were a few other artists of the American West who brought individuality and verve to their work. Of these Henry F. Farny (1847–1916), Charles Schreyvogel (1861–1912), Joseph Henry Sharp (1859–1953), and William Robinson Leigh (1866–1955) are the most outstanding. In addition, Newell Convers Wyeth (1882–1945), father of Andrew Wyeth, whilst not devoting himself entirely to Western themes like the other artists mentioned here, did execute many extremely fine studies of Indians and a famous painting of Frank and Jessie James and their gang (Thomas Gilcrease Institute, Tulsa, Oklahoma).

The art of Schreyvogel, with its vivid, rich colours and restless melodrama, is typical of a man who had studied in Munich. Capable of fine compositions, it is the heavy-handed lack of subtlety (added to an often gruesome colour sense) which spoils so many of his large, pot-boiling, canvases. He is seen at his best in works such as *Custer's Demand* of 1903 in the Thomas Gilcrease Institute, although he was attacked by Remington for the painting's lack of accurate detail. This quibble, which was neatly brought to an end by Custer's

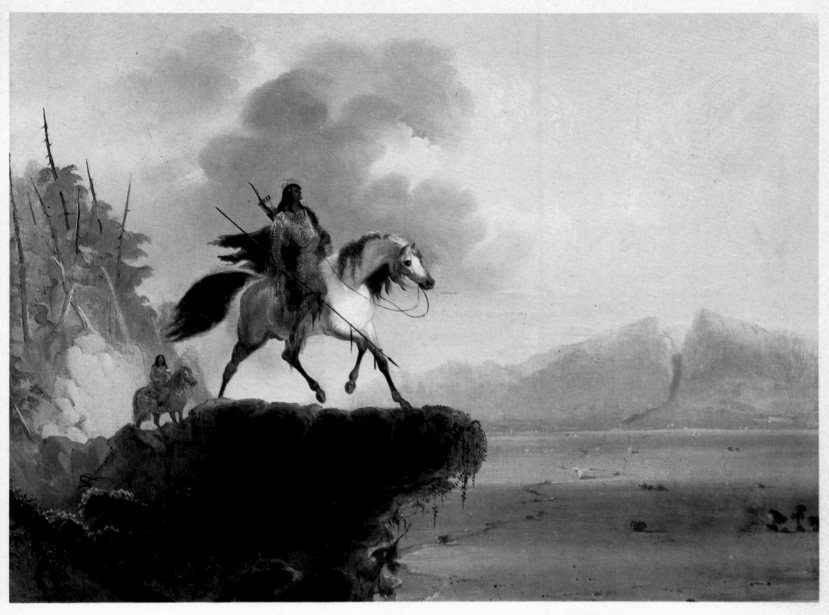

120 *Snake Indians*
Alfred Jacob Miller 1810–74
oil on canvas, 17 × 23 in

121 *Indians Tantalising a Wounded Buffalo*
1837
Alfred Jacob Miller 1810–74
watercolour, 8 × 12½ in

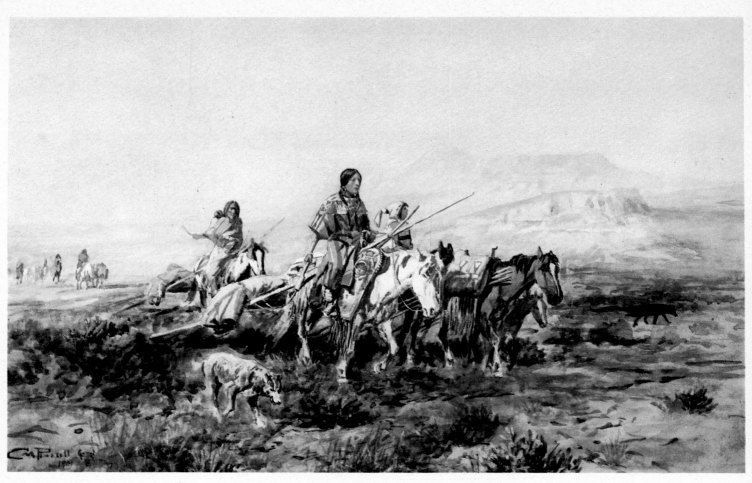

122 *When the Trail Was Long
and Hard between Camps*
1901
Charles Marion Russell
watercolour and gouache,
11½ × 17½ in

123 *Cowboy Fun in
Old Mexico*
Frederick Remington
1861–1909
oil on board, 18 × 18 in

124 *The Lost Dispatches*
1909
Charles Schreyvogel
1861–1912
oil on canvas, 25 × 34 in

aide Colonel Crosby who, when asked his opinion, replied, 'Neither Mr Remington nor Mr Schrey-vogel was there, and I have forgotten', is a typical symptom of many Western artists' approach to their work; they seemed to imagine that as long as they recorded in accurate and minute detail what they saw in front of them, they were of necessity producing great works of art, which, unfortunately, they seldom were.

Perhaps the finest of the late painters of the West, artists who were by then history painters recording scenes and events long since passed, was the much-underrated William Robinson Leigh. Like Schreyvogel, he had been trained in Munich and he too suffered from a crude colour sense. It is in his studies and sketches, especially the studies of animals which show him to be a sensitive,

accurate draughtsman, that he is at his best, rather than in his finished pictures. In such works he could avoid the dilemma of a magazine illustrator which plagued so many Western artists, a dilemma of which Leigh was aware when he wrote in his autobiographical book *My America*: 'At all costs I had hoped to avoid illustrating, yet it seems as if I were doomed to do it.'

In the end, however, we have much for which to thank these artists. At the close of the 19th century, many of the illustrators were aware that they were witnessing the end of a great primitive culture, the death of a people and their way of life. Because of this, they endeavoured to capture as accurately as possible the details of what was vanishing; and some of them were capable of endowing such scenes with great passion and love.

Impressionism in America

The period between 1850 and 1900 produced some of America's greatest artists. Since Copley, West and Stuart had made such a bold impact upon the European public in the early years of the century, American painting had become more parochial. At first the new republic produced no painters who were capable of shaking the art Establishment of the Old World, or at least none who wanted to try.

In the second half of the century, however, there flourished two painters who were, in time, to capture the imagination of the Western world—James Abbott McNeill Whistler and John Singer Sargent; one other who, alone amongst American painters, was to establish an international reputation as an Impressionist—Mary Cassatt; and a group of what one might describe as 'domestic' painters who were, unlike the artists mentioned above, concerned with portraying the American scene and who are now recognised as great masters of American painting—Thomas Eakins, Winslow Homer and George Inness.

The true Impressionism of the great French painters of the 1870s did not have much direct effect upon American art. Four Americans—John Twachtman, Childe Hassam, Ernest Lawson and Theodore Robinson—were obviously closely involved with French Impressionism (indeed Robinson was Monet's only official pupil), but even their

125 *Old Kentucky Home;*
Life in the South
1859
Eastman Johnson 1824–1906
oil on canvas, 36 × 45 in
New York Historical
Society, New York City

126 *Rustic Fiddler
with Little Girl*
1868
Eastman Johnson
1824–1906
oil on canvas, 15½ × 13 in

work is not properly Impressionist; they could approximate the appearance without much interest in how the appearance was attained. In his essay on John Twachtman published in 1921, Eliot Clark wrote perceptively that the artist was 'susceptible to the colourful innovations of the Impressionists and their technical expression, but he was not interested in the science of colour, and did not cultivate the optical illusion of light attempted by the juxtaposition of complementary contrasts . . .' Indeed it could be said that not until the 20th century, with the work of Henri, Glackens, Sloane and, above all, Prendergast, were the lessons of

French Impressionism and Post-Impressionism properly understood in America.

Nevertheless, American painting from the 1860s onwards was increasingly dominated by European, especially French, modes. Just as the Barbizon painters in France led the way to the stylistic breakthrough achieved by Monet, Pissarro, Renoir, Sisley and Degas in the late 1860s and early 1870s, so it was the influence of Millet, Corot, Rousseau and Daubigny which had the earliest and most profound effect upon the American landscape-painters of the second half of the 19th century. One of the earliest and most influential disciples of

127 *The Wounded Drummer Boy*
about 1870
Eastman Johnson 1824–1906
oil on canvas, 46 × 37 in

the Barbizon school was William Morris Hunt (1824–79). On his return to Boston from France in 1855, he set about preaching the tonal doctrines of Corot, and was so successful that he changed the direction of East Coast art for many years to come.

We should also recall the words of George Inness: 'We do not pretend that this is a real tree, a real river, but we use this tree or this river as a means to giving you the feeling or impression that through them a certain effect is produced upon us.' Charles Caffin, in his book published in 1902, *American Masters of Painting*, quoted another remark in a similar vein by Inness, in which the artist described his work as attempting to 'collate the details and render them subordinate to a single powerful impression . . . the realization in each case of a mood of nature, powerfully felt'.

Inness and his followers were essentially closer to Barbizon painting, with its low-keyed palette and vague atmospheric style, than they were to the light-filled brilliance of French Impressionist canvases. But it was due no doubt to the zeal of Hunt, followed by Inness, that Paris in the second half of the 19th century came to be the goal for American artists which Rome had been earlier in the century, and London in the 18th century. The great teaching ateliers of Paris, the studios of Gérôme, Fortuny, Carolus-Duran, Cabanel, Bouguereau, and the atelier Julian run by the critics Boulanger and Lefebvre, were not only the nurseries of the Impressionists and Post-Impressionists, but also attracted many American painters including Eakins, L. C. Tiffany, Sargent, Theodore Robinson, John Twachtman, Childe Hassam, Gari Melchers, Thomas Hovenden and Thomas P. Anshutz. What

128 *New England Church*
1912
Ernest Lawson 1873–1939
oil on canvas, $25\frac{1}{4} \times 30\frac{1}{4}$ in

is surprising is that whilst they were in Paris during the most exciting and revolutionary period of French art, American painters in general were affected only superficially by what was happening all around them.

One painter, however, who spent only a short time in France was Winslow Homer, and he, ironically, is one of the few American artists who may be called an Impressionist. His was not the

weak French Impressionism twice removed of Robinson or Twachtman, but a powerful American Impressionism of great beauty, an art which is respected in the United States beyond almost all American painting produced before the Second World War. Whilst Whistler, Cassatt and Sargent established reputations abroad because they chose to live and work in Europe, Homer, who was greater than any of them, remained in America,

129

except for a short stay in France, a brief stay at, of all unlikely places, Tynemouth on the north-east coast of England, and periodic visits to Bermuda towards the end of his life.

Born in 1836, Homer became a freelance newspaper and magazine illustrator in New York at the age of twenty-three, working mainly for *Harper's Weekly*, and continued to produce illustrations for the press until the late 1870s. In 1862, during the Civil War, he produced his first oil studies. These, I feel, have been slightly overpraised by critics, but whilst they are crude and raw works compared to the artist's later masterpieces, they show, even at such an early stage in his career, that concern with light and contrasting areas of vivid sunlight and muted shadow which was to mark his work in the late 1860s, 1870s and 1880s.

In the period between 1865 and 1870, Homer painted his first great series. Even before his first visit to France between 1867 and 1868, he had already produced pictures which show that not only was he as keenly aware of the same problems of depicting the effects of light as the French Impressionists, but that he was approaching them from the same direction and with an equal skill. Not surprisingly, the results were very similar. We note with some surprise how close *Croquet Scene* of 1866 (Art Institute of Chicago) and *The Croquet Match* of 1868–69 (private collection) are to *Women in the Garden* of 1866–67 by Monet (Louvre, Paris) and the garden scenes of Bazille, or how the hard-edged translucency of *Long Branch, New Jersey* 1869 (Museum of Fine Arts, Boston) may be compared to the beach scenes executed by Monet and Boudin at exactly the same period. At this moment, but in two widely differing places, these men were seeking the same artistic truths. Although there is no evidence, it seems difficult to believe that Homer had not seen Monet's work

during his stay in France, so close are their styles at this time.

This concern with the dazzling brilliance of sunlight infused Homer's work until he left for England in 1881. In such works as *Snap of the Whip* of 1872 (Butler Institute of American Art, Youngerstown, Ohio) and more especially *Waiting for Dad* 1873 (Mellon Collection), Homer continued the Luminist tradition of the 1850s whilst looking forward to the 20th-century realist style of Hopper and Wyeth.

The period between 1881 and 1882, when Homer lived in the harsh, grey, fishing town of Tynemouth, saw a radical change in the mood and style of his paintings. His palette became more muted, coming close to the grey-filled canvases of the Dutch

129 *Long Branch, New Jersey*
1869
Winslow Homer 1836–1910
oil on canvas, 16 × 21¾ in
Courtesy Museum of Fine Arts, Boston
(Charles Henry Hayden Fund)

painters such as the contemporary artist Joseph Israels. Furthermore, the themes of his pictures became tragic and foreboding, almost pessimistic. When he returned to America he left New York and settled on the wild rocky Maine coast at Prout's Neck where, apart from his visits to Bermuda which resulted in some sparkling water-colours, he remained until his death in 1910. Works such as *Hark the Lark* of 1882 (Layton Art Gallery Collection, Milwaukee Art Center), and the powerful compositions of the 1880s such as *The Life Line* 1884 (Philadelphia Museum of Art) and *Eight Bells* 1886 (Addison Gallery of American Art, Phillips Academy, Andover, Massachusetts), show a concern with the harsher, more cruel side of life which was entirely lacking from his earlier

work (except, on a superficial level, in the Civil War paintings). His greatest paintings show scenes of man's struggle against the elements, as in *The Gulf Stream* of 1899 (Metropolitan Museum of Art, New York), where a man in a battered boat waits to be rescued from the destructive and overpowering sea.

Homer had no followers, he taught no-one and he influenced no painter directly. The opposite is true of his contemporary Thomas Eakins (1844–1916), the other great late 19th-century American master. Eakins was more cosmopolitan in outlook than Homer, more outgoing and more concerned with teaching. Homer essentially painted for himself (although he had a keen commercial sense), whilst Eakins devoted perhaps too much time

130 *The Gulf Stream* 1899
Winslow Homer 1836–1910
oil on canvas, 28 × 49 in
Metropolitan Museum of Art, New York
(Wolfe Fund, 1906)

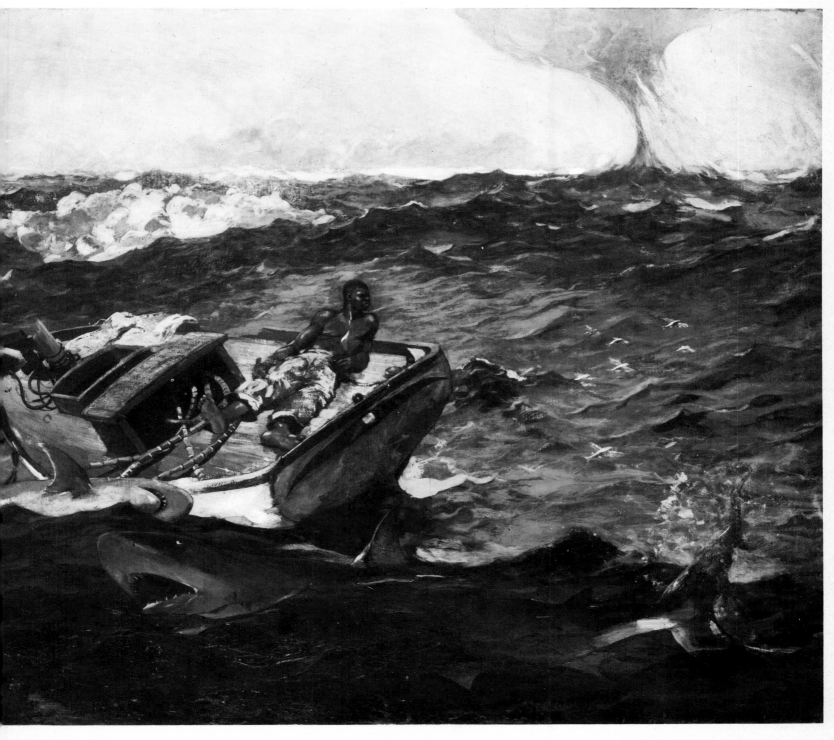

131 *Courtship*
about 1878
Thomas Eakins 1844–1916
oil on canvas, 20 × 24 in

132 *Starting Out After Rail*
1874
Thomas Eakins 1844–1916
oil on canvas, 24 × 20 in
Courtesy Museum of Fine
Arts, Boston
(Charles Henry Hayden
Fund)

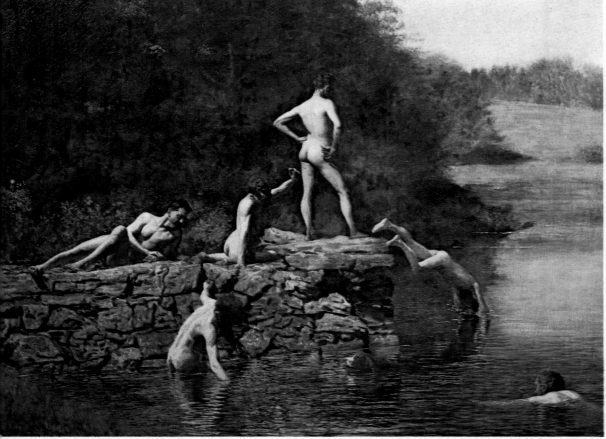

133 *Gallows Island, Bermuda*
about 1899–1901
Winslow Homer 1836–1910
watercolour, $13\frac{1}{2} \times 20\frac{1}{2}$ in

134 *The Swimming Hole*
1883
Thomas Eakins 1844–1916
oil on canvas, 27×36 in
Fort Worth Art Center
Museum

135 *Couch on the Porch*
1914
Childe Hassam 1859–1935
oil on canvas, $26\frac{1}{2} \times 32$ in

136 *Harmony in Grey and Green*
1873
James Abbott McNeill
Whistler 1834–1903
oil on canvas, 74 × 38 in
Tate Gallery, London

137 *The Fox Hunt*
1893
Winslow Homer 1836–1910
oil on canvas, 38 × 68 in
Pennsylvania Academy of
the Fine Arts, Philadelphia

138 *The Gross Clinic*
1875
Thomas Eakins 1844–1916
oil on canvas, 96 × 78 in
Jefferson Medical College of
Philadelphia

attempting to instil the new ideas of the French painters into an eager young generation of American artists, in the face of bitter Establishment opposition, which eventually contrived to wreck the artist's career. The struggle, however, was not wasted. Eakins numbered amongst his pupils one painter, Thomas Anshutz, who, whilst executing a single masterpiece, *Steelworkers at Noon* of about 1880 (private collection), found his true metier in teaching. From his classes sprang a generation of painters who were to change the direction of

American art in the first decades of the new century.

Born in Philadelphia in 1844, Eakins visited the Universal Exposition in Paris in 1867 and studied under two of the leading French Academicians at the time, Gérôme and Fortuny, between 1866 and 1870. He also spent six months in Spain, recovering from an illness, and the paintings he saw there by Velasquez and Ribera were to have profound effect upon his art.

Like Homer, Eakins came to maturity in the

139 *Cowboys in the
Bad Lands*
1888
Thomas Eakins 1844–1916
oil on canvas, 32 × 45 in

early 1870s, producing a series of magnificent boat-
ing pictures which, whilst following in the tradi-
tion of American Luminism, have a broad, dashing
approach which demonstrates the presence of a
unique individual. Pictures like *Max Schmitt in a
Double Scull* 1871 (Metropolitan Museum of Art,
New York), *Starting Out After Rail* 1874 (Museum
of Fine Arts, Boston) or the watercolour of *John
Biglen in a Single Scull* 1873–74 (Metropolitan
Museum of Art, New York), bear only a superficial
resemblance to the calm, impersonal compositions
of Fitzhugh Lane or Martin Johnson Heade.

Throughout his life Eakins was greatly inter-
ested in scientific problems, in mathematics, loco-
motion and optics. He was associated with the

photographer Muybridge in the famous studies of
running figures. All this scientific curiosity was
part of his search for truth to nature, the complete
verity of the artist's vision which was for Eakins
the painter's *raison d'être*. Learning from Velas-
quez, Courbet and Manet, as well as from the 17th-
century Dutch landscape and genre painters, he
was, in effect, America's first Social Realist. In
1875, he produced what is regarded as the master-
piece of American realist painting, the life-size
canvas of a medical operation, an appropriately
scientific subject, entitled *The Gross Clinic* (Jeffer-
son Medical College, Philadelphia). Unhonoured
in its own day – it was rejected by the jury of the
1876 Philadelphia Centennial Exhibition – it is now

acknowledged as a key painting in the development of the American Social Realist tradition.

After *The Gross Clinic*, Eakins became increasingly concerned with portraiture, in which he retained his truthful vision which so distinguishes his masterpiece. In 1879, despite the rejection of *The Gross Clinic*, he was appointed head of the Pennsylvania Academy of Fine Arts; he held this position until 1886, when he was dismissed because of his stubborn insistence that students, both male and female, should learn to draw from the nude model, rather than from plaster casts of Classical statuary. But even though his headship lasted only seven years, he managed to achieve enough to influence the course of American painting in future years.

During his period at the Academy he painted the superb composition of nudes called *The Swimming Hole* 1883 (Fort Worth Art Center Museum, Texas), which shows the same interest in the human body in various postures as the similar compositions executed in France at the same time by Gauguin. Apart from the portraits of his last years he also painted a small number of boxing scenes, which, whilst being the same convenient vehicles for examining the muscular functionings of the human body as *The Swimming Hole*, look forward to the work of George Bellows a few years later.

At the same time as Homer and Eakins were forging a new art in America, three painters,

140 *Nocturne in Black and Gold: The Falling Rocket*
about 1874
James Abbott McNeill Whistler 1834–1903
oil on panel, $23\frac{3}{4} \times 18\frac{1}{2}$ in
Detroit Institute of Arts
(Purchase, Dexter M. Ferry Jnr Fund)

139

141 *The Boating Party*
1893–94
Mary Cassatt 1845–1926
oil on canvas, 35½ × 46¼ in
National Gallery of Art,
Washington (Chester Dale
Collection)

James Abbott McNeill Whistler (1834–1903), Mary Cassatt (1845–1926) and John Singer Sargent (1856–1925), were active in the avant-garde art circles of Europe. None of these three had a substantial American career (Whistler had none at all), and only Whistler had much following amongst his countrymen, although Sargent was lionised in social circles later on in his life. It is probable, however, that America's greatest debt is owed to the least important painter of the three, Mary Cassatt, since she was responsible for the founding early in this century of some of the finest collections of Impressionist paintings now housed in American museums.

Whistler's early years were spent in St Petersburg in Russia, where he first took instruction in drawing. In 1849, at the age of fifteen, he returned to America, and soon afterwards entered the Military Academy at Westpoint. There he was taught drawing by a member of the Hudson River School, Robert W. Weir (1803–89). In 1855, he returned to Europe forever.

Whistler's career is essentially a European one, although his fame, or notoriety, had great effect

142 *Mrs Charles Gifford Dyer*
1880
John Singer Sargent
1856–1925
oil on canvas, 24½ × 17¼ in
Art Institute of Chicago
(Friends of American Art
Collection)

143 *Motherhood*
about 1889
Mary Cassatt 1844–1926
pastel, 23½ × 18 in

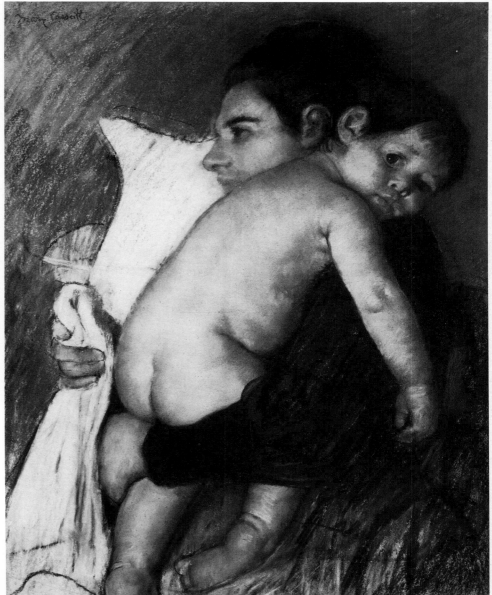

upon American painters. Even in the early years of the 20th century, his influence was pervasive. Although The Eight might parody him under the name 'James NcNails Whiskers' in their charades, they were, nevertheless, inheritors of the stylistic freedom which Whistler had been so instrumental in bringing about, and they acknowledged the fact.

Between 1855 and 1857, Whistler studied with Gleyre in Paris, and remained in that city for four years. He then travelled in Europe, visiting Venice, which was later to be the scene of his artistic revival after his ruinous law suit with Ruskin;

bankrupt, Whistler travelled to Venice in 1879 to execute a magnificent series of etchings which proved a much-needed commercial success. After Venice, he settled in London, becoming embroiled with the Aesthetic Movement centred around Oscar Wilde.

It was during this period that Whistler made his first major contribution to European aesthetics, a contribution the importance of which cannot be valued too highly. Together with architects and designers, notably William Godwin and Christopher Dresser, Whistler was instrumental in bringing about a synthesis of Japanese and European styles which was eventually to have a decisive effect upon the direction of European art. His masterpieces of this period include *Caprice in Purple and Gold Number 2: The Golden Screen* 1864 (Smithsonian Institution), *Purple and Rose: The Lange Lijzen of the Six Marks* 1864 (John G. Johnson Collection, Philadelphia) and *The White Girl* of 1862 (National Gallery of Art, Washington), a portrait of his mistress, Jo Heffernan. Also at this time were painted the various nocturnes, culminating in 1874 with that most infamous and wonderful of his pictures, *Nocturne in Black and Gold: The Falling Rocket* (Detroit Institute of Arts), the painting which Ruskin, in a moment of inchoate fury, likened to a pot of paint flung in the public's face, a remark for which Whistler, equally unadvisedly, sued the great pundit.

144 *Beacon Street, Boston – October Morning*
Childe Hassam 1859–1935
oil on canvas, 12 × 10 in

145 *Early Spring*
John Henry Twachtman 1853–1902
oil on canvas, 12 × 16 in

146 *Landscape at Auvers* 1890
Theodore Robinson 1852–96
oil on canvas, 13 × 19 in

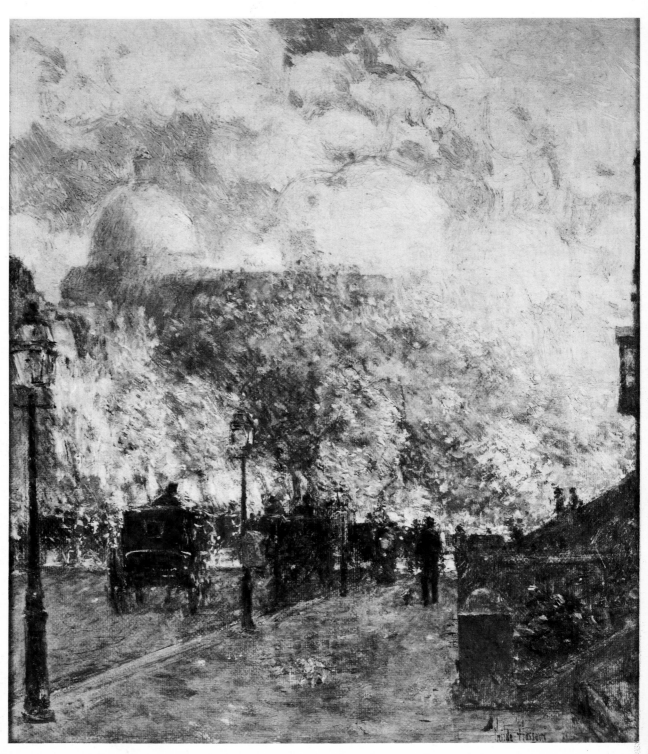

Whistler won a Pyrrhic victory, and was awarded a farthing as damages. Nevertheless, the case did have the beneficial effect of loosening the hold Ruskin had upon Victorian taste; he was certainly the greatest of all 19th-century critics but by the late 1870s he had also become a reactionary.

Mary Cassatt holds no such important place in the history of painting. Born in Philadelphia in 1845, a year after Thomas Eakins, Cassatt studied at the Pennsylvania Academy of Fine Arts, and in 1866 left for Europe. From 1873 she lived in Paris and through the close friendship which she enjoyed with Degas (whose influence, including Cassatt's use of pastel, is apparent throughout her work), she was drawn into the circle of the Impressionists. She devoted herself mainly to one subject, the theme of the mother and child, although she painted a few landscapes which seem to be influenced more by Pissarro and Sisley than by Degas. She was not a great artist but this was not so much because of Richardson's stricture that 'it is hard to see greatness in such monotony of subject' but because she simply lacked the vision and the talent to be more than a follower. At her best, she produced work of a finely judged delicacy but such pictures are, unfortunately, rare.

Of the three expatriates, John Singer Sargent is the least American (he was born in Florence and did not visit America until he was in his thirties). As a youth, he settled in Paris, visiting Spain and Morocco between 1879 and 1880. In 1884, he exhibited the greatest of all his early portraits, *Madame Gautreau* (Metropolitan Museum of Art, New York), and this picture caused such controversy that he moved to London.

Madame Gautreau shows the artist at a peak which he may have equalled but which he never surpassed. In it, all the subtle tonality and depth and the broad, vivid brushwork which he had learnt from his three great masters, Velasquez, Hals and Manet, perfectly synthesise to form a picture of splendid resonance and power. So often

147 *Steelworkers – Noontime*
about 1880–82
Thomas Pollock Anshutz
oil on canvas, 17 × 24 in

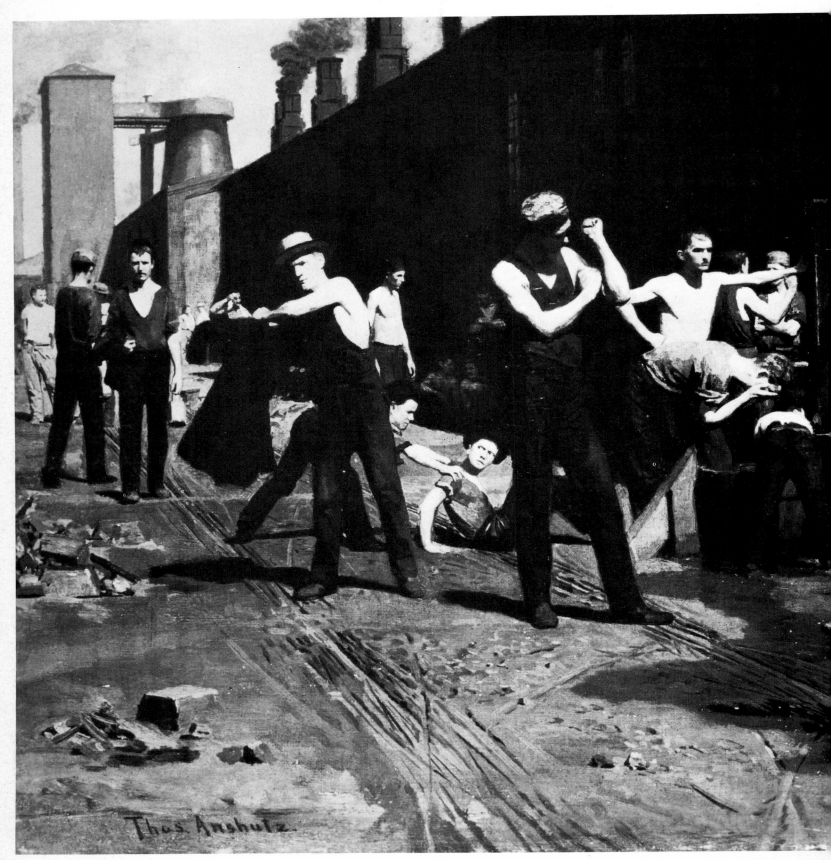

in later life, when he was the richest and most patronised of society portrait-painters, the drama of his early portraits gives way to the facile brilliance into which his amazing technical dexterity led him. In 1887 he visited America, and his reputation as the greatest of English portrait-painters, the favourite of royalty, naturally caused him to have a spectacular success. Indeed, so great was

148 *Portrait of William Charles Le Gendre*
about 1884
William Merritt Chase
1849–1916
oil on canvas, 49 × 31 in

149 *The Reader*
William Merritt Chase
1849–1916
oil on canvas, 20 × 16 in

the reception afforded him that thereafter he made regular trips to the United States to paint the bejewelled matrons of the Gilded Age.

American 'French' Impressionism, such as it was, centred around the activities of J. Alden Weir (1852–1919), John H. Twachtman (1852–1902) and Childe Hassam (1859–1935). These three were instrumental in forming in 1898 the group of Impressionist-orientated painters called 'The Ten'. The other seven, Thomas Dewing, Edmund Tarbell,

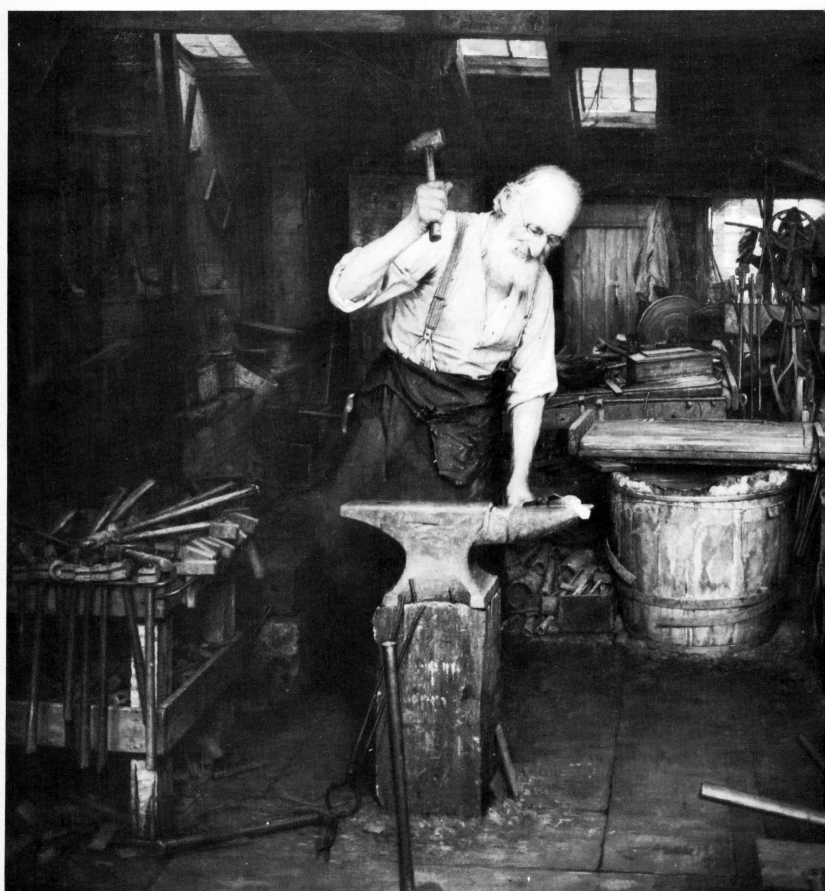

Frank Benson, Joseph de Camp, Willard Metcalf, E. F. Simons and Robert Reid, were painters of distinctly minor talent, and were it not for being members of a famous group would almost certainly have fallen into an even greater obscurity than

they have already. After Twachtman died in 1902, William Merrit Chase (1849–1916), an artist who had considerable influence in America during the 1880s, took his place.

We should not forget Theodore Robinson who, in 1888, became the only pupil of Claude Monet at Giverny. Robinson was probably the first American painter (apart, of course, from Mary Cassatt) to become totally Impressionist in his depictions of light, colour-filled landscapes, although he was not a painter as talented as either Hassam or Twachtman. Robinson was no teacher, and although he was probably the purest of the American Impressionists, he was a lonely figure who suffered from persistent ill-health, and he made little impact.

In contrast, William Merrit Chase, who had studied in Munich, and who in the 1880s began painting in a manner derived from the broad painterly style of the Munich school and of Sargent combined with the colourful palette of the Impressionists, was a born teacher. It was largely through his example, albeit a rather muddled one, that a whole generation of American painters adopted a hybrid version of Impressionism.

It was Chase's style, then, which had the deepest effect – we can still see clear indications of it in the work of Robert Henri and The Eight early in the new century. Childe Hassam, however, had studied in Paris in the 1880s and therefore, like Robinson's, his work is based directly on Impressionism. His pictures, often clear, light-filled landscapes of great quality, are a direct contrast to the heavy work of Chase's followers. The same is true of another American Impressionist, Homer D. Martin (1836–97), who, after painting Hudson River landscapes in a Luminist style, became deeply influenced by the Impressionists late in life. In 1894 he produced a series of pictures which are extremely close to the work executed by Monet in the 1880s. A good example is *The Harp of the Winds* 1895 (Metropolitan Museum, New York), which bears a remarkable resemblance to the series of paintings by Monet depicting a group of poplars on the banks of the Epte.

The course of American painting at the end of the 19th century was, then, somewhat confused. The great Hudson River tradition had faded out and was replaced by what was, in general, a watered-down version of French Impressionism, whilst Winslow Homer was painting some of the greatest American landscapes without having any noticeable impact upon his fellow artists. There was one theme, however, which runs through much of the painting of this period and which was to emerge as the dominant influence in the next century. Thomas Eakins' teaching at the Pennsylvania Academy, his concern with naturalism, social truth and the strong painterly techniques which he had evolved through a close study of such masters as Velasquez, Hals and Manet, had taken deep root. Through his example, and that of his pupil and successor Thomas Anshutz, American art was to achieve great things in the new century.

150 *The Blacksmith*
1907
J. D. Chalfont
oil on canvas, $25\frac{3}{4} \times 33\frac{1}{2}$ in

The Eight

The realism of Eakins and Anshutz was a pervasive influence amongst the young artists of Philadelphia at the beginning of the 20th century. American painting in general suffered from the same faults as those in most other countries. The late 19th century witnessed the growth of a conglomerate style filched from all the movements of the past, but whereas previous ages had been able to invest styles based upon historical precedent with an individual quality, the late 19th-century painters suffered from an inability to control their subject-matter – they were unable to 'select'. As a result, the academic painters frequently lapsed into bombast, melodrama and empty rhetoric, thinly disguised by technical facility.

Eakins, who had struck a brave blow for artistic freedom in an essentially Puritan environment, was rejected by the art Establishment of his own day, only to become a hero of the young generation of painters who were unwilling to suffer the authoritarianism of the academies. In Philadelphia, a number of young artists gathered themselves into a fellowship, usually called 'The Eight', but also known by the then derogatory terms which were flung at it by contemporary critics – 'The Black Gang', or more often 'The Ash Can School'. Particularly relevant for the work of The Eight was Eakins' championship of native themes as worthy subject-matter. He had recommended his pupils to 'study their own country and to portray its life and types'. It was to be The Eight's portrayal of American urban life, rather than their mode of painting, that was to be their real contribution to art in the new century.

The driving force behind this association, the catalyst for a rich and adventurous development in modern American painting, was a man of no great talent as a painter, but who had organising energy and was a deeply committed and persuasive teacher. Robert Henry Cozad, known as Robert Henri, was born in Cincinnati in 1865. At the age of twenty-one he entered the Pennsylvania Academy and studied under Anshutz. Two years later, he left for Paris and studied the work of the Impressionists and Manet, the latter becoming, with Hals and Velasquez, the principal influence on his

own painting.

He returned to Philadelphia in 1891, and in the same year met William Glackens and John Sloan through Charles Grafly, an instructor at the Pennsylvania Academy who had met Henri in Paris. Both Sloan and Glackens were artist-journalists, as were two other painters who were soon to become members of the group, George Luks and Everett Shinn. The training these artists received as newspaper illustrators had a significant effect upon their work when they turned to painting. Barbara Rose, in her book *American Art Since 1900*, describes the matter thus:
'Rushing to fires, strikes, murders, mine disasters, and other sensational events, Sloan, Glackens, Luks and Shinn recorded their perceptions on any available scrap of paper in a kind of visual shorthand. Encouraged by Henri to translate their sketches into paintings, they used to great advantage the rapid execution and spontaneous style they had developed as newspaper artists.'

148

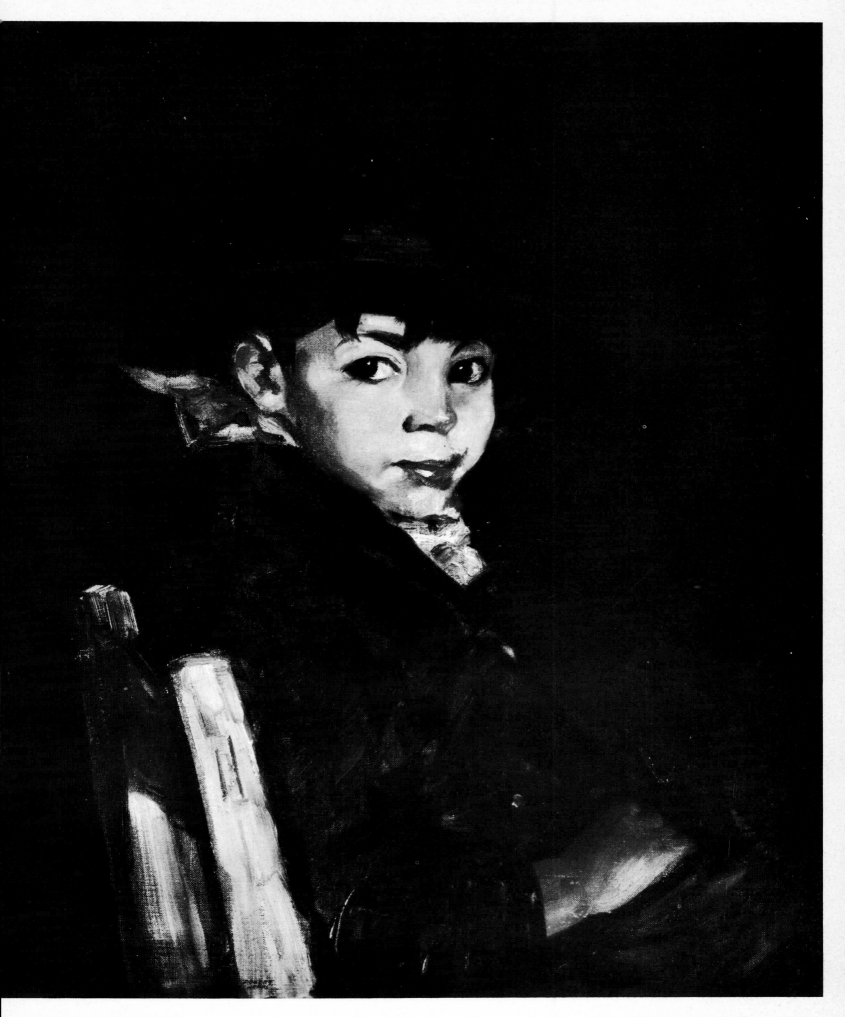

These five artists gathered regularly at Henri's studio at 806 Walnut Street; artistically they were well in tune with each other, although Glackens became far more interested in the gay, colourful palette of the Impressionists. The sense of social commitment to be found in the art of certain members of The Eight, most noticeably in that of Sloan, is entirely lacking in Glackens' pictures, which became increasingly close to the late work of Renoir, both in mood and style. It was not surprising, therefore, that when in 1912 an eccentric chemist called Albert C. Barnes, millionaire inventor of a patent medicine called Argyrol, asked Glackens to purchase paintings for him in Europe,

153 *The Breakfast Porch*
William Glackens 1870–1938
oil on canvas, 20 × 24 in

154 *Lady on a Divan*
about 1935
Everett Shinn 1876–1953
oil on board, 25½ × 19¼ in

the artist purchased those magnificent examples of Impressionism and Post-Impressionism now housed in the Barnes Foundation in Merion, Pennsylvania. Thus, as with Mary Cassatt, Americans owe a debt to Glackens which must be rated at least as high as the pleasure to be derived from his own paintings.

In 1896, Henri moved to New York, and over the next eight years Glackens, Sloan, Luks and Shinn joined him there. The great period of The Eight, therefore, lasted from 1896 to roughly 1910, was set in New York and reached its apogee with the famous exhibition at the Macbeth Gallery in 1908.

This exhibition has been compared with the Armory Show of 1913 for the important part it played in the history of American aesthetics. In fact it was a far more insular affair, and by the time it took place the style of the Philadelphians had diverged so much as to display little obvious unity. In addition, the presence in the show of Ernest Lawson, Maurice Prendergast and Arthur B. Davies, not one of whom had anything in common

with any of the others, led to a certain justifiable confusion in the minds of the critics as to just what it was The Eight were trying to prove; one writer, with a mixture of admiration and dismay, referred to the 'clashing dissonances of eight differently tuned orchestras'.

Looking back on that exhibition today from a distance of over sixty years, it is not difficult to perceive that, although the paintings as a whole represented a remarkable breakthrough in America, two artists emerged whose work, whilst having very little in common other than an appreciation of the qualities of light brought to art by the Impressionists and the Post-Impressionists, has not in any sense 'dated' since their own day. The pictures of Luks, Shinn and Henri appear too trite and laboured today. They were working so consciously towards a 'new art' and their models—Hals, Velasquez and Manet—were so dominating that we are aware of a certain empty rhetoric, an inability to rise above their themes and sources which inhibits their vision and mars our appreciation of the final result.

With John Sloan and Maurice Prendergast, however, the opposite is true. We are aware with both these painters of a unique and strong personality which has absorbed and transformed the lessons of the modern European movements rather than using them like a veneer. It is interesting to compare Prendergast's brilliant, dappled views of New York, in a style which owes much to the Nabis, especially Bonnard and Vuillard, to Glackens' *Chez Mouquin* (Art Institute of Chicago), which was exhibited in the 1908 show, or to Henri's *The Masquerade Dress: Portrait of Mrs Henri* 1911 (Metropolitan Museum of Art). In Glackens' and Henri's works, the influence of Manet is so strong as to almost crush the personalities of the two painters. They have not added anything to what already existed. In Prendergast's case, however, whilst we recognise, as a kind of academic gesture, the sources of his style, we cannot fail to appreciate the degree to which he has understood the mechanics, whilst remaining free to interpret what he saw in a mature and idiosyncratic fashion. Barbara Rose has described Prendergast as being the first American to understand Parisian modernism. Whilst this is not a judgement with which I would disagree, it is worth remarking that whereas Henri and his followers might also be said to have understood the new tendencies in European art, they, unlike Prendergast, were not capable of properly interpreting what they had learnt.

The Ash Can School, as it name implies, was concerned with the depiction of life 'as she is lead'. One of the weaknesses of many of the artists, however, was that they were not willing or capable to burrow into the harsh reality of the city life around them. George Luks lived in and drew inspiration from the slums of Manhattan's Lower East Side. He remarked that, 'A child of the slums will make a better painting than a drawing-room lady gone over by a beauty shop', but in such works as *The*

Spielers 1905 (Metropolitan Museum of Art, New York), we are aware of a sentimentality which all too often belies any sense of social commitment; there is perhaps too much pretension and too little truth in his attitude.

Everett Shinn wrote: 'I was often accused of being a social snob. Not at all—its just that the uptown life with all its glitter was more good-looking . . .' In social and artistic attitudes, therefore, some of these apparently radical painters were more reactionary than might, at first glance, be supposed. They recall the words written by the Hudson River painter Asher B. Durand in the 1840s: 'That there are haunts of poverty and wretchedness equally startling, and perhaps more extended I well know, but I have not sought them—on the contrary, I have avoided them as unprofitable spectacles.'

To such criticism one painter, John Sloan, stands as a triumphant exception. In the introduction to the retrospective exhibition of his work held at the Whitney Museum of American Art in 1952, the American scholar Lloyd Goodrich wrote: 'His art had that quality of being a direct

155 *Revere Beach* 1896
Maurice Prendergast 1859–1924
watercolour, 14 × 10 in

156 *The Old Monk* about 1928–32
George Luks 1867–1933
oil on canvas, 20 × 16 in

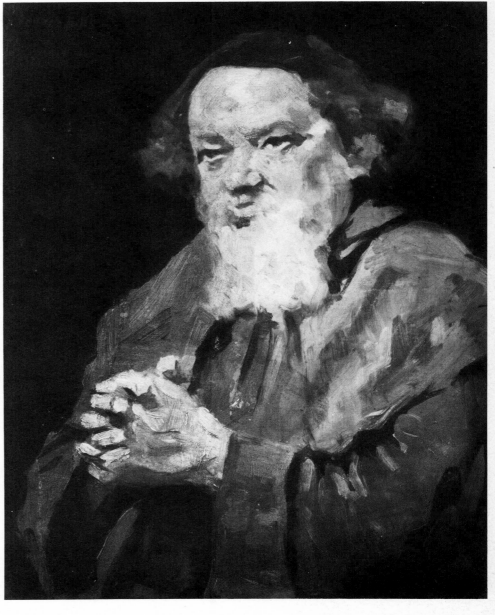

157 *Grey and Brass*
1907
John Sloan 1871–1951
oil on canvas, 20 × 30 in

154

product of the common life, absolutely authentic and unsweetened, that has marked the finest genre of all time.' Whilst Shinn, Luks and other painters of the same era like Jerome Myers (1867–1940), Guy Pène du Bois (1884–1958) and George Bellows (1882–1925) may have devoted their art to the description of life in New York, as befitted pupils of Henri, only in the work of Sloan do we sense that absolute commitment to subject, regardless of what that subject may be, which gives his paintings such strength and beauty.

Born in 1871, Sloan was the last of The Eight to leave Philadelphia for New York, and the only one who did not at some time study in Europe. Although his art is often happy and fast, caught up in the furious pace of New York, his best paintings are perhaps those of intimate, quiet scenes which would in themselves be unremarkable were it not for the beauty and drama which, flashing into his vision for one split second, the artist is able to capture. Here again, Sloan's training as a newspaper artist stood him in good stead. He was able to singularise the instant of greatest moment from a given situation and to depict it without superfluous trappings. His best work is as concise and pure as shorthand—we think of pictures such as *The Cot* 1907 (Bowdoin College Museum of Art, Brunswick, Maine), *The Wake of the Ferry* 1907 (Phillips Collection, Washington, D.C.) or *Sunday, Women Drying Their Hair* 1912 (Addison Gallery of American Art, Phillips Academy, Andover, Massachusetts), perhaps the artist's masterpiece, which won high praise from Theodore Roosevelt when the President visited the Armory Show in 1913, where it was first exhibited.

Naturally, historical irony having about it a certain inevitability, Sloan, as one of the greatest of The Eight, was also one of the least successful, not selling a painting until he was in his late forties. He was an uncompromising painter, some of whose work, such as *The Wake of the Ferry*, is tinged with the same pessimistic gloom as we see in Ben Shahn. Shortly before his death in 1951, Sloan, reviewing the ravages wrought by progress, could look back to his early days in New York and see that, grim as they might have been, they had an innocence which had been lost irretrievably: 'You young people don't realize how sweet—sweet and sad—New York was before Prohibition. But now, who'd want to paint a street strewn with automobiles? The skyline? Its like a comb in the restroom of a filling station. A tooth here and there missing, and all filled with dirt. Unfortunately we're the dirt.'

Amongst Henri's New York pupils was Rockwell Kent. It was he who, in 1910, two years after The Eight's first exhibition (which, surprisingly, had been both a financial and critical success), organised, on lines inspired by the example of the modern French painters, an unjuried independent show to coincide with the official exhibition of the National Academy of Design. The Eight were included along with over two hundred other exhibitors, amongst whom the names of three of Henri's pupils, George

158 *Cornelia Street*
1920
John Sloan 1871–1951
oil on canvas, 20 × 16 in

159 *Mountain Farm, Woodstock, N.Y.*
1922
George Bellows 1882–1925
oil on canvas, 20 × 24 in

160 *Flowers*
William Glackens 1870–1938
oil on canvas, 24 × 18 in

161 *Stag at Sharkey's*
1907
George Bellows 1882–1925
oil on canvas, $36\frac{1}{4} \times 48\frac{1}{4}$ in
Cleveland Museum of Art
(Hinman B. Hurlbut
Collection)

159

Bellows, Edward Hopper and Stuart Davis, stand out. Hopper and Davis will be discussed in later chapters; Bellows, however, is relevant to any discussion of the Ash Can School.

Born in Ohio in 1882, Bellows came to New York in 1904, but, although he became a pupil of Henri almost immediately, he was not invited to participate in the 1908 show. Bellows, like Prendergast and Sloan, absorbed many influences and evolved a strong forceful style which makes him one of the most interesting of the Ash Can School. Although he showed an acute awareness of the art of Manet and Degas, *Polo at Lakewood* (Columbus Gallery of Fine Arts, Columbus, Ohio), for instance, being a painting which relies heavily on Impressionism, both stylistically and in subject-matter, it was in his development of the American, or to be more accurate, Philadelphian, brand of realism that his true importance lies. Absorbing the lessons of Eakins and Anshutz via Henri, he produced such works as *Stag at Sharkey's* 1907 (Cleveland Museum of Art), probably the most vivid and powerful boxing picture ever executed (we remember Eakin's depiction of a similar subject painted a few years before), *The Lone Tenement* 1909 (National Gallery of Art, Washington), and *Man on the Docks* 1912 (Randolph-Macon Woman's College, Lynchburg, Virginia), a painting similar to Anshutz's *Steelworkers–Noontime*, but of a greater harshness and violence.

Unfortunately, Bellows later in life became influenced by Jay Hambridge's somewhat ill-conceived theory of dynamic tension in art. The result was a rounding of his forms and a hardening of contours which, ironically, caused much of the innate tension in his pictures to disappear, as it did with other artists like du Bois. Thus the equally famous but far less satisfactory boxing picture of 1924, *Dempsey and Firpo* (Whitney Museum of American Art), shows a sad decline in artistic vision. His late work is certainly more technically assured than his early paintings, but there can be little doubt as to which have the greater spontaneity and excitement. The year after *Dempsey and Firpo* was painted, Bellow's career came to a premature end when, at the age of only forty-two, he died of a ruptured appendix.

Every art movement appears to need its jester and in the case of The Eight that function was performed admirably by George Luks. An avid participant in the burlesque dramas which The Eight wrote and performed in Henri's Philadelphia studio – dramas which tended to ridicule the aesthetic pretensions of their English contemporaries – Luks, the son of a miner, had wandered around Europe for almost ten years. Whilst there, he visited most of the great European art galleries, learnt from the German academic style and also, surprisingly, professed an admiration for Renoir, although there is little trace of the French artist's influence to be seen in Luks' own work.

In Philadelphia, Luks was joined by Glackens and Shinn as artist-reporter, whilst weaving Walter Mitty-like fantasies of himself as a prize-fighter (a photograph exists of him engaging in a mock fight in Henri's studio, watched by Sloan, Shinn and other artists). Although not as a boxer, Luks did enjoy a greater measure of financial success than most of the other members of The Eight, since he was commissioned to continue the popular cartoon strip *The Yellow Kid* after its creator left for a rival newspaper.

We have already noted Luks' interest in the slums, an interest which he not only expressed in his previously quoted 'Child of the slums' remark but which he also expressed in typically ebullient terms: 'Guts! Guts! Life! Life! That's *my technique*'. In point of fact, Luks' depiction of the realities of existence in slum areas is anything but satisfactory; we are never fully convinced of the 'Guts!' behind the vision – so often we feel the presence of what can be described appropriately as schmaltz. This is not to say that Luks was not an artist of genuine integrity; he believed in what he saw, but as with his boxing he was not careful to discriminate between the actual and his interpretation of it. For an artist whose life was part falsehood, part truth, the two often merging into one, his end was suitably bizarre. In 1933, he entered a speak-easy, drank too much and annoyed someone with his habitual drunken routine of, in John Sloan's words, 'saying something nasty and getting things going'; before he was able to complete the routine by slipping quietly away leaving the bar in a state of chaos, someone dragged him outside and beat him to death.

In many respects, the Ash Can School was neither a unified nor an artistically satisfactory movement. It produced painters of great brilliance, notably Prendergast and Sloan, and through the personality of its impresario, Robert Henri, generated an energy which, in 1913, was to result in the Armory Show, which might be said to have heralded the great age of American art. It is in the powerful individuality of much of The Eight's work, their ability to produce from totally unlikely situations paintings of great beauty, that their real achievement lies. At their best, they were amongst the first artists in the Western world to come to terms with the realities of city life.

Surely it was the work of Sloan, Luks, Shinn and Bellows, as well as that of Reginald Marsh and Edward Hopper, that Thomas Wolfe had in mind when he wrote in his great novel of the 1930s *You Can't Go Home Again*:
'In the course of George Webber's life, many things of no great importance in themselves had become embedded in his memory . . . always they were little things which, in an instant of clear perception, had riven his heart with some poignant flash of meaning . . . he remembered two deaf mutes he had seen talking on their fingers in a subway train; and a ringing peal of children's laughter in a desolate street at sunset; and the waitresses in their dingy little rooms . . . washing, ironing, and rewashing day after day the few adornments of their shabby finery, in endless preparations for a visitor who never came.'

162 *Café Lafayette*
(Portrait of Kay Laurell)
1914
William Glackens 1870–1938
oil on canvas, 31¾ × 26 in

163 *Fiesta*
about 1898
Maurice Prendergast
1859–1924
watercolour, 12½ × 19½ in

Cubism in America

Every great art movement needs its impresario. In the 20th century, significant groups of artists in every country have been fortunate in finding at least one man who, either through his own active involvement as an artist or because of his connections with the art market, has been prepared to devote himself to promoting a particular cause. Some men–Durand-Ruel, Kahnweiler and above all Diaghilev–have made an art out of the act of promotion itself, and as such are insolubly linked with the artists whom they supported. In America Robert Henri, as we have seen, was the force behind the development of a new Social Realism, but the painters who gathered round him had little to do with the new movements which were beginning to take shape in Europe. After all, the year in which The Eight held their exhibition was the year after Picasso painted *Les Demoiselles d'Avignon*.

Essentially, then, The Eight were still rooted in the Impressionist and Post-Impressionist idiom. Even the most technically advanced of them, Maurice Prendergast, was stylistically a Post-Impressionist. The beginnings of true modernism in America, however, may be dated roughly concurrently with the work of The Eight and their followers. To make another historical analogy, the year in which Rockwell Kent organised the independent show in New York was also the year in which Arthur Dove painted his first abstractions.

The growth of modernism in the United States at the end of the first decade and during the second decade of the 20th century was largely due to the efforts of one man. Alfred Stieglitz, a superb photographer, founded the Little Gallery of the Photo-Secession in 1905 with his friend and colleague Edward Steichen, on Fifth Avenue, New York City. In 1907, in addition to showing photographs, he also exhibited some paintings by Pamela Colman Smith; with this action, Stieglitz began the policy of the gallery, later simply called '291' after its street number, of showing all that was new and dynamic in European and American art. The quality of the exhibitions held at 291, and the colossal impact the gallery had upon American art, may be gauged from the following paragraph in Barbara Rose's book on modern American art: 'Stieglitz presented the first American exhibitions of Matisse (1908), Toulouse-Lautrec (1909), Rousseau (1910), Picabia (1913) and Severini (1917). In April 1911, 291 exhibited drawings and water colors by Picasso showing his complete evolution through Cubism, and in March, 1914, Stieglitz gave Brancusi his first one-man show anywhere. Stieglitz was responsible for the first exhibition of children's art and the first major exhibition of Negro sculpture. Among the American painters he introduced were Alfred Maurer and John Marin (1909); Marsden Hartley, Max Weber, Arthur Dove and Arthur B. Carles (in a group show in 1910); Abraham Walkowitz (1912); Oscar Bluemner (1915); the sculptor Elie Nadelman (1915); Georgia O'Keeffe (1916) and Stanton MacDonald-Wright (1917).'

In other words, he was the catalyst which sparked off the creation of Parisian modernism in America, and he played as vital a role in the development of modern art in America as Kahnweiler did in France.

Naturally, the focal point for American painters became Paris, and was to remain so for a long period; when Paris' control over the artistic sensibilities of the Western world slipped after the Second World War, it was to New York that European artists looked, for the first time, for their inspiration. In 1907, Henri Matisse started classes in Paris and a number of young American painters, including Arthur Burdett Frost, Patrick Henry Bruce, Arthur B. Carles and Max Weber, enrolled. Oscar Bluemner, Preston Dickinson, Maurice Sterne, Charles Sheeler and Charles Demuth also studied in France, as did the two American creators of that unique offshoot of Cubism called Synchromism, namely Morgan Russell and Stanton MacDonald-Wright. Three other American painters who visited Paris a few years later were Joseph Stella, John Marin and Marsden Hartley, the latter financed by Stieglitz himself.

Although the years between 1910 and 1920 produced some remarkable interpretations of Cubism and Italian Futurism, the latter having as much, if not more, influence in the United States, it must be admitted that American artists were not much concerned with the intellectual technicalities of Cubism, merely with utilising its basic surface

164 *New York*
1913
Max Weber 1881–1961
oil on canvas, 40 × 32 in

163

appearance. Again in Barbara Rose's words, 'For the majority of Americans who called themselves Cubists, Cubism meant little more than sharp lines and acute angles.'

Synchromism, as we said, was a style based upon Cubism and invented by two young American painters, Stanton MacDonald-Wright and Morgan Russell. It began about 1913, and both artists worked in the style until about 1918–20. Essentially, Synchromism was Cubism twice removed; the true Cubism of Picasso and Braque was concerned primarily with form, to which all other elements, including colour, were subordinated. Certain French painters, of whom Robert Delaunay was the most important, became disenchanted with what they considered to be such narrow definitions. Whereas the Cubists were concerned with the scientific analysis of solid, tangible objects and their relationships to each other in space, the Orphic Cubists, as they were called, were more interested in the non-objective dynamism of colour. It was this aspect of the new art, evolved by Delaunay around 1910–11, which most interested the Americans who had always shown a marked preference for the more colourful aspects of modernism (if anything Fauvism had a greater influence in America than Cubism). The Synchromists differed from the Orphists in one crucial respect however, which was, in Douglas Cooper's words in *The Cubist Epoch*, 'that where Delaunay used "simultaneous" contrasts of colour to evoke light and give form to space, the Synchromists either used the visual illusion created by juxtaposed colours advancing and retreating to evoke an undefined, half-imaginary form in space, or applied bands of colour systematically in order to set up a polyphonic rhythm.' This 'polyphonic rhythm' is, in fact, more apparent in the later works of Stanton MacDonald-Wright than in those of Russell. In such works as *Synchromy in Purple* 1917 (Los Angeles

County Museum), *Oriental. Synchromy in Blue-Green* 1918 (Whitney Museum of American Art), MacDonald-Wright shows that he became increasingly more figurative and more inclined towards the 'fast' image of Italian Futurism than he had been at the outset of Synchromism. Around 1914–15, the work of both painters was extremely close, although even in such apparently similar works as Russell's *Synchromy* of 1914–15 (private collection) and MacDonald-Wright's *Abstraction on Spectrum (Organisation 5)*, about 1915 (Des Moines Art Center, Nathan Emory Memorial Collection), we can see the latter's tendency towards a more atmospheric image; often the intersecting planes are almost transparent.

In America, Synchromism attracted, briefly, a small group of followers. Both Patrick Henry Bruce and Arthur Burdett Frost had been pupils of Matisse, and like the leaders of the movement, their colours were essentially Fauvist, welded on, often rather uneasily, to a Cubist idiom. Andrew Dasburg, Thomas Hart Benton (later to become a leading regionalist and opponent of European modernism), and Morton Schamberg, soon to be one of America's most important exponents of Dada, also painted in a brilliant colourful style, which, whilst ostensibly based upon Synchromatist principles, in fact had more in common with Futurism. Bruce led a particularly insecure and tragic existence, destroying almost all his work in 1932, four years before committing suicide.

The two painters who perhaps gained most from Cubism, without being overawed by it, were Max Weber and John Marin. Weber went to Paris in 1905, and studied under Matisse two years later. This initial contact with Fauvism caused him always to use a bright, multi-hued palette. By the time he returned to America in 1909, he had also absorbed the Cubist principles of Picasso, learning to appreciate some of the basic forces behind Cubism, one of which, primitive sculpture, was to remain a lifelong interest. In America, he became interested in Futurism, and, in 1915, painted what many consider to be his masterpiece, *Chinese Restaurant* (Whitney Museum of American Art, New York), a picture which, alone amongst American paintings at this time, may be compared favourably with the new Synthetic Cubism then being evolved by Picasso, Braque and Gris in Paris. We should not forget, however, that as early as 1910–11 Weber had been painting Cubist compositions, of which *Nude* 1911 (Albright-Knox Art Gallery, Buffalo, New York) is perhaps the best known, which demonstrate clearly that he had reacted to the early Analytical Cubism of Picasso and Braque with a swiftness and depth of understanding unique amongst American artists.

In the 1920s, Weber's style became less abstract, moving towards the decorative elements of the School of Paris, and he began painting works on Jewish themes which, not surprisingly, appear to owe much to Chagall and Mané-Katz. Paintings such as *Adoration of the Moon* 1944 (Whitney Museum of American Art), whilst unquestionably

167 *Chinese Restaurant*
1915
Max Weber 1881–1961
oil on canvas, 40 × 48 in
Collection Whitney Museum
of American Art, New York

suggesting a deep emotional commitment, have little of the strength of the early Cubo-Futurist compositions upon which Weber's reputation as one of the most accomplished of American modernists is firmly based.

Like Stanton MacDonald-Wright, John Marin used the basic vocabulary of Cubism to develop his own style, which was totally different to the formal geometricity of the Parisian Cubist painters. In addition he was primarily interested in landscape (and especially in atmospheric effects) which, apart from a small group of works by the French Cubists, was not, generally speaking, an important part of the Cubist idiom. He was also interested in Eastern painting, and in his predominant use of watercolour managed to attain a rare and successful synthesis of the delicacy of Oriental brushwork and the more solid Western imagery. Between 1905 and 1911, during which time he travelled extensively in Europe, the direction of Marin's painting changed from an almost traditional concern with tonal values and a carefully constructed scheme to a quick vibrant spontaneity in which fast lines, placed with the maximum of economy and overlaid

168 *Sabbath*
1941
Max Weber 1881–1961
oil on canvas, 21 × 28 in

169 *Stonington, Maine*
1921
John Marin 1870–1953
watercolour, 26¾ × 21¾ in

170 *Herring Weir,*
Deer Isle, Maine
1928
John Marin 1870–1953
watercolour, 15 × 19 in

168

with a transparent wash, depict a scene with an admirable lack of pretension and yet with a strength which belies the apparently effortless compositional method.

This strength is enforced by the painted 'frame' which surrounds the image, so that the eye is controlled and directed always towards the focal point; the elements of the watercolours, executed around 1914 to 1916 when Marin first visited the same rugged Maine coast which had so attracted Winslow Homer, are those which characterise his work right up to his death in 1953. His is a refined

169

170

171 *New York Interpreted*:
The Bridge
1922
Joseph Stella 1880–1946
oil on panel
Newark Museum,
New Jersey

172 *Young Sea Dog with*
Friend Billy
1942
Marsden Hartley 1877–1943
oil on canvas, 40 × 30 in

and delicate art which is one of the most interesting and idiosyncratic legacies of Cubism.

Joseph Stella, born in Italy in 1879, did not come to America until the age of twenty-three, and after seven years as a magazine illustrator, returned to visit the country of his birth in 1909. His initial contact with European modernism was, therefore, through the Italian Futurists and it was they who most closely influenced his painting. Although such works as *Battle of Light, Coney Island* 1914 (Yale University Art Gallery, New Haven), and the second version of this same composition in the University of Nebraska Collection, seem to owe something to Duchamp and his brother Jacques Villon, yet their

furious pace and concern with machine technology show a strong sympathy for the Italians.

Of all the artists who borrowed from the Europeans, however, Marsden Hartley was perhaps the most eclectic. Born in 1877, Hartley first studied under William M. Chase, who had lasting effect on the younger artist's work, with its broad, bravura brushstrokes, but who certainly was not responsible for his brilliant use of colour, in which he was superior to all other American painters of the period. Between 1908 and 1911, when he left for Paris, Hartley mainly executed landscapes, which are firmly based on the late 19th-century American tradition. The year after he arrived in Paris he left for Germany, and it was there, under the influence of Kandinsky and the Blue Rider group (an influence which, contrary to the evidence of his pictures, Hartley always denied), that the artist produced what are probably his greatest works. In *Painting Number 5* 1914–15 (Whitney Museum of American Art), Hartley produced a memorable 'collage' of German militaristic motifs, painted in a rich palette with a beautifully textured surface. Indeed the surface quality of this painting bears a strong resemblance to the encaustic technique revived by Jasper Johns, and it is not surprising to find that *Painting Number 5* has always been greatly admired by Johns.

Unfortunately, however, Hartley was not able to sustain the strength and visual majesty of these paintings. Like many of the great French Fauvists, the artist appears to have burnt himself out in a short period of intense creativity. The period between 1920 and 1935 was spent painting landscapes which, initially close to the post-Fauve style of Derain, gradually became more solemn and melodramatic. Towards the end of his life (he died in 1947) Hartley, like so many American artists,

173 *Related to Brooklyn Bridge*
1928
John Marin 1870–1951
oil on canvas, 26 × 30 in

174 *Oriental. Synchromy in Blue-Green*
1918
Stanton MacDonald-Wright
1890–
oil on canvas, 36 × 50 in
Collection Whitney Museum of American Art, New York

172

175 *Leaning Figure*
about 1910
Max Weber 1881–1961
paper mounted on board,
18½ × 24 in

176 *Hot Still-scape for
Six Colours*
1940
Stuart Davis 1894–1964
oil on canvas, 36 × 45 in

became fascinated by the Maine coast, and he also worked in Canada. Whilst preferable to the landscapes of his middle years, even these late works represent a sad failure of sustained vision.

Arthur Dove was one of the most artistically successful and individual of the painters who gathered around Stieglitz. In many respects, not least of which is the fact that he began painting purely abstract works around 1910, the same year as the accredited inventor of abstraction, Wassily Kandinsky, Dove was one of the most advanced American painters of his generation, an intuitive artist who appears to have had little in common with the circle in which he worked.

Intense creativity has often seemed a strangely dangerous occupation within an American context, and the history of recent American art is littered with tragedy. Dove's greatest friend, Alfred Maurer, certainly the greatest exponent of Fauve painting in America (his best works may be ranked with those of the School of Paris) lived a life of great misery; after painting a series of tragic, mask-like heads in the Cubist style in 1932, he, like Bruce four years later, took his own life.

Together with the presence and personality of Stieglitz, one of the major influences on the development of modern art in America was the Armory Show, possibly the most lavish presentation of new art which has taken place in this century. In 1913, some 1,600 paintings and sculptures were exhibited in the 69th Regiment Armory on Lexington Avenue, New York, the brainchild of the newly formed Association of American Painters and Sculptors, and the fruit of two years work.

The sixteen charter members of the Association were, in fact, a fairly conservative group. In general they represented the American Impressionists and the Ash Can School, rather than anything particularly progressive, whilst their President, Arthur B. Davies, was chosen more because he offended no-one than because he was considered an artist of any outstanding merit. Ironically, however, Davies, of all unlikely people, showed a decided interest in, and liking for, the new European art, and it was he who insisted, against the wishes of the majority of the committee, that the show should contain a representative cross-section of modern European painting and sculpture. He did, however, make a significant concession to his own love of Symbolism by including no less than thirty-two works by Odilon Redon, the largest number of paintings by any single artist in the show and almost completely irrelevant in the context in which they were exhibited.

Davies, Walter Kuhn, a fine figurative painter and secretary of the Association, and Walter Pach, an American artist living in Paris who was intimate with the circle surrounding the Steins, were responsible for gathering the European exhibits. When the show opened, the European paintings –ranging from a work by Goya lent by the great collector and patron John Quinn, through Ingres, Delacroix, the Impressionists, Post-Impressionists and the great French movements of the first years of the century–outnumbered the American entries, and in terms of quality were completely superior. Robert Henri remarked: 'If the Americans find they've just been working for the French, they won't be tempted to do this again,' and he was right; three times as many European paintings were sold as American, and there never was such an exhibition again.

In many ways the Armory Show was not fully representative of modern painting. It contained only two paintings by the German Expressionists, and the Italian Futurists, because they were not allowed to have their own room, withdrew in chagrin. Nevertheless, the American public was able for the first time to have a reasonably comprehensive look at the directions art was taking, and, if they did not necessarily approve, they were at least curious.

The 'star' of the exhibition was undoubtedly a painting by a twenty-five-year-old Frenchman; Marcel Duchamp's *Nude Descending a Staircase* (Philadelphia Museum of Art) became the subject of intense and sensational publicity whipped up by a delighted, but often stupidly vicious, press. 'Spot the nude' competitions were organised, cartoonists had a field day, and several facetious titles, including 'Staircase descending a nude' were coined.

Ironically, however, this campaign of ridicule

177 *Two Women*
Alfred H. Maurer 1868–1932
oil on canvas, $21\frac{1}{2} \times 18$ in

178 *Structure*
1942
Arthur Dove 1880–1946
oil on canvas, 25 × 32 in

had the effect of making the work one of the most famous of all 20th-century pictures–a painting which, together with its maker, was to have a profound and lasting effect upon American art right up to our own day. Two years after the Armory Show, Duchamp returned to America with Francis Picabia, and these two masters of Dada found a ready audience amongst the younger generation. Two painters, Morton Schamberg and Man Ray, became ardent disciples, although the former, who died at the early age of thirty-six, became more interested in the quasi-Cubist machine imagery of Picabia than in the splendid iconoclasm of Duchamp, which so attracted Man Ray. The latter produced one masterpiece under Duchamp's influence, *The Rope Dancer Accompanies Herself with Her Shadows* 1916 (Museum of Modern Art, New York), but thereafter virtually ceased to paint, involving himself with other modes of creativity, of which photography was the most fruitful.

Nothing was the same after the Armory Show. The dormant talent of a great nation had been violently awoken. The process of maturing which then began was slow but came to a magnificent fulfilment some thirty years later. American painters as a group began to appreciate that they no longer needed Europe and that there was enough diversity and internationalism in the United States itself to satisfy even the most demanding cultural longing.

The Armory Show also began a process of patronage of modern art which has since turned America into the richest storehouse in the world. First among the great collectors of contemporary paintings and sculpture were Gertrude and David Stein in Paris, followed by John Quinn, whose collection was all-embracing and included one of the greatest libraries of modern books and manuscripts ever assembled by a private person, Lillian Bliss, Katherine Dreier, Albert Barnes, Duncan Phillips, A. E. Gallatin, Walter Arensburg, who collected Duchamp's work in particular, Ferdinand Howald and Gertrude Vanderbilt Whitney. Through the splendour of their collections and their generosity in donating them to the American people, they have made their names, like those of the artists they supported, immortal.

Cubism had a long life in America. In the 1920s and 1930s, a number of artists painted in a style obviously derived from the late Cubism of Picasso and Léger. Gerald Murphy, friend of Scott Fitzgerald and the model for Dick Diver in *Tender is the Night*, painted a small number of highly idiosyncratic compositions with a machine-like pre-

The Rope Dancer Accompanies Herself With Her Shadows

179 *The Rope Dancer
Accompanies Herself with
Her Shadows*
1916
Man Ray 1890–
oil on canvas, $52 \times 73\frac{1}{2}$ in
Collection The Museum of
Modern Art, New York
(Gift of G. David Thompson)

cision, but with great wit, in a manner reminiscent of Léger. These amazing pictures make the same, sad, whimsical comment on the quality of 20th-century life as Charlie Chaplin's *Modern Times*.

Of far greater significance, however, is the work of Stuart Davis, one of the greatest exponents of Cubism in America, whose career began in the 1920s and who, by the time he died in 1964 aged seventy, had absorbed the lessons of the most influential teacher in contemporary American art, Josef Albers. In a sense, then, Davis is the link between the Armory Show and the Abstract Expressionists and Pop Artists, much of whose imagery–cigarette packets, neon signs, advertising –Davis was using in his great compositions of the 1920s and 1930s. All the major movements of 20th-century art–Cubism, Dada, Surrealism, Abstract Expressionism, colour-field, Pop–touched Davis's work and made their mark, but only to Cubism did he subordinate himself to any great extent.

Starting as a pupil of Robert Henri, his first major painting, *Lucky Strike*, was executed in 1921 (Museum of Modern Art, New York), as witty a use of the popular media as has been produced in America. In 1956, a quarter of a century later, he painted *Colonial Cubism* (Walker Art Center, Minneapolis), a picture which shows an obvious awareness of Matisse's paper cut-outs, as well as Albers' theories, and was painted as a good-humoured reply to the critics who accused him of being too European, and hence un-American. The result is a magnificent, vivid picture, as full of movement and rhythm as the best work of the Abstract Expressionists.

Urban realism and social commitment

180 *Upper Deck*
1929
Charles Sheeler 1883–1965
oil on canvas, 29 × 22 in

American painting between 1920 and 1940 has been given a number of labels in an attempt to guide the spectator through what was essentially a time of experiment and flux. Although contact with avant-garde European painting provided a stimulus towards a truly modern American art, yet the influence of European painters was so strong, the scope of their achievements so daunting, that the attempts by some Americans to create their own individual mode of Cubism can be seen, in retrospect, as a gallant but somewhat fruitless attempt to cope with the centuries of experience needed to produce works so sophisticated as those of the School of Paris in the first two decades of the 20th century. The contact of American painters with European art was (it could be nothing else) a superficial one, although there is nothing derogatory implied by the word 'superficial'.

However in the 1920s and 1930s, a far more coherent national school began to emerge, simply because American painters realised that they could not hope to produce an art of international significance unless, paradoxically, they were prepared to come to terms with their own environment. Thus it is that the use of the Cubist vocabulary by Charles Demuth, Charles Sheeler and John Marin, or the powerful urban realism of Edward Hopper, are far more satisfactory, and have had more lasting impact than, say, Synchromism, which, for all its unquestionable honesty, can be no more than a mere footnote in the history of European Cubism. With Hopper especially, America produced a painter of unquestionable greatness, an individual whose approach to painting, in its total acceptance of the scene in which, and for which, it was created, was an example to the generation of artists who, in the late 1940s, made American painting supreme in the Western world.

There is, however, yet another paradox about American painting of the 1930s. Having decided that the United States was the most fitting subject for them to depict, artists such as Thomas Hart Benton, and his leading champion the critic Thomas Craven, proclaimed the virtues of 'Americanism' in strident, chauvinistic terms which reduced much Regionalist painting to the same insular level which other artists had been striving so hard to overcome. In an interview given many years later, Jackson Pollock, Benton's greatest and most unlikely pupil, remarked that he had cause to be grateful to Benton since, if he had not been so totally opposed to the latter's style of painting, he might not have found the strength to make his own contribution.

Towards the second decade of the 20th century, a distinct style began to emerge in the work of a group of painters centred around the Stieglitz gallery. These included the dealer's wife Georgia O'Keeffe, Preston Dickinson, Charles Demuth, Charles Sheeler and Niles Spencer. The binding factor in their work is the use of the Cubist style to depict American landscape (by a happy coincidence, Lyonel Feininger's work in Europe is very similar in both style and mood). The work of Dickinson, Demuth, Sheeler and Spencer is executed in a clinical style which became known as Cubist-Realism or Precisionism. In their paintings these artists foreshadowed the techniques of today's Photo-realists, and it is interesting to note that one painter active at this time, Man Ray, was experimenting with the air-brush to produce works he called 'aerographs'. Paintings such as *Jazz* of about 1919 (Columbus Gallery of Fine Arts), which are abstract compositions, have the same cool impersonality we associate with much present-day realist painting.

To the group mentioned above, Georgia O'Keeffe is obviously something of an exception. Her work is far more sensual and personal, and only in the sense that she drew inspiration from the phenomena around her can her work be categorised in the way we have attempted. Her best paintings, huge canvases of single flowers, works of great strength and sensuousness, were executed in the 1920s. From 1929 onwards, when she began to spend her summers in New Mexico, she drew from the heat and almost lunar desolation of that landscape inspiration for a series of dramatic compositions of great originality.

Charles Demuth was born in Lancaster, Pennsylvania in 1883. After a period of study at the Drexel Institute in Philadelphia, he enrolled at the Pennsylvania Academy of Fine Arts in 1905, meeting up with Morton Schamberg, and where he was

181 *Poppies*
1950
Georgia O'Keeffe 1887–
oil on canvas, 36 × 30 in

taught by Thomas Anshutz and William Merrit Chase. Charles Sheeler and John Marin had left the same academy two years earlier, whilst in New York another artist who came to be known as a Precisionist, Preston Dickinson, was studying under a painter who had been greatly influenced by Anshutz, namely George Bellows, who also taught Man Ray. This early connection with the Ash Can School, a connection which also links such realists as Rockwell Kent, Yasuo Kuniyoshi and Kenneth Hayes Miller who were taught by Henri and Chase, is important to our understanding of the theme of industrial technology, and its effects upon the landscape and the quality of life which underlies much of the best American painting from about 1915 to the advent of Abstract Expressionism some

thirty years later.

Between 1907 and 1908, Demuth travelled in Europe and spent two years studying at the Academie Moderne, the Academie Julien and the Academie Colarossi in Paris between 1912 and 1914; he was deeply influenced by Cubism and also, a most significant development in his artistic life, became a close friend of Marcel Duchamp. When he returned to America, and for the next two or three years, nothing very coherent emerged. He was painting naturalistic oils and watercolours, the latter, surprisingly enough, in a style reminiscent of the Austrian Egon Schiele.

The breakthrough is usually considered to have occurred during the winter he spent in Bermuda in 1916–17. At this time he began composing water-

colours of industrial scenes in a hard-edged Cubo-Realist style, which he was to develop and perfect over the next decade. We have only to compare the loose, vaguely Expressionist *Dunes* of 1915 to the Bermuda landscape of 1916 (both Columbus Gallery of Fine Arts), to see how radical the change had been.

His greatest works are the monumental oils of 1920 to 1928, culminating in the splendid series of 'poster portraits', of which the most famous, the portrait of the poet William Carlos Williams entitled *I Saw the Figure Five in Gold* 1928 (Metropolitan Museum of Art, New York), has remained one of the best loved and certainly the most influential of all American paintings of this period.

Whilst Sheeler, Dickinson and Demuth found a stark and unique beauty in the American industrial landscape, they were not blind to the social and ecological damage that was being caused. Demuth's *The Tower* of 1920 and *Modern Conveniences* of 1921 (both Columbus Gallery of Fine Arts) are cool depictions of American rural architecture, with, however, more than a touch of irony in the titles.

In *Incense of a New Church* of 1921, and *Aucassin and Nicolette*, executed in the same year (both Columbus Gallery of Fine Arts), the irony becomes far more overt. The first picture shows smoke streaming from a dark, forbidding cluster of factory buildings, the composition encircled by a dome so as to give the impression of a long, echoing Gothic cathedral. Whilst Richardson's interpretation of the picture ('Looming smoke-stacks and waste fumes are treated as harbingers of their own veneration') may be accepted on one level, the irony of the title also implies the notion of the worship of false gods. The second picture, showing the bleak towers of a grim factory building, takes its title from the names of the doomed lovers of a French medieval romance; the irony is more subtle than in *Incense of a New Church*, but the pessimism is just as plain.

Charles Sheeler was born in the same state and in the same year as Demuth, and also studied at the Pennsylvania Academy of Fine Arts. After travelling with William Merritt Chase in Europe, he opened a studio in New York in 1906 with his friend and erstwhile fellow-pupil Morton Schamberg. In 1908, he visited Italy and in 1909 worked with Schamberg in Paris, at which time the direction of his art changed drastically as a result of seeing the works of Cézanne and the Cubists. For the next few years, Sheeler worked in a style close to the semi-abstractions of Schamberg and Man Ray. However he was not entirely happy with the abstract mode and soon returned to a greater degree of representation. In the catalogue of his retrospective exhibition at the Museum of Modern

182 *Love, Love, Love (Homage to Gertrude Stein)* about 1928
Charles Demuth 1883–1935
oil on canvas, $20 \times 23\frac{3}{4}$ in

183 *Buildings, Lancaster*
1930
Charles Demuth 1883–1935
oil on composition board,
24 × 20 in
Collection of Whitney
Museum of American Art,
New York
(Anonymous gift)

184 *Gate of Adobe Church*
1929
Georgia O'Keeffe 1887–
oil on canvas, 20 × 16 in

Art in 1939, he wrote that there was a period: 'when a consciousness of structure and design as essential considerations was first becoming evident in my work. Whilst the use of natural forms has for the most part been prevalent in my paintings, a brief excursion into abstraction was made. These abstract studies were invariably derived from forms seen directly in nature . . . The duration of this period was determined by the growing belief that pictures realistically conceived might have an underlying abstract structure. The belief has continued with me as a working principle.'

This statement is, of course, crucial to an understanding of Cubist-Realism. As disciples of Cézanne and Picasso, these artists always sought to depict the basic geometric structure beneath the outward appearance, whether the object was man-made or natural. Sheeler himself became more and more interested in the principles of modern architecture, predominantly industrial architecture, and at the same time became more involved with photography. Indeed, from the time he began photographing architecture in 1912, his career was just as much that of photographer as it was painter. Between 1923 and 1931, he worked as a commercial photographer for Condé Nast, and it was this activity, carried out during the time of his greatest achievements as a painter, which resulted in a style which one critic has described as a mixture between 'abstract purism and photographic realism'.

Sheeler was less of a social commentator than

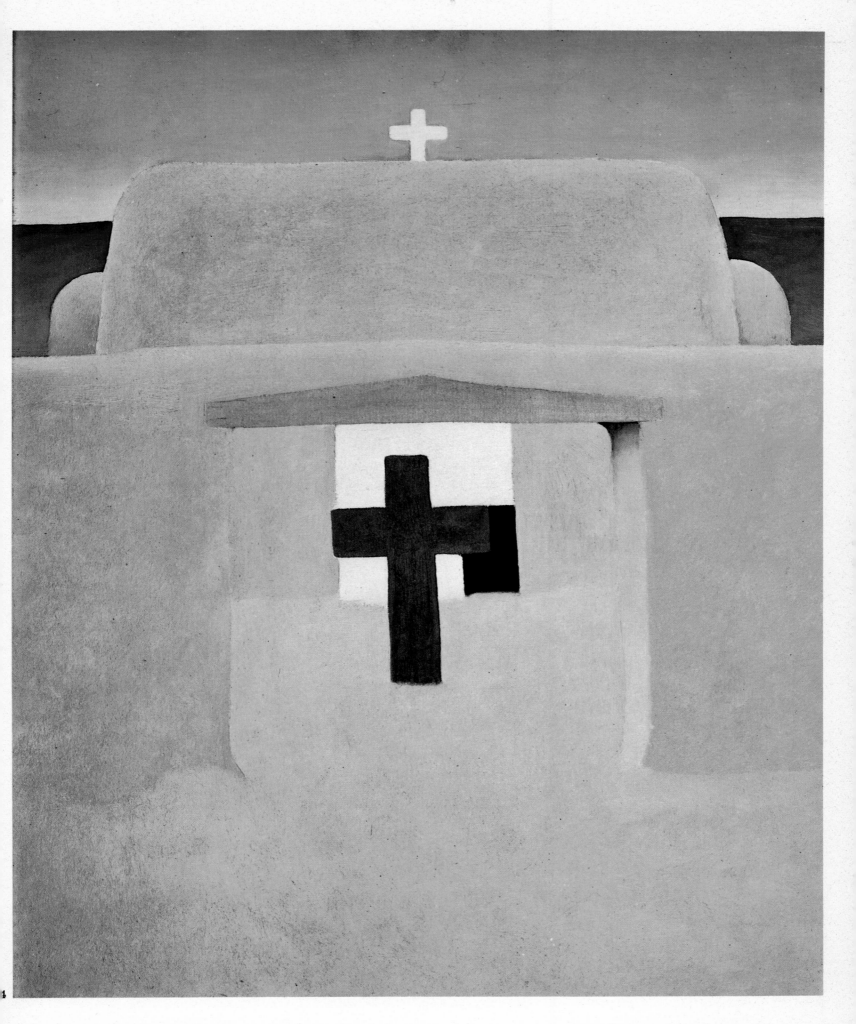

185 *Canyons*
1951
Charles Sheeler 1883–
oil on canvas, 25 × 22 in

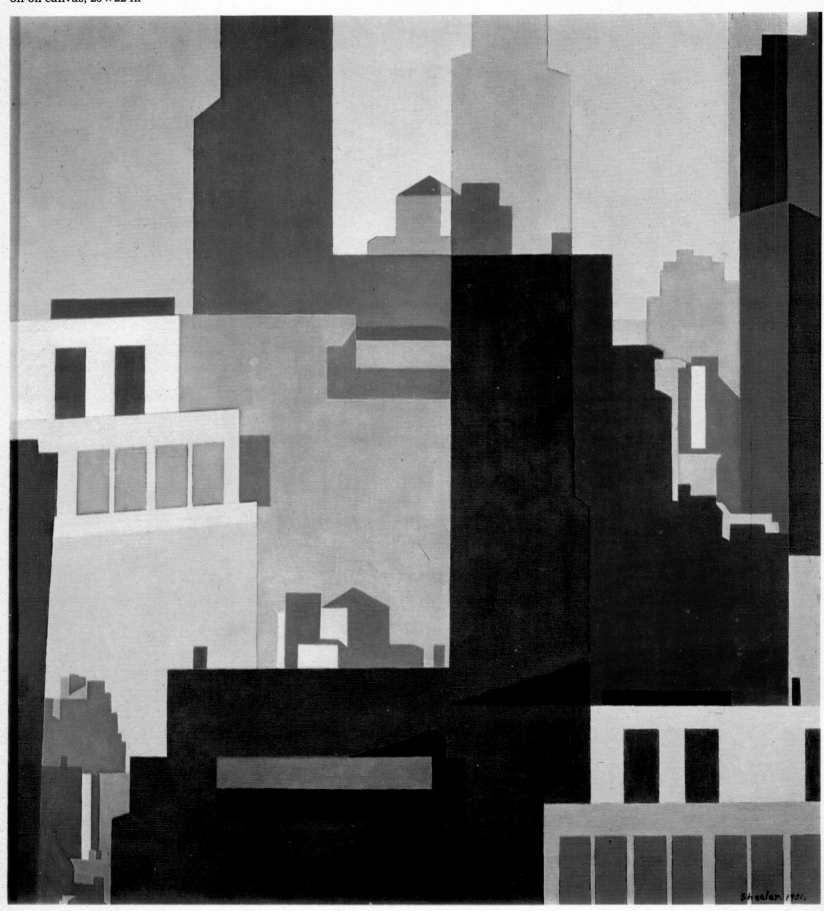

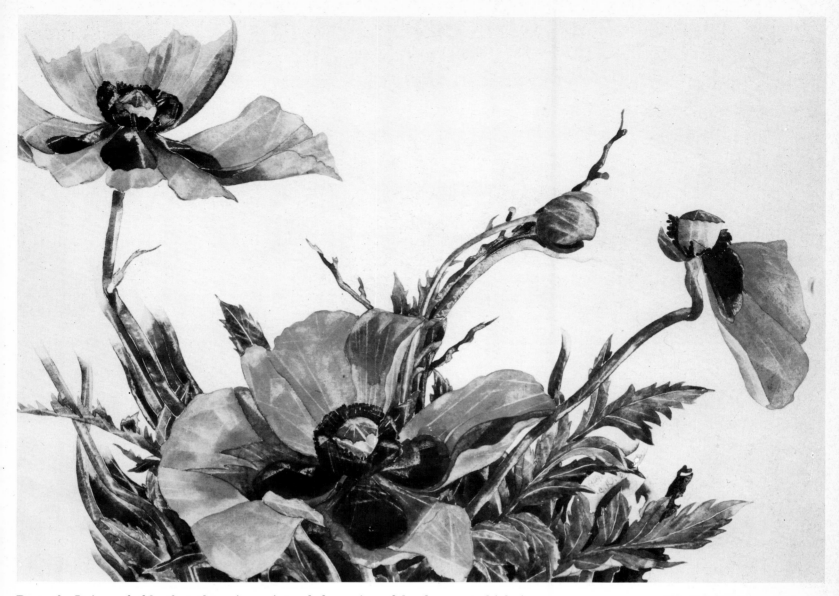

Demuth. It is probable that there is no intended irony in such pictures as *American Landscape* (Museum of Modern Art, New York), or even in *Classic Landscape* (private collection), in which the gleaming, clean lines of a factory complex are likened to Greek architecture (indeed one wonders if Grant Wood was making a direct reference to this when he painted *American Gothic*). Certainly in Sheeler's masterpiece *Upper Deck* 1929 (Fogg Art Museum), and in *Interior* 1926 (Whitney Museum of American Art) and *Objects on a Table (Still-life with White Teapot)* 1924 (Columbus Gallery of Fine Arts), he shows that his concern is primarily with line, and the fine spatial tensions resulting therefrom, rather than with the socio-political commitment of the Regionalists and the Social Realists.

Preston Dickinson's work is in many ways less satisfactory than either Sheeler's or Demuth's. Born in New York in 1891, he studied under the Impressionist Ernest Lawson, and under George Bellows. Between 1910 and 1911, he worked in Paris, where the strongest influence on his work was that of Cézanne. Between 1913, when the Cézanne landscapes he saw in the Armory Show added impact to the paintings he had seen already in France, and about 1920, Dickinson painted a

series of landscapes which in many cases come dangerously close to being mere pastiche. Only in about 1924 did his own style emerge, and he then produced a series of splendid industrial landscapes and rich still-lifes which are a distinct improvement on his previous work. His still-lifes, perhaps the finest example of which is the *Still-life Number 1* of about 1924 (Columbus Gallery of Fine Arts, Ferdinand Howald Collection), are less satisfactory than the landscapes, primarily because of the rather uncontrolled use of colour and also because of their disturbing closeness to the late work of Gris and to the still-lifes of Derain's post-Fauve period. The landscapes, however, have that same controlled elegance associated with other leading Cubist-Realists. Unfortunately, Dickinson's style did not have time to develop fully – he died prematurely at the age of thirty-nine.

Niles Spencer was born in 1893 at Pawtucket, Rhode Island. He became a teacher at the Rhode Island School of Design in 1915, but was soon dismissed; even though his lectures were firmly based upon the philosophy of Henri and the Ash Can School, they were still considered too progressive. In 1921 he went to Paris and was duly impressed by the Cubists, and the direction his art was to take

186 *Red Poppies*
1929
Charles Demuth 1883–1935
watercolour, 14 × 20 in

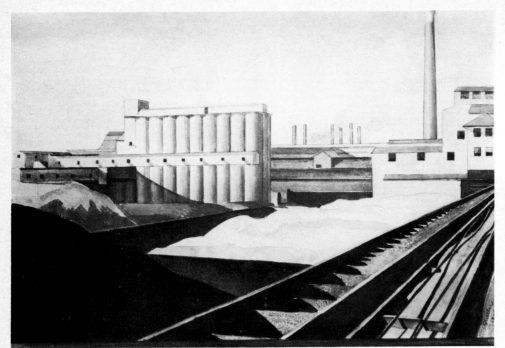

187 *Classic Landscape*
1928
Charles Sheeler 1883–1965
oil on canvas, $8\frac{1}{2} \times 12$ in

188 *Still-life with Compote*
1922
Preston Dickinson
1891–1930
pastel, $15\frac{1}{2} \times 18\frac{1}{2}$ in

was formalised the following year when he met and became good friends with both Sheeler and Demuth. In his choice of subject-matter – predominantly industrial landscapes, the finest of which were executed in the late 1920s – Spencer is definitely one of the Precisionist school, yet his style is heavier and less sophisticated than that of his friends. In some pictures, such as *Corporation Shed* of 1928 (Columbus Gallery of Fine Arts, Ferdinand Howald Collection), we are inevitably reminded of de Chirico's metaphysical landscapes, whilst in others, the underlying structure is closer to Stuart Davis's version of Cubism than to Sheeler's or Demuth's.

Active concurrently with the Precisionists were several painters who may be divided into three groups, although some of the painters belonged to more than one group. Charles Burchfield, Edward Hopper and Andrew Wyeth were concerned with the depiction of rural and small-town America. Whilst they found an uncomplicated beauty in such scenery, Burchfield and Wyeth were, in general, more poetic and idealistic than Hopper, although Burchfield at least was capable of strong social protest of a type which, in Hopper's words about his friend's art, described, 'All the sweltering, tawdry life of the American small town, and behind all, the sad destruction of our suburban landscapes'. The second group, of whom the leading members

were Thomas Hart Benton, John Steuart Curry and Grant Wood, has been described as 'Regionalist', a label which has little meaning and is perhaps confusing. In fact, the grouping of these three artists together, initially the work of the critic Thomas Craven, is itself misleading, since the chauvinistic conservatism of Benton, his emphasis on 'American values', has little real connection with the far more satiric vision of Grant Wood. If, like Burchfield and Hopper, Wood was striving for a better America, Benton, it would seem, already found it pretty good. The third group are generally known as the Social Realists, of whom perhaps the most famous is Ben Shahn. They con-

tinued the tradition of the Ash Can School, depicting the material and spiritual poverty of American city life during the Depression.

Edward Hopper (1882–1967) was a student of Robert Henri in New York between about 1900 and 1906. The measure of his greatness lies in the fact that whilst he, like Benton and others whom Barbara Rose has characterised as the 'American Scene' painters, was concerned with the investigation of a particular environment and way of life, his work never falls to the level of bathos and melodrama of which Benton's work in particular is so often guilty.

After leaving Henri's classes, Hopper studied in

189 *Early Sunday Morning*
1930
Edward Hopper 1882–1967
oil on canvas, 35 × 60 in
Collection Whitney Museum
of American Art, New York

190 *Cicada Song*
(Autumnal Fantasy)
1917–44
Charles Burchfield
1893–1967
watercolour, 37 × 52½ in

Paris. He enjoyed a financial success with his work in the Armory Show, but then almost completely stopped painting for a decade, becoming a commercial illustrator. Like the Pop painters later in the century, many of whom had the same contact with commercial art, this experience may partly explain Hopper's unerring gift for achieving the maximum impact with the utmost simplicity of means from a comparatively mundane scene. As many critics have pointed out, Hopper's principal theme was loneliness. When he returned to painting in the 1920s, he executed such stark compositions as *House by the Railroad* 1925 (Museum of Modern Art, New York), which set the tone of his work for the rest of his life. His studies of people, often in crowded, enclosed spaces but always, paradoxically, alone as in *New York Movie* 1939 (Museum of Modern Art, New York), the paintings of isolated loneliness–*Room in New York* (University of Nebraska Art Galleries, F.M. Hall Collection) or *Gas* 1940 (Museum of Modern Art, New York) and the desertion of particular locales, *House on the Railroad, Seven A.M.* 1948 and *Early Sunday Morning* 1930 (Whitney Museum of American Art)–all have that air of sadness, combined with a deep sympathy and indignation, which raises Hopper's art to a level of true greatness.

Hopper was no technical innovator, and the painterly qualities of his work are certainly traditional. Whilst not consciously turning his back on the developments in construction pioneered by the Cubists, he felt perhaps that American artists had first to know themselves before they could truly know anything else. A painter of unquestionable integrity, his work, whilst outside the mainstream of Western painting at this time, is in no way anachronistic. Faced with his art, we cannot help seeing the superficiality of much of the American experimentation with Cubism.

Charles Burchfield (1893–1967) was close to Hopper in spirit, and yet his art is generally more lyrical. He was a romantic, just as concerned with the inherent beauty of the American scene as he was with its frequent despoliation. Whilst such compositions as *Black Iron* 1935 (private collection) are grim indictments of industrial waste, the power of a technological society to create an inhuman desert, yet it is in such compositions (almost all of which are watercolours) as *Song of the Red Bird* (private collection), a gentle poetic evocation of well-loved scenery, that the artist appears to be at his finest.

Distinct from the art of Hopper and Burchfield is that of those painters who have been rather

incongruously described as Regionalist. Benton, Grant Wood, and John Steuart Curry, the three leading members of this 'school', if such it can be called, had differences so great, both in style and temperament, that any grouping on an artistic level becomes difficult to justify; that they were so grouped was largely due to the efforts of the reactionary, extreme right-wing critic Thomas Craven, who made the works of the Regionalists a vehicle for an intense, almost ludicrous, chauvinism. In his book on modern American art, Rudi Blesh quoted Benton's pupil Jackson Pollock: 'They put the screws on with a vengeance . . . You were only trying to find how you needed to paint and you were un-American. I noticed that some damned fine American painters, men like John Marin, for example, wouldn't touch the movement with a ten foot pole.'

Of the artists whom Craven chose to lionise, only Benton showed himself to be a suitable vehicle for such treatment. In his biography *An Artist in America*, published in 1937, he referred to the painters who had gathered around Stieglitz (he appeared to forget conveniently that he had once been one of them) as 'an intellectually diseased lot, victims of sickly rationalizations, psychic inversions and God-awful cultivations'. On a slightly more rational note, he also wrote of the Regionalist movement:

'We were different in our temperaments and many of our ideas, but we were alike in that we were all in revolt against the unhappy effects which the Armory Show of 1913 had on American painting. We objected to the new Parisian aesthetics which was more and more turning away from the living world of active men and women into an academic world of empty pattern. We wanted an American art which was not empty and we believe that only by turning the formative processes of art back again to meaningful subject matter, in our cases specifically American subject matter, could we expect to get one.'

In some ways, of course, there is great truth in Benton's remarks. We have already discussed the superficiality of the American understanding of Cubism and we would certainly agree that American painting, if it was to develop its own character, had to come out from under the shadow of European aesthetics. But this would not be achieved by taking up a narrow-minded provincial stand, by retreating into a flag-waving patriotism, an attitude of mind which all but ruined British painting in the last decades of the 19th century. It is for this reason that Hopper will almost certainly be judged by history as a great painter who came to terms with his heritage, whilst Benton will be seen in future years, as he is already being seen now, as a minor painter wielding a political weapon with singularly ill effect.

In an interview given to the magazine *Art and Architecture* in 1944, Jackson Pollock once again pointed to the flaw in Benton's artistic ethic. In reply to the question, 'Would you like to go abroad?', Pollock said, 'No, I don't see why the problems of modern painting can't be solved as well here as elsewhere'. This was a positive response; it acknowledged the truth, also recognised by Hopper, that if an artist does not keep faith with his own environment and the experiences which emanate therefrom, his work will lack strength and, more importantly, integrity. But this does not mean that an artist must of necessity reject the lessons of other artists from other countries. Pollock absorbed and transformed the innovations of Europe, Benton sought to reject them utterly. Their different achievements may be seen as a direct result of their two diverse attitudes.

Benton's rejection of European modernism (he had painted in a Synchromist style early in his career) had the quality of harsh moralism which characterises the rejection by anyone of something to which he has at one time been addicted. In the 1930s, when the Communist mural painters from Mexico, Rivera, Siquieros and Orozco were infuriating the right-wing element of America by their activities, Benton was painting his murals in the New School of Social Research in New York, the ugliness of which come close to the Socialist Realism of much recent Russian art. Compared with the work of Ben Shahn, Jack Levine or of the

191 *Self-portrait*
1955
John Steuart Curry
1897–1946
oil on canvas, 30 × 25 in

192 *Weighing Cotton*
Thomas Hart Benton
1889–
oil on canvas, 31 × 38 in

193 *Daughters of Revolution*
1932
Grant Wood 1892–1942
oil on canvas, 20 × 40 in
Cincinnati Art Museum
(Courtesy Associated
American Artists, New
York)

194 *American Gothic*
1930
Grant Wood 1892–1942
oil on beaver board,
29¾ × 24¾ in
Art Institute of Chicago
(Friends of American Art
Collection)

190

Mexicans themselves, such works as these, or the vulgar 'Classical' nudes in an American setting such as *Persephone* of 1939 or *Susannah and the Elders* 1938 (California Palace of the Legion of Honor, San Francisco) seem overblown and bathetic. Certainly Benton captured some of the excitement and gaudy vitality of the American scene and he honestly believed that a 'grassroots' approach, both to painting and to the environment, was the only one which was going to have direct appeal to people. But there is something naive in his belief that America was capable, *per se*, of producing great painting, and more than a little of the perverse in his intransigent right-wing approach.

In contrast, Grant Wood was a painter of more complexity and artistic talent than Benton. We cannot imagine the latter painting such a deep-felt and penetrating satire on American patriotism as Wood's *Daughters of Revolution* 1932 (Cincinnati Art Museum). Members of the Sons of the American Revolution, ironically, described this painting with considerable accuracy: '. . . three sour-visaged squint-eyed and repulsive-looking females, represented as disgustingly smug and smirking because of their ancestral heroes of the American Revolution'.

With that somewhat wicked sense of humour which often characterised his work, Wood depicted these three 'ugly sisters' as standing in front of the 19th-century's most crass and vulgar rendition of American history, Emanuel Leutze's *Washington Crossing the Delaware*. What prompted Wood's picture was the refusal by the Daughters of the American Revolution to dedicate a stained-glass window designed by the artist for the Cedar Rapids Veteran Memorial because it had been made in Germany; the fact that Leutze was a German no doubt appealed to the artist's sense of the ridiculous. The same humour can be seen in *Parson Weems' Fable* 1939 (John P. Marquand Collection), which depicts the story of the young George Washington cutting down a cherry tree and then owning up. The painter, much to the indignation of patriots, purposely called the painting a 'fable' and added to the fun by depicting Washington in the guise of the elderly 'Athenaeum' head grafted on to a child's body, probably a reference to the fact that the story did not gain currency until after the President's death. In commenting on the picture, Wood said, 'I have taken a tip from the good Parson and used my imagination freely.'

Unquestionably Wood's most famous painting, and one of the best known of all American pictures is *American Gothic* 1930 (Art Institute of Chicago), a portrait of the artist's sister Nan and of Dr. B. H. McKeely, a dentist from Cedar Rapids. Executed when the artist was thirty-eight, this work gained him immediate fame, winning a bronze medal in an exhibition organised by the Art Institute of Chicago. In this painting, a far more direct appeal to the honest virtues of hard work and sobriety than Benton's harsh clamorings, Wood not only shows his indebtedness to 15th-century Flemish painting in his meticulous brushwork and clear, bright colours, but also enters the mainstream of American realist painting. It has that same sense of sadness to be found in Walker Evan's magnificent photographs for James Agee's *Let Us Now*

196 *Wonderland Circus,*
Sideshow, Coney Island
1930
Reginald Marsh 1898–1954
tempera on masonite,
$47\frac{1}{2} \times 47\frac{1}{2}$ in

197 *Black Iron*
1935
Charles Burchfield
1893–1967
watercolour, 29 × 41 in

198 *Christina's World*
1948
Andrew Wyeth 1917–
tempera on gesso panel,
$32\frac{1}{4} \times 47\frac{3}{4}$ in
Museum of Modern Art,
New York (Purchase)

199 *T.P.'s Beach*
1950
Thomas Hart Benton
1889–
tempera on paper mounted
on board, 21 × 28 in

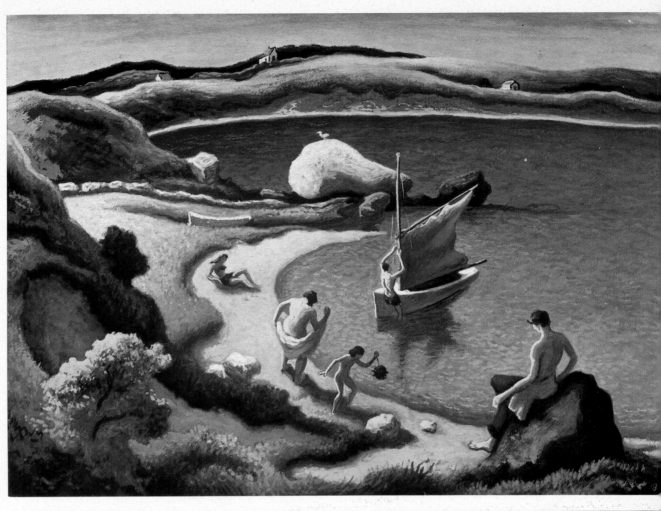

200 *The World's Greatest Comics*
1946
Ben Shahn 1898–
tempera on panel, 35 × 48 in

Praise Famous Men, but the fanaticism, or rather the indictment thereof, which has been read into it, has perhaps been overstated by many critics.

Born in 1917, and still painting today, it is arguable that Andrew Wyeth is the finest of all the 'American Scene' painters. Although he has suffered from over-exposure and the reduction of some of his work to the level of a cliché, no-one can deny the extraordinary impact he has made on the American consciousness and can undervalue his unique contribution to the development of realist painting in America. Wyeth's approach to realism, however, is far more complex than might at first sight appear. Like the young generation of realist painters working in America today, Wyeth absorbed all that 20th-century art had to teach him and thinks of himself as deeply rooted in the modernist tradition: 'I'm no more like a realist such as Eakins and Copley, than I'm like the man in the moon . . . I want more than half the story. There are some people who like my work because they see every blade of grass. They don't see the tone. If you can combine realism and abstraction, you've got something terrific.' This approach is comparable to Sheeler's 'growing belief that pictures realistically conceived might have an underlying abstract structure.'

In Wyeth's work, a perfectly controlled structure is combined with an external realism. Like Wood, he seems to owe much to the Early Netherlandish artists, but he is possibly the only one of the 'American Scene' painters to have a real understanding of modern European art.

In 1929, the Wall Street market crashed and America was plunged into the bitter era of the Depression. Like workers in every sphere, artists found it difficult, at times impossible, to sell their work, and if it had not been for the Federal Art Project of the Works Progress Administration, it is likely that many artists would have been unable to support themselves through their work. Through the WPA, artists of all types were employed by the Government and paid a monthly salary. A part of the total project was the institution of the Public Works of Art project, which employed literally thousands of artists all over America in producing large-scale commissions for public buildings. The Mexican painters mentioned above, Siqueiros, Rivera and Orozco, had revived the art of mural painting in America through their work at Pomona College, the School for Social Research, New York, Dartmouth College, the San Francisco Stock Exchange, the Detroit Institute of Arts and Radio City. Amongst others, George Biddle, Ben Shahn, William Gropper and Arshile Gorky (who was responsible for the celebrated *Aviation: Evolution of Forms under Aerodynamic Limitation* for Newark Airport) executed murals, whilst almost all the painters who were to make such an impact in the 1940s, including de Kooning, Pollock, Gottlieb, Reinhardt, Gorky and Rothko were employed in some capacity. The wonder of it all was that, as so many critics have pointed out, when the WPA ceased in 1943, so little of real worth had resulted.

201 *The Board of Directors*
Ben Shahn 1898–
gouache, $13\frac{1}{4} \times 16\frac{1}{4}$ in

202 *The Modern Inquisitor*
about 1938
Philip Evergood 1901–
oil on canvas, 27×20 in

However, in that it was a unique attempt by a government to support its country's artists in time of considerable economic and social difficulty, the WPA was a project worthy of admiration and gratitude.

During the 1930s, a third 'school' of American painting developed, concerned with life in the large cities and with social protest. This movement included such stylistically diverse painters as Ben Shahn, Philip Evergood, Peter Blume, Jack Levine,

203 *The Passion of Sacco and Vanzetti*
1931–32
Ben Shahn 1898–
tempera on canvas,
84½ × 48 in
Collection Whitney Museum
of American Art, New York
(Gift of Edith and Milton
Lowenthal in memory of
Juliana Force)

Reginald Marsh and Moses Soyer. In 1936, the most politically minded of these painters formed themselves into a left-wing, anti-fascist group calling itself the Artist's Congress; its secretary, not surprisingly, was Stuart Davis, whose Cubist renderings of urban scenes, influenced as they were by the French painter and Communist Fernand Léger, were greatly admired by the younger generation.

Art and politics lie uneasily together, and there is little doubt that much of what was produced by the Social Realists now strikes us as hollow posturing, as rigidly left as Benton was stubbornly right. Nevertheless, the strength of the best paintings of the movement lies in the passionate conviction of the artists in the rightness of their cause. Social and political protest is a timeless activity, and, whilst even forty years is too short a period in which to make objective historical valuations, yet the tragedy and indignation of Shahn's *Sacco and Vanzetti* series, a powerful indictment of injustice and inhumanity, will certainly impress the sensitive beholder long after the event which prompted the statement has faded into history.

We have quoted Thomas Wolfe before, but a passage from *You Can't Go Home Again* perfectly describes the feelings and motivations of the Artist's Congress, as well as those of such painters as Hopper:

'In other times, when painters tried to paint a scene of awful desolation, they chose the desert or heath of barren rocks, and there would try to picture man in his great loneliness–the prophet in the desert . . . But for a modern painter, the most desolate scene would be a street in almost any one of our great cities on a Sunday afternoon. Suppose a rather drab and shabby street in Brooklyn, not quite a tenement perhaps, and lacking therefore even the gaunt savagery of poverty, but a street of cheap brick buildings, warehouses and garages, with a cigar store or a fruit stand or a barber shop on the corner. Suppose a Sunday afternoon in March–bleak, empty, slaty grey. And suppose a group of men, Americans of the working class, dressed in their 'good' Sunday clothes–the cheap machine-made suits, the new cheap shoes, the cheap hats stamped out of universal grey. Just suppose this, and nothing more. The men hang round the corner before the cigar store or the closed barber shop, and now and then, through the black and empty streets, a motor car goes flashing past, and in the distance they hear the cold mumble of an elevated train. For hours they hang round the corner, waiting–waiting–waiting . . .
for what?
Nothing. Nothing at all. And that is what gives the scene its special quality of tragic loneliness, awful emptiness and utter desolation. Every modern city man is familiar with it.'

The Social Realists were not, however, completely concerned with life in the city. In 1935 the Farm Security Administration commissioned a number of distinguished photographers, including Ben Shahn, to depict the plight of the poverty-stricken farmers of the South and Mid-West. Among them were Dorothea Lange, John Vachon, Carl Mydens, Arthur Rothstein and Russell Lee, whilst the unquestionable masterpiece of the whole project was that magnificent essay by James Agee, illustrated with Walker Evans' photographs, called *Let Us Now Praise Famous Men*. If the WPA produced little else of lasting significance, this joint work at least is an enduring monument.

Ben Shahn's role as a painter has always been the most controversial of any of the Social Realists. He was concerned primarily with specific causes; he used his brush like Swift or Voltaire used their pens, to uphold justice and pour contempt on dishonesty and cant. When in 1927 Nicola Sacco and Bartolomeo Vanzetti, two immigrant Italians, were executed for a murder of which they may well have been innocent, Shahn began a series of twenty-three paintings based on the subject. The most famous of them, *The Passion of Sacco and Vanzetti*, depicts all the protagonists of the drama, including the three men who decided that the trial had been impartial who are shown standing over

204 *Germinal – Homage to Zola*
1963
Philip Evergood 1901–
oil on canvas, 44 × 39½ in

205 *Pip and Flip,*
Twins from Peru
1932
Reginald Marsh 1898–1954
tempera on masonite,
$47\frac{1}{2} \times 47\frac{1}{2}$ in

the coffins containing the bodies of the executed men and carrying lilies, the symbol of purity, innocence and martyrdom.

Philip Evergood and Jack Levine were also capable of powerful social protest of this kind. Evergood's *American Tragedy* (private collection) depicts the events on Memorial Day, 1937, when a thousand Republic Steel workers went to the newly formed Steelworkers' Union rally; the march was savagely broken up by the police, who seriously injured over a hundred of the workers and killed nine others, one of whom, a woman, was shot in the back. In the same year, Levine executed his most telling exposure of political corruption, *The Feast of Pure Reason* (Museum of Modern Art, New York), using his peculiarly glutinous, opalescent style to achieve a gloomy, sinister effect. Sixteen years later, Levine painted *Gangster Funeral* (Whitney Museum of American Art, New York) and showed that he had lost none of his powerful sense of outrage at the gross criminality behind much 'big business'.

Peter Blume, whilst being an artist of political protest equal in stature to Shahn or Evergood, used a more Surrealist idiom which often detracts from the power of his cause. His most famous work, *The Eternal City* 1934–37 (Museum of Modern Art, New York), savagely parodies Mussolini's fascism and its effect upon Italian life. Here he employed a Surrealist idiom which appears to owe much to Dali, but in so doing he partly destroyed the effect to be gained from a more straightforward narrative approach such as Evergood's.

Reginald Marsh was perhaps closest to Wolfe's description of the artist and his subject. He was concerned with life in the city; his broad, bold style, derived from his admiration of Rubens and Van Dyck, captures vividly the frenetic pace of city life and its paradoxical loneliness. An artist working slightly later, George Tooker, also captured the claustrophobia and misery of city life but, unlike Blume, he was able to use a basically Surrealistic approach to good effect.

The period between 1900 and 1940 was one of considerable activity in the arts in America. Artists had experimented with European Fauvism, Cubism and Expressionism with some success, whilst a unique awareness of the values of the American environment first began to make itself apparent. It was this latter feeling which was to have the most decisive effect in the future. Perhaps we should leave the final words to Edward Hopper: 'The question of the value of nationality in art is perhaps unsolvable. In general it can be said that a nation's art is greatest when it most reflects the character of its people. French art seems to prove this . . . If an apprenticeship to a master has been necessary, I think we have served it. Any further relation of such a character can only mean humiliation to us. After all we are not French and never can be, and any attempt to be so is to deny our inheritance and to try to impose upon ourselves a character that can be nothing but a veneer upon the surface.'

American painting since 1945

American art had by the late 1930s served its apprenticeship, to use Hopper's felicitous phrase. But in order for it to develop further, a catalyst was necessary. Ironically, the rise of Nazism and the political chaos into which Europe was plunged during the 1930s and 1940s proved to be the key factor in the birth of an avant-garde American art some twenty-five years ago.

Great artists are often somewhat anti-Establishment figures, and the dictatorships which took control of Europe meant the end of artistic freedom for some of the most outstanding figures in the history of 20th-century painting and sculpture. Consequently, throughout the 1930s a number of leading artists left Europe and made their way to the United States. Duchamp, of course, had been a regular visitor to America since the Armory Show, whilst Léger had been in the States briefly in the early 1930s. In 1933, the Bauhaus, that unique centre of art and design, with certainly the most illustrious teaching faculty that any art school has ever been able to boast, was forced to close. Josef Albers, who over a quarter of a century later was to have tremendous effect upon the development of American painting, was one of the first to arrive, and in 1934 started teaching at Black Mountain College in North Carolina. Hans Hofmann, who had not been on the Bauhaus staff, but who had been one of the most important art teachers in Germany since 1915, had visited America in 1930 as a lecturer at the University of California at Berkeley. He settled permanently in the United States in 1932, and a year later opened his own school in New York, which was to become of prime importance in the development of Abstract Expressionism.

Following Albers' lead, some of the greatest of the Bauhaus teachers, in search of both political and artistic freedom, soon settled in America. These included Mies van der Rohe, Walter Gropius, Marcel Breuer, Laszlo Moholy-Nagy, Herbert Bayer and the ex-patriot American Lyonel Feininger. Later in the decade the Surrealists began to arrive from France: Yves Tanguy, André Breton, André Masson, Max Ernst, Salvador Dali, Kurt Seligmann and the Chilean Robert Matta. Also from France came Marc Chagall and Pavel Tchelitchev, the Cubist-Purists Léger, Ozenfant and Hélion, and the sculptors Ossip Zadkine and Jacques Lipchitz. One of the last to arrive, in 1940, was the leading member of the Dutch De Stijl group, Piet Mondrian.

Almost all of these artists, legendary figures to many of the young generation of American painters, settled in New York and, by their presence and their willingness to teach and help, were instrumental in founding that group which has dominated Western art in the second half of the 20th century, the New York School.

As with the growth of modernism in America at the beginning of the century, and the influential part played by Alfred Stieglitz, so the immigrant artists and the young generation of painters and sculptors in the United States in the late 1930s found one person with the energy, foresight and financial ability to actively support and encourage them—Peggy Guggenheim. Miss Guggenheim had lived in Europe for many years, had started a gallery in London called Guggenheim Jeune, and knew many of the leading European painters intimately (she was married to Max Ernst). With the rise of Nazism, she returned to the United States and in 1941 founded in New York a combined gallery and museum which she called Art of This Century. Here were exhibited the works of many of the European painters who had settled in America, as well as those of young American painters such as Pollock, Motherwell, Baziotes, Rothko, Still, and Gottlieb. One of the earliest links between the European painters and the development of a distinctive American school was the work of the American immigrant painter Arshile Gorky. If we accept de Kooning's statement that it was Jackson Pollock who 'broke the ice', we must also accept that Gorky was the first American painter to absorb the mythological and literary content and the automatic technique of much Surrealist painting in such a way as to retain both the basic imagery and strong emotionalism of his source, and also to break away into a freer, more abstract, gestural mode.

Arriving in the United States in 1920 at the age of sixteen, Gorky 'apprenticed' himself to the two great masters of modern painting, Cézanne and Picasso. Throughout the 1920s, he painted many landscapes in a style derived from, and often very

close to, the late work of Cézanne, and also several works which owe much to the Pink Period of Picasso and the latter's early Cubist compositions. In the finest work in this style, *The Artist and His Mother* 1926–29 (Whitney Museum of American Art), Gorky already demonstrates that delicate, free use of paint combined with a composition of great strength and balance which was to characterise his work in the 1940s.

Although the study of Cézanne and Picasso was essential to his development as a painter, subjecting him to necessary disciplines, Gorky soon found that he needed to move away from the rigidity of

the Cubist analysis of space. The inspiration he needed came from the Surrealists. In a famous essay published in the *Partisan Review* in 1955, Clement Greenberg wrote:
'... Gorky submitted himself to Miró in order to break free of Picasso, and in the process did a number of pictures we now see to have independent virtues although at the time – the late 1930s – they seemed too derivative. But the 1910–18 Kandinsky was even more of a liberator and during the first war years stimulated Gorky to greater originality. A short while later André Breton's personal encouragement began to

206 *Study for Homage to the Square: Dimmed Centre*
1961
Josef Albers
oil on masonite, 18 × 18 in

203

inspire him with a confidence he had hitherto lacked, but again he submitted his art to an influence, this time of Matta Echaurren, a Chilean painter much younger than himself.'

In the early 1940s, Gorky's paintings developed in richness and originality of form at a surprising rate. He was an artist of deep sensuality and his work is redolent with sexual symbolism, the cryptography of the body. *The Liver is the Cock's Comb* 1944 (Albright-Knox Art Gallery)—even the title

is purposely carnal—is perhaps the greatest painting of this period, and prefigures that sustained series of masterpieces executed in 1947 and 1948 which includes *Agony* 1947 (Museum of Modern Art, New York), *The Plow and the Song* 1947 (private collection) and *The Betrothal II* 1947 (Whitney Museum of American Art, New York).

Gorky's life ended in great tragedy. In 1946, a fire in his studio destroyed the majority of his most recent work and later in the same year he was

207 *Abstraction*
Arshile Gorky 1904–48
oil on masonite, 24 × 18 in

208 *The Betrothal, II*
1947
Arshile Gorky 1904–48
oil on canvas, 50¾ × 38 in
Collection Whitney Museum
of American Art, New York

209 *Primeval Landscape*
1953
William Baziotes 1912–
oil on canvas, 60 × 72 in
Samuel S. Fleisher Art
Memorial administered by
the Philadelphia Museum
of Art

210 *The Sorcerer*
1948
Adolph Gottlieb 1903–
oil on canvas, 38 × 30 in

operated upon for cancer. Working frantically throughout 1947, he produced some of his greatest paintings. 1948 was the culminating year in this last desperate period: Gorky broke his neck in an automobile accident and became separated from his wife and family. Finally the strain became unbearable; on July 21, 1948, at the age of forty-three, he hanged himself. Perhaps the words of André Breton about *The Liver is the Cock's Comb* sum up the scope of Gorky's achievement:
'Here is an art entirely new, at the antipodes of those tendencies of today, fashion aiding confusion, which simulate Surrealism by a limited and superficial counterfeit of its style. Here is the terminal of a most noble evolution, a most

patient and rugged development which has been Gorky's for the past twenty years; the proof that only absolute purity of means in the service of unalterable freshness of impressions and the gift of unlimited effusion can empower a leap beyond the ordinary and the known to indicate, with an impeccable arrow of light, a real feeling of liberty.'

The Surrealists' approach to creativity and the unconscious also had a liberating effect on the other members of the growing New York School. William Baziotes used imagery based upon organic forms, following Miró, Arp and Ernst, as did Mark Rothko and Adolph Gottlieb. In 1937, Gottlieb exiled himself to the Arizona desert for a year and

produced a series of still-lifes based upon the forms of cacti; this led into his 'pictographs' of the 1940s, in which strange two-dimensional shapes were laid across the canvas like hieroglyphics, and were indeed intended to be 'read'. This element of 'reading' through the medium of an individually worked out 'calligraphy' can also be seen in the 'white writing' paintings of Mark Tobey, who was deeply influenced by the subtlety and delicacy of Japanese and Chinese calligraphy.

Franz Kline's work falls mid-way between the more tightly controlled style of Gottlieb and

211 *Broadway Norm*
1935
Mark Tobey 1890–
tempera, 13 × 9¼ in
Collection Mrs Carol Ely
Harper, Seattle

Baziotes and the free, gestural painting of Pollock, although there can be little doubt that the shape and form of Oriental calligraphy too had an influence upon Kline's development. The huge black and white images of his early period (later he relied more on colour) show an obvious affinity with the works of such painters as Philip Guston and Bradley Walker Tomlin, although there was also a more prosaic reason for his change from representational to an abstract mode. Elaine de Kooning, writing in the catalogue of the Franz Kline Memorial Exhibition at the Washington Gallery of Modern Art in 1962, described this event as follows:

'One day in 1939, Kline dropped in on a friend who was enlarging some of his own small sketches in a Bell-Opticon. "Do you have any of those little drawings in your pocket?", the friend asked. Franz always did and supplied a handful. Both he and his friend were astonished at the change of scale and dimension when they saw the drawings magnified bodilessly against the wall. A four by five inch drawing of the rocking chair Franz had painted over and over, so loaded with implications and aspirations and regrets, loomed in gigantic black strokes which eradicated any image, the strokes expanding as entities in themselves, unrelated to any reality but that of their own existence. He fed in the drawings one after another and again and again the image was engulfed by the strokes that delineated it.'

It was in its ability to free American art from the convention of portraying perspective that Abstract Expressionism achieved its greatest breakthrough. The techniques of automatic creation experimented with in Paris in the 1920s were revived again by Pollock and others, who attempted to create a spontaneous language removed from the academic strictures of European art. Whereas earlier abstract artists such as Mondrian and Kandinsky had used disciplined techniques to achieve formal compositions, Pollock worked quite freely, often dribbling strands of paint on to the canvas, relying on impulse and irrational ideas to make the picture, rather than working to a specific plan or image.

The act of painting then became the subject of the picture. Pollock's method of painting has become notorious: laying the canvas on the floor, he worked on it from all sides because he felt that by so doing he could enter into the composition physically. As he has said: 'When I am in my painting, I'm not aware of what I'm doing. It's only after a sort of get-acquainted period that I see what I have been about. I have no fears of making changes, destroying the image, etc., because the

212 *Painting Number 7*
1952
Franz Kline 1910–62
oil on canvas, $57\frac{1}{2} \times 81\frac{1}{2}$ in
Solomon R. Guggenheim
Museum, New York

213 *Number 32*
1950
Jackson Pollock 1912–56

214 *Two Standing Women*
1949
Willem de Kooning 1904–
oil on canvas, $29\frac{1}{2} \times 26\frac{1}{4}$ in

215 *Route 40*
1960
Willem de Kooning 1904–
oil on canvas, 27½ × 39 in

painting has a life of its own. I try to let it come through. It is only when I lose contact with the painting that the result is a mess. Otherwise there is pure harmony, an easy give and take, and the painting comes out well.'

Another innovation was that the composition ceased to have a set boundary – extend the canvas to infinity and the painting expands with it. Pollock, de Kooning, Still and Rothko all began to use larger and larger canvases in the late 1940s, so that by 1950 they were all using surfaces which were almost mural size.

In an interview given in the *New Yorker* in 1950, Pollock said:
'Abstract painting is abstract. It confronts you. There was a reviewer a while back who wrote that my pictures didn't have any beginning or any end. He didn't mean it as a compliment but it was. It was a fine compliment.'

The other principal artist of the movement was Willem de Kooning, who came to America when he was twenty-two having already studied in Europe. He was the only major artist of his generation not to abandon representational art completely. Throughout his life he developed the theme of the female figure. In his pictures woman appears powerful and destructive, and further violence is intro-

duced in the broken shapes, slashing brushstrokes, and rough finish of the canvas.

Pollock's paintings, like those of Willem de Kooning, Philip Guston, Franz Kline, Adolph Gottlieb and Robert Motherwell, rely more upon gesture, on an interaction of ceaseless and often violent aggressive movement of paint, to achieve their ends. In contrast, Barnett Newman, Ad Reinhardt and Mark Rothko moved around 1950 towards a more open colour field to create spatial tension. Yet there are crucial differences as well as similarities between these three. Rothko and Rheinhardt used the subtle counterbalance of one or two closely related colours to achieve a complex surface movement. Newman was much more involved with areas acting upon each other than colours; he used texture to weave as sensuous a surface web as anything produced by Pollock, but he was, far more than Rothko or Rheinhardt, a draughtsman. As he himself said: 'I am always referred to in relation to my colour. Yet I know that if I have made a contribution, it is primarily in my drawing. The Impressionists changed the way of seeing the world through their kind of drawing; the Cubists saw the world anew in their drawing, and I hope I have contributed a new way of seeing through drawing. Instead of using outlines, in-

216 *Untitled*
1946
Jackson Pollock 1912–56
gouache, $22 \times 32\frac{1}{2}$ in

217 *Orange, Red, Yellow*
1956
Mark Rothko 1903–
oil on canvas, $79\frac{1}{2} \times 69$ in

218 *Hanging Gardens*
1966
Helen Frankenthaler 1928–
oil on canvas, 82¼ × 69½ in

219 *Four Pin Ball Machines*
1962
Wayne Thiebaud
oil on canvas, 72 × 72 in
Allan Stone Galleries,
New York

220 *Hot Fudge Sundae*
1972
Ralph Goings
oil on canvas, 40 × 56 in
Gallerie Ostergren, Sweden

221 *1947-Y*
1947
Clyfford Still 1904–
oil on canvas, 69 × 50 in

222 *Jagged*
1960
Adolph Gottlieb 1903–
oil on canvas, 72 × 48 in

223 *Red Number 2*
Sam Francis 1923–
oil on canvas, 76 × 45 in

stead of making shapes or setting off spaces, my drawings declare the space. Instead of working with the remnants of space, I work with the whole space.'

The Abstract Expressionists created a climate of opinion in America which was unprecedented. They showed at last that it was possible for a group of young American painters to create out of a legacy of European experiment an art which was unique in itself and which could stand on its own merits, indeed was infinitely more bold and adven-

224 *Figure Number 2*
1955
Jasper Johns 1930–
encaustic with newspaper
collage on canvas, 17 × 13¾ in

turous than anything being attempted in a Europe still dominated by the Cubist ethos. For the first time in its history, American painting had become supreme in the Western world.

Ironically, however, just at a time when the Abstract Expressionists had made such an amazing technical and critical breakthrough, the second generation, basking in the reflected glory of their elders, began to revolt. It did not take long for Robert Rauschenberg and Jasper Johns to return to a more painterly and representational mode, and in so doing for Rauschenberg to erase a drawing by Willem de Kooning since he felt that such a gesture would not only create a work of art in its own right (with that absolute logic which characterises the Pop Artists, Rauschenberg felt that erasure was as valid a method of creation as application, a natural extension of the Zen philosophy he had absorbed from John Cage at Black Mountain), but that it would be also a symbolic

gesture against an artist who was already being accorded 'Old Master' status.

By 1953, Helen Frankenthaler in New York had rejected what she felt were the too painterly qualities of the Abstract Expressionists. In spite of their technical innovations, they still applied paint to a canvas, whatever the physical gestures involved and the implements used. In contrast, Frankenthaler began staining the unprimed canvases she used so that the colour appeared to be in the fabric rather than applied to it. The luminous effects so produced, almost infinitely variable and subtle, greatly impressed two painters from Washington, Kenneth Noland and Morris Louis, when they visited New York in 1953; Louis was particularly impressed with a painting he saw called *Mountains and Sea* which changed his art overnight. From then on, he produced those magnificent intangible wraiths and veils of paint which appear to grow out of the surface of the picture

and hang and shimmer and sway in front of it. A later painter, Jules Olitski, reached towards the same effects although his canvases are not stained, paint being applied with an air-brush. Noland gradually moved towards a more hard-edged image, in which bands of colour interact upon each other in a method directly based upon Albers' colour theories as embodied in that sustained series of combined paintings and art lessons called *Homage to the Square*. The same is true of Frank Stella, who like Noland has acknowledged his debt to Albers as well as to Newman, whose theories of drawing as the total space obviously are relevant to Stella's vast and magnificient structures.

Reacting against Abstract Expressionism in a totally different way were the Pop Artists who came to maturity in the late 1950s and the 1960s. They deplored the fact that avant-garde art had cut itself off so much from reality and ordinary life that it was no longer capable of communicating intelligibly to anyone but the artists themselves and their own coterie. Instead they chose to portray the most aggressively contemporary objects taken from the world of the mass media (advertising, the comic strip, the newspaper photograph, the billboard) and the supermarket, since these are the things which impinge most directly on our everyday vision.

For example, Roy Lichtenstein adopted the images of the comic strip (Mickey Mouse, Donald Duck, the 'superman' heroes and slushy heroines), as well as laboriously simulating the techniques by which these had been originally reproduced— the bold simplified drawing, the Ben Day dots and the bright poster colours. He then went a step further in applying the comic strip manner to some of the sacred cows of fine art—Greek temples and portraits by Picasso. On the other hand Andy Warhol painted typical supermarket packages

225 *Tropical Zone*
1964
Kenneth Noland 1924–
oil on canvas, 83 × 212½ in

226 *No Thank You!*
1964
Roy Lichtenstein 1923–
acrylic on canvas, 38 × 35 in

such as Brillo boxes, Campbell's soup cans and Coca-Cola bottles, as well as using the multi-image of the film strip in his 'portraits' of Hollywood stars and other celebrities–Marilyn Monroe, Elvis Presley, Jackie Kennedy and Elizabeth Taylor–often employing the commercial technique of the silk-screen print to do so. People might well be puzzled as to the meaning of the blots and splashes and esoteric titles of Abstract Expressionism, but it is only too obvious what a Pop painting is about. For the Pop painter, art was to be brought down to earth.

More difficult to guess is the artist's attitude towards his subject matter. The Pop Artists deliberately rejected the extreme subjectivism of the Abstract Expressionists, favouring a cool unemotional approach. The impersonal, often glossy technique rarely gives anything away. Indeed Lichtenstein has said that any variation in the colour of his paints is due to a change by the manufacturer. We might often wonder whether the

227 *Protractor Variation Number 1*
1968
Frank Stella 1936–
polymer and fluorescent polymer on canvas,
60 × 120 in
Courtesy Kasmin Gallery, London

228 *Step-on Can with Leg*
1961
Roy Lichtenstein 1923–
acrylic on canvas

229 *Campbell Soup Can with Peeling Label*
1962
Andy Warhol 1931–
Liquitex on canvas,
72 × 54 in

artist is being satirical, propagandist, or whether his work is just a cheerful celebration of modern life.

Following the Pop Artist's concern with irony, a new school of realist painters has emerged who seek to paint tiny fragments of the world in which they live with hypnotic accuracy. The pictures of New York streets by Richard Estes and Robert Cottingham or of human faces by Chuck Close, the obses-sion with various forms of transport seen in the work of Ralph Goings, Robert Bechtle and others, are far less emotional than the Pop paintings of similar subjects, but are no less ironic for that. None of these painters is concerned with *trompe-l'oeil*. They do not wish the viewer to feel he is looking at anything other than a representation of a given object, place or person. But in another sense the paintings are *trompe-l'oeil*: so meticu-

230 *Pink Disaster*
1965
Andy Warhol 1931–
acrylic on canvas
(silkscreen), 22 × 28 in

231 *Love*
1966
Robert Indiana
Liquitex on canvas,
60 × 60 in

232 *Seated Nude on Bentwood Chair*
1967
Philip Pearlstein 1924–
oil on canvas, 50 × 43¾ in

lously do the artists finish their almost inhuman canvases that the spectator may well think (and often does think, when seeing one reproduced in a magazine) that he is looking at a photograph. And the final ironic paradox of the whole thing is that more often than not the painting has in fact been executed from a photograph.

The achievement of American painters in just 250 years is a magnificent one. For over two centuries, the artist in the United States had no tradition, no solid national heritage upon which to build and develop his art. Copley, West and Stuart had to leave America in order to gain the recognition they deserved, whilst the same happened in the 19th century with Whistler and Sargent. In our own century, the one American who chose to leave America and work in a solely European ambience, Lyonel Feininger, has a reputation enjoyed by no other American who experimented with Cubism, although there are others just as talented and who produced work which is comparable to his. The Abstract Expressionists, however, changed not only the direction of Western painting, in their total break from Cubist modes, but they also inspired confidence in an independent American art which has been a constant source of encouragement and inspiration to the younger generations of painters. It can be honestly said that no other country has achieved so much in the field of art in such a short space of time.

Naive painting in America

233 *Portrait of Johnny Nye*
19th century
artist unknown
oil on canvas, 41 × 29½ in

The United States is notable for the remarkable number of naive or primitive artists she has produced, artists who have worked outside the mainstream of painting in that country. Perhaps only France has produced so many artists capable of transcending their technical limitations purely by virtue of an overwhelming vision and an uncontrollable urge to paint. In the 18th and 19th centuries painting had not been elevated to the almost sacred level of today. We remember the words of John Singleton Copley that: 'People generally regard it as no more than any other useful trade . . . like that of a carpenter, tailor, or shewmaker, not one of the most noble arts of the world . . .' The fact was, however, that many itinerant portrait-painters, makers of 'Counterfeit Presentments' in the days before photography, were usually also engaged in one or other of the humble crafts which Copley described, whilst even some of the most famous of painters, men such as Gilbert Stuart, Benjamin West and Charles Willson Peale, were not averse to earning money by painting shop or tavern signs.

Out of the multifarious activities of the American peripatetic artisan there arose in the 18th century a distinctive manner of painting. Artists such as Pieter Vanderlyn, grandfather of John (about 1687–1778), John Durand (active 1766–82), Winthrop Chandler (1747–90), Rufus Hathaway (1770–1822), Reuben Moulthrop (1763–1814), Ralph E. W. Earl (1785–1838), son of Ralph Earl who, in spite of his academic training, was himself more of a primitive than a sophisticated, society portrait-painter, Joshua Johnston (active 1796–1824), Ammi Phillips (1788–1865), Francis Alexander (1800–80), Edward Hicks (1780–1849), Erastus Salisbury Field (1805–1900) and William Matthew Prior (1806–73) were all men who were primarily craftsmen performing a useful, if not very lucrative, job of work rather than 'artists' in the exalted sense used by Copley. Almost all of them were sign painters, woodworkers etc.; one 20th-century painter, Morris Hirschfield, was a tailor.

The style of the 19th-century primitive portrait

234 *Niagara Falls*
19th century
artist unknown
charcoal, 19 × 29 in

235 *Portrait of
Harriet Leavens (?)*
about 1815
Ammi Phillips 1788–1865
oil on canvas, 56¼ × 27 in
Fogg Art Museum,
Cambridge, Massachusetts
(Gift of the Estate of Harriet
Anna Niel)

was essentially based upon the precedents set by the portrait-painters of the 17th and 18th centuries, a style which was itself based upon English Elizabethan originals. The portraits which have survived are flat, two-dimensional and lacking in any attempt to modulate light and tone. However, their strength lies in their innate decorative sense; the sitters are usually shown dressed in their finest clothes and there is an obvious attempt on the part of the artists to impart dignity and social standing to their subjects. Winthrop Chandler is probably the finest of all the 18th-century primitive portraitists. Most of his life was spent in his native Woodstock, although he was apprenticed to a house-painter in Boston early in his life. Almost all of his portraits are of relatives or friends and his worldly success was minimal – he died in considerable poverty. Yet when we look at the *Portrait of Samuel Chandler* and the *Portrait of Mrs Samuel Chandler* (both dated 1780 and in the National Gallery of Art, Washington), we realise that we

are faced with an artist whose instinctive ability to produce a sophisticated decorative pattern was of a very high order. The same is true of Rufus Hathaway. His masterpiece, the *Portrait of Molly Whales Leonard* 1790 (Metropolitan Museum of Art, New York), is a superb, almost Rococo, composition which, with its diverse but subtly related elements, always reminds me of the earliest Surrealist compositions of Miró. As a portrait, however, this picture is amazing for the lady is portrayed as downright ugly.

The 19th century produced two primitive painters of outstanding ability, Edward Hicks and Joseph Pickett. Hicks was born of Quaker parents in Bucks County, Pennsylvania, and spent most of his life in the town of Newtown in the same state. He was trained as a coach and sign-painter and although he painted panel pictures when young, he gave up art at the age of thirty-one because of his fanatical religious belief that painting was immoral. However he returned to painting later in

life. His three most famous subjects which he repeated over and over were the scene from the life of the great Quaker hero William Penn, *Penn's Treaty with the Indians*; *The Grave of William Penn*; and that most famous of all 19th-century primitive subjects, *The Peaceable Kingdom*, the first version of which was created in 1820. Although a strong element of didactism and religious fervour runs through Hicks' art, it is not, surprisingly, morose or too moralistic; indeed his paintings are imbued with a gentle and almost humorous spirit which may be the reason that they have retained their strength and found so many admirers. In 1811, soon after he moved to Newtown, he was given a commission to paint a tavern sign. The owner of the establishment was somewhat offended when the young painter produced a work which showed the former in a state of obvious intoxication. Hicks disarmingly replied, 'Thee is usually that way and I wanted it to look natural,' at once the true artist and the saver of souls! Even his view of the Ameri-

236

237

can landscape was tinged with a knowledge of the glory of God's handiwork. The Museum of Modern Art in New York owns a view of the *Falls of Niagara*, on the frame of which the artist has inscribed:

'With uproar hideous first the Falls appear,
The stunning tumult thundering on the ear
Above, below, where'er the astonished eye
Turns to behold, new opening wonders lie.
This great o'erwhelming work of awful Time
In all its dread magnificence sublime,
Rises on our view amid a crashing roar
That bids us kneel, and Time's great God adore.'

Joseph Pickett was born in 1848 in New Hope, Pennsylvania, where he spent the whole of his life, dying there in 1918. He was a carpenter and boat-builder and did not take up painting until late in life. He attempted to paint the history of his home town with such works as *Washington under the Council Tree* (Newark Museum), *Coryell's Ferry and Washington Taking Views* (Whitney Museum of American Art, New York) and his masterpiece and one of the greatest American naive paintings, *Manchester Valley* (Museum of Modern Art, New York). As is often the way with primitive artists, Pickett used some unusual techniques in his paintings (the desire to improvise is after all, instinctive, it cannot be taught) and in many of his paintings he used such materials as sand, gravel,

230

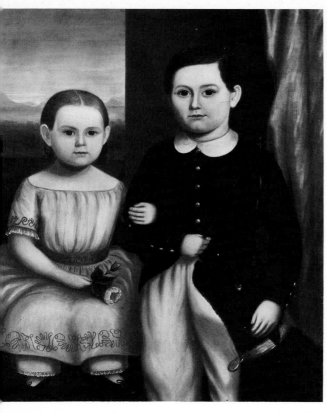

stones and sea-shells to create textural effects, the same materials for the same purposes as were used by such artists as Picasso, the Surrealists and Dubuffet. In 1918, he sent one of his paintings for entry to the Pennsylvania Academy exhibition. Not surprisingly it was rejected, but it did receive three votes, one of which was cast by Robert Henri whose ability to spot genius in the bud was almost unfailing.

The invention of photography was largely responsible for the end of the itinerant portrait-painter; he had served a necessary function in the scattered communities and now a more efficient means had overtaken him. In the 20th century, the practice of painting outside any school continued unabated, although the motivations were different; these were men and women who painted for a variety of reasons, none of which entailed actually selling their work, and none of them painted portraits on commission.

John Kane is unquestionably the greatest primitive painter America has produced in the present century, although the strength and sophistication of his work almost belies the label primitive. His vision of the hard, toil-worn society in which he lived was as full of compassion as any held by the

236 *The Bicyclist*
1865
artist unknown
oil on canvas, 16 × 24½ in

237 *Girl with a Basket*
1820
artist unknown
oil on canvas, 36 × 29 in

238 *Boy and Girl*
19th century
artist unknown
oil on canvas, 36 × 26 in

239 *The Peaceable Kingdom*
about 1830–40
Edward Hicks 1780–1849
Brooklyn Museum,
New York (Dick S.
Ramsay Fund)

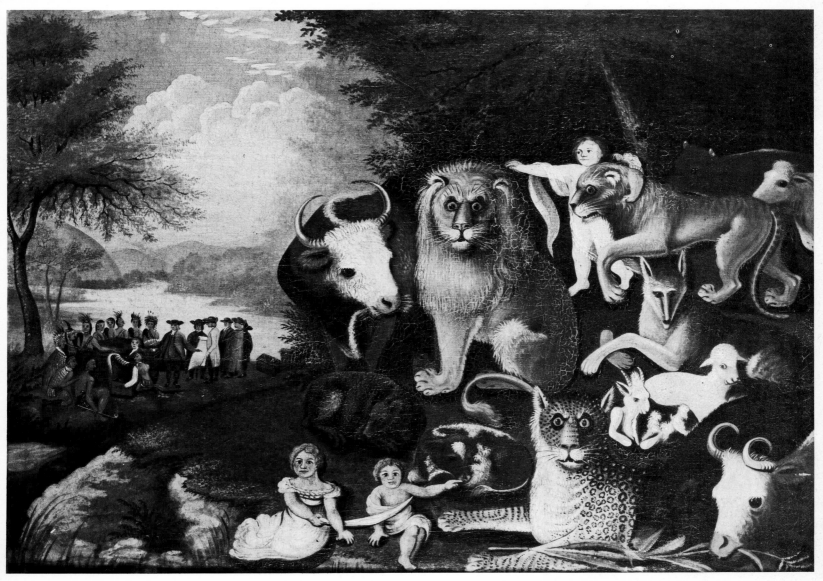

231

Social Realists whom we have already discussed, and his work is worthy to stand beside that of Levine, Hopper, Shahn and Evergood as an indictment of the misery of poverty. But it is also remarkable for its recognition of man's ability to rise above his environment. When asked about his work, he replied:

'I have been asked why I am particularly interested in painting Pittsburgh. Her mills with their plumes of smoke, her high hills and deep valleys and winding rivers. Because I find beauty everywhere in Pittsburgh. The city is my own. I have worked on all parts of it, in building the blast furnaces and then in the mills and in paving the tracks that brought the first street cars out of Fifth Avenue to Oakland. The filtration plant, the

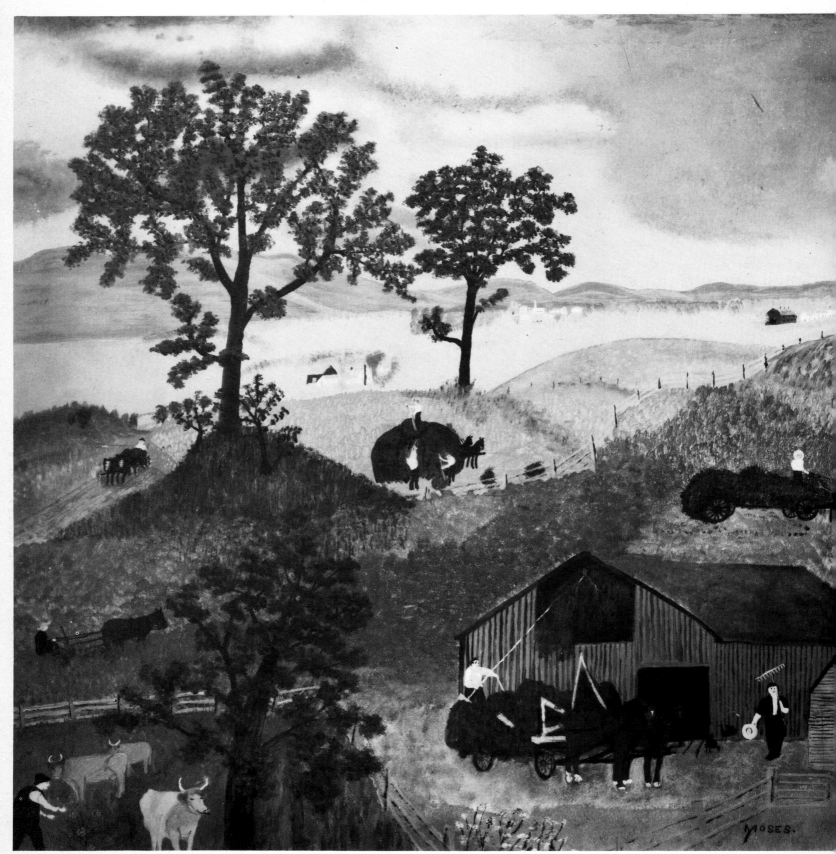

bridges that span the river, all these are my own. Why shouldn't I want to set them down when they are to some extent children of my labors? And when I see Pittsburgh I see with it my recollections as well as the way it now looks. And so I see it both the way God made it and as man changed it.'

Morris Hirshfield, Lawrence Lebduska, the Negro

Horace Pippin and the almost legendary Anna Mary Robertson (Grandma Moses) are other painters who have raised the art of primitive painting to a level unequalled apart from the Frenchmen Rousseau, Seraphine and Bombois. They were all people who painted simply for their own satisfaction, in a completely untutored style. Morris Hirshfield wrote in *My Biography*, quoted in

241 *Night Call*
Horace Pippin
oil on canvas, 28 × 32 in

242 *Bathers*
John Kane 1860–1934
oil on canvas, 10 × 14 in

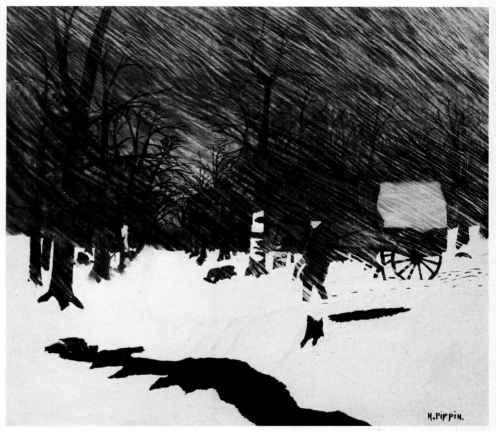

233

243 *Landscape
(Philadelphia)*
John Kane 1860–1934
oil on canvas, 20 × 24 in

244 *Jungle Landscape*
1932
Lawrence Lebduska
oil on canvas, 30 × 34 in

Sydney Janis' enchanting book, *They Taught Themselves To Paint:*
'At the age of eighteen I left Europe and came to America and went into business with my brother in the manufacturing of woman's coats and suits . . . I stayed in this line for twelve years. While we were making a very nice line of merchandise we could not call it a financial success, so we sold the business and shortly thereafter entered a new field – the manufacturing of boudoir slippers, where I made a huge success . . . The E. Z. Walk Mfg. Co. I called it . . . My first paintings on which I worked so laboriously and which took me so long to produce, were started in 1937 and were called the *Beach Girl* and *Angora Cat.* It seems that my mind knew well what I wanted to portray but my hands were unable to produce what my mind demanded.'

But surely the most succinct, yet the most unforgettable statement about primitive art, its aspirations, hopes and above all its innocence, was made by Horace Pippin:
'My opinion of art is that a man should have love for it, because my idea is that he paints from his heart and mind. To me it seems impossible for another to teach one of Art.'

235

Acknowledgments

I should like to thank all those who have given me help and advice in the writing of this book. With James Dugdale and Elizabeth Lecky of London I have had many fruitful conversations about 20th-century American painting. Patterson Sims of the O. K. Harris Gallery, New York, with his wife Drayton Grant, took me deep into the New York art scene. Alvin Martin of the Fogg Art Museum, Cambridge, Massachusetts, unstintingly gave me his time and advice, despite heavy commitments, as did other staff members of that excellent institution. The staff of Sotheby Parke-Bernet, New York, were, as usual, most patient, and I received much kindness from William and Marina Beadleston of the William J. Beadleston Gallery, New York. Finally I should like to thank Sean and Rosemary Scully, the former one-time Frank Knox Fellow of Harvard University, at whose home in Brookline, Massachusetts, this book was completed and to whom it is dedicated.

Ian Bennett

The following books and articles have been quoted in the text:

Thomas Hart Benton, *An Artist in America*, 3rd revised edition, University of Missouri Press, 1968.
Charles Caffin, *American Masters of Painting*, Grant Richards, London, 1903.
Douglas Cooper, *The Cubist Epoch*, Phaidon Press, London, Los Angeles County Museum of Art and Metropolitan Museum of Art, New York, 1971.
Alfred Frankenstein, *The reality of appearance: the trompe l'oeil tradition in American painting*, New York Graphic Society, 1970.
Lloyd Goodrich, John Sloan retrospective exhibition catalogue, Whitney Museum of American Art, 1952.
Clement Greenberg in *Partisan Review*, 1955.
Elaine de Kooning, Franz Kline Memorial Exhibition catalogue, Washington Gallery of Modern Art, 1962.
Jean Lipman, *American Primitive Painting*, Oxford University Press, 1942.
Barbara Novak, *American Painting of the 19th Century: Realism, Idealism and the American Experience*, Praeger, New York, 1969, and Pall Mall Press, London, 1969.
Jackson Pollock, interview in *Art and Architecture*, 1944.
Jackson Pollock, interview in *The New Yorker*, 1950.
E. P. Richardson, *Painting in America*, Thomas Y. Crowell Company, New York, 1956.
Barbara Rose, *American Art Since 1900*, New York, and Thames and Hudson, London, 1967.
Charles Sheeler exhibition catalogue, Museum of Modern Art, New York, 1939.
Theodore Stebbins Jnr, Martin Johnson Heade exhibition catalogue, 1969.
Sarah Tyler, *Modern Painters and their Painting*, 1886.
Thomas Wolfe, *You Can't Go Home Again*, Harper & Row, New York, and Heinemann, London.

Sources of photographs:

Albany Institute of History and Art, Albany, New York 4; Art Institute of Chicago, Chicago, Illinois 142, 194; Brompton Studio, London 32; Brooklyn Museum, Brooklyn, New York 239; California Palace of the Legion of Honor, San Francisco, California 102; Christie, Manson & Woods, London 25, 63, 73, 75, 84, 170, 201, 240; Cincinnati Art Museum, Cincinnati, Ohio 193; Cleveland Museum, Cleveland, Ohio 161; A. C. Cooper, London 228; Corcoran Gallery of Art, Washington, D.C. 47; Detroit Institute of Arts, Detroit, Michigan 8, 35, 58, 61, 140; Fratelli Fabbri, Milan 219; Fogg Art Museum, Cambridge, Massachusetts 104, 180, 235; Fort Worth Art Center Museum, Fort Worth, Texas 134; Richard Green (Fine Paintings) Ltd, London 13; Solomon R. Guggenheim Museum, New York 212; Hamlyn Group Picture Library contents page, 14, 136; O. K. Harris Gallery, New York 220; Harvard University Law School, Cambridge, Massachusetts 16; Historical Society of Pennsylvania, Philadelphia, Pennsylvania 20; Thomas Jefferson University, Philadelphia, Pennsylvania 138; Kasmin Gallery, London 227; Kunstsammlung Nordrhein–Westfalen, Dusseldorf 213; Metropolitan Museum of Art, New York 66, 68, 71, 90, 130; Museum of Fine Arts, Boston, Massachusetts 11, 19, 26, 29, 56, 62, 65, 93, 97, 98, 99, 129, 132; Museum of Modern Art, New York 179, 198; National Gallery of Art, Washington, D.C. 17, 141; National Gallery of Canada, Ottawa 21; William Rockhill Nelson Gallery of Art, Kansas City, Missouri 38; Newark Museum, Newark, New Jersey 171; New York Historical Society, New York 5, 59, 125; New York State Historical Association, Cooperstown, New York 92; Pennsylvania Academy of the Fine Arts, Philadelphia, Pennsylvania 22, 57, 137; Philadelphia Museum of Art, Philadelphia, Pennsylvania 23, 34, 209; St Louis Art Museum, St Louis, Missouri 18, 94, 95; Seattle Art Museum, Seattle, Washington 211; Sotheby & Company, London 1, 17, 31, 54, 80, 113; Sotheby Parke-Bernet, New York title page 9, 10, 12, 15, 24, 28, 30, 33, 36, 37, 39, 40, 41, 42, 43, 46, 48, 49, 50, 51, 52, 55, 64, 67, 69, 70, 72, 74, 76, 77, 78, 79, 81, 82, 83, 85, 86, 87, 88, 89, 91, 96, 100, 101, 103, 105, 106, 107, 108, 109, 110, 111, 112, 114, 115, 116, 117, 118, 119, 120, 121, 122, 123, 124, 126, 127, 128, 131, 133, 135, 139, 143, 144, 145, 146, 147, 148, 149, 150, 151, 152, 153, 154, 155, 156, 157, 158, 159, 160, 162, 163, 164, 166, 168, 169, 172, 173, 175, 176, 177, 178, 181, 182, 184, 185, 186, 187, 188, 190, 191, 192, 195, 196, 197, 199, 200, 202, 204, 205, 206, 207, 210, 214, 215, 216, 217, 218, 221, 222, 223, 224, 225, 226, 229, 230, 231, 232, 233, 234, 236, 237, 238, 241, 242, 243, 244; Wadsworth Atheneum, Hartford, Connecticut 44; Whitney Museum of American Art, New York 167, 174, 183, 189, 203, 208; Worcester Art Museum, Worcester, Massachusetts 2, 3, 7; Yale University Art Gallery, New Haven, Connecticut 6, 45, 53, 60, 165.

Index

Numbers in italic refer to illustrations